Canon[®] EOS **7D** *Digital Field Guide*

Canon[®] EOS 7D

Digital Field Guide

Charlotte K. Lowrie

Canon[®] EOS 7D Digital Field Guide

Published by Wiley Publishing, Inc. 10475 Crosspoint Boulevard Indianapolis, IN 46256 www.wiley.com

Copyright © 2010 by Wiley Publishing, Inc., Indianapolis, Indiana

Published simultaneously in Canada

ISBN: 978-0-470-52129-8

Manufactured in the United States of America

10987654321

No part of this publication may be reproduced, stored in a retrieval system or transmitted in any form or by any means, electronic, mechanical, photocopying, recording, scanning or otherwise, except as permitted under Sections 107 or 108 of the 1976 United States Copyright Act, without either the prior written permission of the Publisher, or authorization through payment of the appropriate per-copy fee to the Copyright Clearance Center, 222 Rosewood Drive, Danvers, MA 01923, (978) 750-8400, fax (978) 646-8600. Requests to the Publisher for permission should be addressed to the Permissions Department, John Wiley & Sons, Inc., 111 River Street, Hoboken, NJ 07030, 201-748-6011, fax 201-748-6008, or online at http://www.wiley.com/go/permissions.

LIMIT OF LIABILITY/DISCLAIMER OF WARRANTY: THE PUBLISHER AND THE AUTHOR MAKE NO REPRESENTATIONS OR WARRANTIES WITH RESPECT TO THE ACCURACY OR COMPLETENESS OF THE CONTENTS OF THIS WORK AND SPECIFICALLY DISCLAIM ALL WARRANTIES, INCLUDING WITHOUT LIMITATION WARRANTIES OF FITNESS FOR A PARTICULAR PURPOSE. NO WARRANTY MAY BE CREATED OR EXTENDED BY SALES OR PROMOTIONAL MATERIALS. THE ADVICE AND STRATEGIES CONTAINED HEREIN MAY NOT BE SUITABLE FOR EVERY SITUATION. THIS WORK IS SOLD WITH THE UNDERSTANDING THAT THE PUBLISHER IS NOT ENGAGED IN RENDERING LEGAL. ACCOUNTING, OR OTHER PROFESSIONAL SERVICES, IF PROFESSIONAL ASSISTANCE IS REQUIRED. THE SERVICES OF A COMPETENT PROFESSIONAL PERSON SHOULD BE SOUGHT. NEITHER THE PUBLISHER NOR THE AUTHOR SHALL BE LIABLE FOR DAMAGES ARISING HEREFROM. THE FACT THAT AN ORGANIZATION OR WEB SITE IS REFERRED TO IN THIS WORK AS A CITATION AND/OR A POTENTIAL SOURCE OF FURTHER INFORMATION DOES NOT MEAN THAT THE AUTHOR OR THE PUBLISHER ENDORSES THE INFORMATION THE ORGANIZATION OF WEB SITE MAY PROVIDE OR RECOMMENDATIONS IT MAY MAKE. FURTHER, READERS SHOULD BE AWARE THAT INTERNET WEB SITES LISTED IN THIS WORK MAY HAVE CHANGED OR DISAPPEARED BETWEEN WHEN THIS WORK WAS WRITTEN AND WHEN IT IS READ.

For general information on our other products and services or to obtain technical support, please contact our Customer Care Department within the U.S. at (877) 762-2974, outside the U.S. at (317) 572-3993 or fax (317) 572-4002.

Wiley also publishes its books in a variety of electronic formats. Some content that appears in print may not be available in electronic books.

Library of Congress Control Number: 2009940872

Trademarks: Wiley and the Wiley Publishing logo are trademarks or registered trademarks of John Wiley & Sons, Inc. and/or its affiliates. All other trademarks are the property of their respective owners. Wiley Publishing, Inc. is not associated with any product or vendor mentioned in this book.

About the Author

Charlotte K. Lowrie is a professional photographer and award-winning writer based in the Seattle, Wash., area. She has more than 25 years of photography experience ranging from photojournalism and editorial photography to stock and wedding shooting. Her images have appeared in national magazines, newspapers, and on a variety of Web sites including MSN.com, www.takegreatpictures.com, and the Canon Digital Learning Center.

Charlotte currently divides her time among maintaining an active photography business, teaching photography, and writing books and magazine articles. Charlotte is the author

of 13 books including the bestselling *Canon EOS 50D Digital Field Guide* and eight other Digital Field Guides, and she co-wrote *Exposure and Lighting for Digital Photographers*. In addition, she teaches monthly online photography courses at BetterPhoto.com. Visit her Web site at wordsandphotos.org.

Credits

Acquisitions Editor Courtney Allen

Project Editor Chris Wolfgang

Technical Editor John Smith

Copy Editor Marylouise Wiack

Editorial Director Robyn Siesky

Editorial Manager Cricket Krengel

Business Manager Amy Knies

Senior Marketing Manager Sandy Smith

Vice President and Executive Group Publisher Richard Swadley

Vice President and Executive Publisher Barry Pruett **Project Coordinator** Lynsey Stanford

Graphics and Production Specialists Ana Carrillo Nikki Gately Jennifer Henry Andrea Hornberger Jennifer Mayberry

Quality Control Technician Laura Albert

Proofreading and Indexing Susan Hobbs Valerie Haynes Perry

This book is dedicated in loving memory to my Dad, who taught me to pursue excellence, and it is dedicated to God, an unfailing source of inspiration and insight.

Acknowledgments

Thanks to my long-time group of photographer friends, especially Ellen, Peter, Jon, and Rob. Our ongoing discussions of images, ideas, and insights is invaluable. And, of course, thanks to my family for their unfailing support.

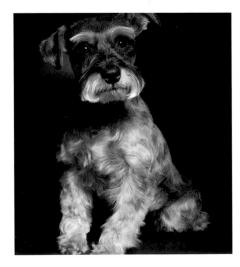

Contents

Introduction

XX

1

CHAPTER 1 Roadmap to the 7D

Camera Controls Overview	2
Front of the camera	3
Top of the camera	5
Back of the camera	3
Side of the camera 12	2
Bottom of the camera	3
Lens Controls Overview 14	1
Viewfinder display	5
Camera menus	7

CHAPTER 2

Camera Setup and Image Playback	23
Choosing Image Format and Quality	24
JPEG format	24
RAW capture	25
The best of both worlds: shooting RAW and JPEG	28
Working with Folders and File Numbering	30
Creating and selecting folders	31
Choosing a file numbering option	32
Continuous file numbering	32
Auto reset	33
Manual reset	35
Miscellaneous Setup Options	35
General setup options	36
Adding copyright information	39
Image Playback Options	40
Searching for images and moving	10
through multiple images	
Displaying images on a TV	
Protecting and Erasing Images	
Protecting images	
Erasing images	45

CHAPTER 3

Controlling Exposure and Focus	47
Working with Exposure	48
Defining exposure goals	48
Practical exposure considerations	48
Choosing a Shooting Mode	51
Semiautomatic, Manual, and Bulb	
shooting modes	51
Program AE (P) shooting mode	
Shutter-priority AE (Tv) mode	
Aperture-priority AE (Av) mode	58
Manual (M) mode	60
Bulb	62
C modes	62
Automatic shooting modes	62
Full Auto mode	63
Creative Auto mode	63
Setting the ISO Sensitivity	
Metering Light and Modifying Exposure	68
Using metering modes	69
Evaluating exposures	71
Brightness histogram	72
RGB histogram	73
Modifying and bracketing exposures	75
Auto Lighting Optimizer	75
Highlight Tone Priority	76
Safety Shift	77
Auto Exposure Lock	78
Exposure Compensation	79
Auto Exposure Bracketing	81
Using the 7D Autofocus System	84
Choosing an autofocus mode	84
Choosing an AF area	86
Selecting a Drive Mode	91

CHAPTER 4 Getting Great Color

Getting Great Color	93
Choosing a Color Space	94
Setting the White Balance	97
Setting a specific color temperature	103
Fine-tuning white balance	104
Using White Balance Auto	
Bracketing	104
Using White Balance Correction	106

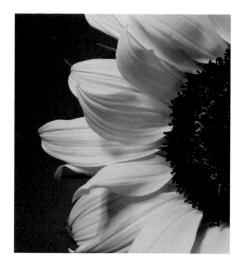

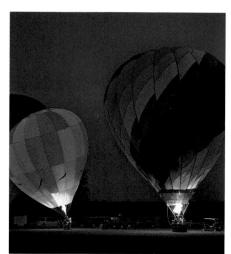

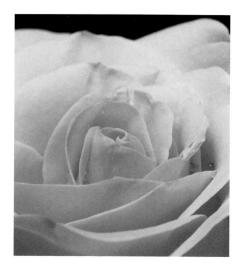

107
109
113
114

CHAPTER 5 Customizing the 7D

-	4	0
		u
		J

8	
Exploring Custom Functions	120
Custom Function groupings	120
Custom Functions specifics	122
C.Fn I: Exposure	122
C.Fn II: Image	125
C.Fn III: Autofocus/Drive	127
C.Fn IV: Operation/Others	134
Setting Custom Functions	139
Registering Camera User Settings	140
Customizing My Menu	142

CHAPTER 6

Shooting in Live View and Tethered 1	45
About Live View Shooting	146
Live View features and functions	147
Live View focus	147
Exposure simulation and metering	149
Silent shooting modes	149
Using a flash	150
Setting up for Live View Shooting	150
Working with Live View	151
Shooting in Live View	152
Shooting Tethered or with a Wireless	
Connection	154

CHAPTER 7 Using Movie Mode

Using Movie Mode	159
About Video	160
Video standards	160
Video on the 7D	161
Recording and Playing Back Videos	163
Setting up for movie recording	164
Recording movies	165
Playing back videos	167

CHAPTER 8 Working with Flash and Studio Lights

Flash Technology and the 7D	170
Shooting with the Built-in Flash	171
Working with the built-in flash	173
Red-eye Reduction	173
Modifying Flash Exposure	173
Flash Exposure Compensation	173
Flash Exposure Lock	175
Setting Flash Control Options	176
Using the flash autofocus assist beam	
without firing the flash	178
Wireless Flash and Studio Lighting	180
Using multiple Speedlites wirelessly	180
Setting up wireless flashes	181
Exploring flash techniques	183
Bounce flash	183
Adding catchlights to the eyes	183

169

185

CHAPTER 9 Lenses and Accessories

Evaluating Lens Choices for the 7D	186
Building a lens system	186
Understanding the focal-length	
multiplier	187
Types of Lenses	188
About zoom lenses	189
About prime lenses	190
Working with Different Types of Lenses	191
Using wide-angle lenses	191
Using telephoto lenses	193
Using normal lenses	195
Using macro lenses	196
Using tilt-and-shift lenses	197
Using Image Stabilized lenses	197
Calibrating and Fine-Tuning Lenses	199
Calibrating lenses for focus accuracy	199
Setting lens peripheral correction	201
Doing More with Lens Accessories	203
Lens extenders	203
Extension tubes and close-up lenses	
Learning Lens Lingo and Technology	

CHAPTER 10 Event and Action Photography 207

Event and Action Photography	208
Packing the gear bag	208
Setting up the 7D for event and action	
shooting	210
Shooting Events and Actions	212
Exposure approaches and shooting	
techniques	212
Tips for capturing the moment	217

CHAPTER 11

Nature and Landscape Photography 219

Nature and Landscape Photography	220
In the camera bag	221
Setting up the 7D for outdoor	
shooting	223
Approaches to Exposure	227
Basic exposure technique	229
Advanced exposure approach	232
Exposing nonaverage scenes	234
Shooting Landscape and Nature	
Images	237

CHAPTER 12 People Photography

People Photography 2	42
Selecting gear 2	43
Setting up the 7D for portrait shooting 2	44
Making Natural-light Portraits 2	47
Outdoor portraits 2	47
Window light portraits	49
Exposure approaches	50
Making Studio Portraits	51
Keep It Simple 2	53

241

APPENDIX A Exploring RAW Capture

-	-	-	
Learning	about RAV	N Capture	255
Canon's	RAW Conv	version Program	258
Sample I	RAW Image	e Conversion	258

255

APPENDIX B

How to Use the Gray Card and					
Color Checker	261				
The Gray Card	. 261				
The Color Checker	. 262				
Glossary	263				
Index	272				

Introduction

f you're reading this introduction in a bookstore as you try to decide which of many books on the Canon EOS 7D to buy, or if you bought the book sight unseen, this is the place to learn what to expect in this Digital Field Guide.

This book assumes that you already own the Canon EOS 7D digital SLR. And if you've used the 7D for any amount of time, then you know that the camera offers superb image quality and speedy performance at 8 frames per second. With the addition of high-resolution 1080i video, the 7D truly becomes a multimedia story-telling tool that opens new doors to creative expression. Under the hood of the 7D, you get the latest iteration of Canon's venerable DIGIC processor with 14-bit processing for smooth tonal gradations, rich color, an expanded ISO range up to 6400 or expanded to 12800, Live View shooting, and loads of handy customization options.

In the Canon DSLR lineup, the 7D provides an ideal segue for serious photographers who want to advance their work — photographers who also expect a full complement of creative controls and high resolution in a light-weight, easy-to-use camera — all of which the 7D offers. For professional photographers, the 7D is a fine second camera body or even primary camera that is versatile enough to shoot even the most demanding assignments.

The challenge for new 7D photographers is putting to use all that the camera has to offer in everyday shooting. That's what this book is designed to do — to be your go-to resource. Here you'll learn not only what the camera features and options are, but also get suggestions on when and how to use them — all without needing to refer back to the camera manual.

You probably have a good sense of the power of the EOS 7D by now, but you may be using only a few of the individual features. This book offers practical suggestions for setting up the camera for specific subjects and scenes so that you use a full set of features in combination. You can use the suggestions as described, or you can use them as jumping-off points for your specific shooting needs. Either way, putting the camera's full power to work for you makes your shooting more efficient so that you can concentrate on the creative work of exploring subjects, lighting, and composition.

Introduction

Any photography book that you buy should have staying power; in other words, it should be useful to you now and months or years from now. So with that in mind, the book includes both basic and advanced shooting techniques so that both get started quickly and explore the bevy of advanced features as you have time.

You may be wondering if this is the type of book where you can skip around reading chapters that intrigue you in random order. You can, of course, read in any order that you want, but try to read Chapters 1 through 4 early. These chapters provide the foundation for learning the camera, setting up a good workflow, and getting great color. From there you can explore Live View shooting, video, flash, lenses, and specific shooting specialty areas in any order that you want.

Finally, I want to thank the many readers who have contacted me over the years. Your questions, suggestions, and ideas for previous books continue to influence the content of the books that I write today. Thank you, and keep the questions and ideas coming.

The team at Wiley and I hope that you enjoy reading and using this book as much as we enjoyed creating it for you.

Wishing you many beautiful images to come,

Charlotte

CHAPTER

Roadmap to the 7D

his chapter puts some of the new features and technologies of the Canon EOS 7D into everyday perspective and offers a roadmap to navigating the camera controls and menus. The Canon 7D offers photographers high image resolution, snappy performance, and plenty of creative control. It fits easily and comfortably in your hand, with just enough heft to make it feel substantial.

The 7D's fast performance records images at a rate of 8 frames per second (fps) and at a stunning 18-megapixels. For example, the 18-megapixel image sensor at 5184 × 3456 pixels produces fullresolution prints at approximately 11.5 × 17 inches at 300 ppi, or 21 × 14 inches at 240 ppi for inkjet prints.

All in all, the 7D makes shooting pleasurable and satisfying while delivering excellent image resolution and quality.

Camera Controls Overview

The following sections provide methods for using the controls in logical and efficient ways because once you learn the overall design, you can make camera adjustments more efficiently.

There are three main controls that can be used together or separately to control most functions on the 7D:

Main dial and Quick Control dial. These enable you to make changes for the four dualfunction buttons located along the top LCD panel, such as the AF-Drive button (Autofocus mode and Drive mode). You use the Main dial to change the first named function next to the button. So for the AF-Drive button,

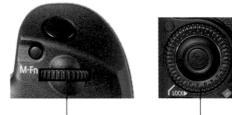

Main dial

Quick Control dial

you turn the Main dial to change the Autofocus mode and the Quick Control dial to change the Drive.

This holds true for the Metering Mode/White Balance and ISO-Flash Compensation buttons on the camera as well. Some camera menu screens, such as the Quality screen, also use the Main and Quick Control dials for selecting different values on the screen.

Multi-controller. This eight-way control functions as a button when it is pressed, and as a joystick when it is tilted in any direction. With the Quick Control screen, the Multi-controller is the primary control. To activate the Quick Control screen, press the Q button, and then tilt the Multi-controller to move around the screen. Once an option is selected, turn the Quick Control dial or Main dial to make changes. You can use the Multi-controller to select the AF point, a white

1.2 The Multicontroller

balance setting, move through an image in magnified view during playback, and to enlarge the frame in Live View.

Setting (Set) button. The Set button confirms changes you make to many menu items, and it opens submenus. On the Quick Control screen, accessed by pressing the Q button on the back of the camera, you can select a setting using the Multi-controller, such as White Balance, and then press the Set button to display all the options for the setting — in this case, the White Balance screen showing all White Balance options.

Front of the camera

The front of the camera includes the nicely sculpted grip that increases control and balance when handling the camera, as well as the controls that you use often. The front of the camera includes the following features, from left to right:

- Red-eye reduction/Self-timer lamp. When using the built-in flash with the Red-eye Reduction option turned on, this lamp lights to help reduce pupil size to reduce the appearance of red in the subject's eyes if the subject looks at the lamp. In the two Self-timer modes, this lamp flashes to count down the seconds (either 10 or 2) to shutter release.
- Remote control sensor. Works with the accessory Remote Controllers RC-1 or RC-5 for remote release of the shutter up to 16.4 feet from the camera. Point the remote control at this sensor and press the transmit button. The Self-timer light lights when the Drive mode is set to one of the Self-timer modes.
- DC coupler cord hole. Enables you to use household power when using the accessory AC Adapter Kit ACK-E6.
- Mirror. As you compose an image, the reflex mirror reflects light from the lens to the pentaprism so you see in the viewfinder eyepiece what's captured by the imaging sensor. The viewfinder offers 100 percent frame coverage. In Live View shooting, the mirror is flipped up to allow a current view of the scene. If you are using Quick mode focusing, the mirror flips down to focus, thereby suspending Live View momentarily.
- Lens mount and contacts. The lens mount is compatible with Canon EF and EF-S lenses. EF-S lenses are compatible with only the cropped image sensor size of the 7D and other Canon EOS digital SLR cameras. EF lenses are compatible with all EOS digital SLRs. The lens mount includes a red index marker that is used to line up EF-mount lenses and a white index mount marker that is used to line up EF-S lenses.

Canon EOS 7D Digital Field Guide

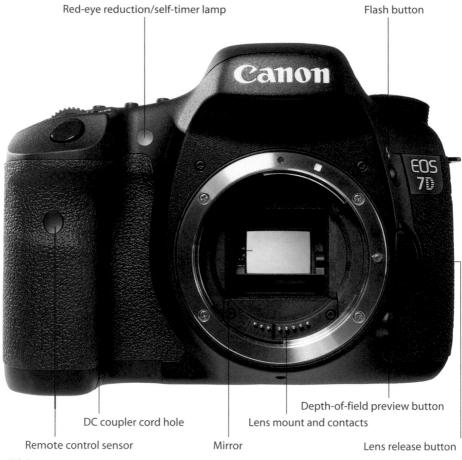

1.3 EOS 7D camera front

- Depth-of-Field preview button. Pressing this button stops down the lens diaphragm to the currently selected aperture so that you can preview the depth of field in the viewfinder. The larger the area of darkness, the more extensive the depth of field will be. The button can be used also be used during Live View shooting. If the lens is set to the maximum aperture, the Depth-of-Field preview button cannot be depressed because the diaphragm is already fully open.
- Lens Release button. This button releases the lens from the lens mount. To disengage the lens, depress and hold down the Lens Release button as you turn the lens so that the red or white index mark moves toward the top of the camera.

Flash button. In P, Tv, Av, M, and B shooting modes, press this button to pop up and use the built-in flash. In Full Auto shooting mode, pressing the Flash button has no effect because the camera automatically determines when to use the built-in flash.

Top of the camera

Dials and controls on the top of the camera provide access to frequently used shooting functions in addition to the hot shoe and diopter control.

- Mode dial. Turning this dial selects the shooting mode, which determines how much control you have over image exposures. Shooting modes are grouped as follows:
 - Fully automatic shooting modes:

Full Auto

Creative Auto

- Creative shooting modes:
 - P (Program AE)

Tv (Shutter-priority AE)

Av (Aperture-priority AE)

M (Manual exposure)

B (Bulb)

- Camera User Settings. This group includes three shooting modes that you can program with your favorite camera settings:
 - C1
 - C2
 - C3

Just turn the dial to line up the shooting mode that you want to use with the white mark to the right of the dial.

Canon EOS 7D Digital Field Guide

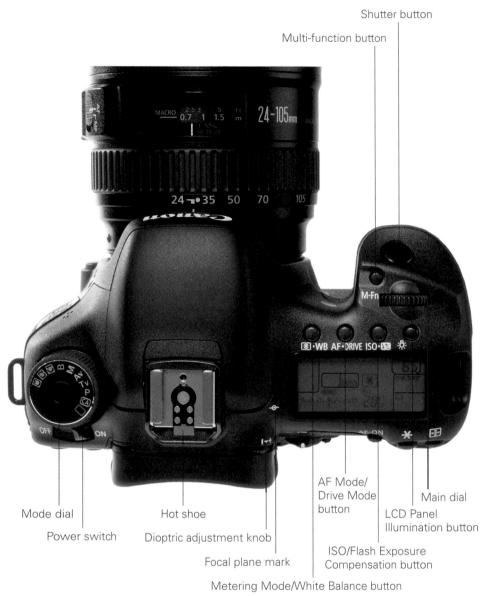

1.4 EOS 7D top of the camera

Shooting modes are detailed in Chapter 3. Chapter 5 explains how to set up the customizable Camera User Setting, or C modes.

- **Power switch.** The power switch turns the camera off and on.
- Hot shoe. The hot shoe mounting plate with flash sync contacts is where you mount an accessory flash unit. The 7D hot shoe is compatible with E-TTL II auto flash with accessory Canon EX-series Speedlites, and offers wireless multi-flash support. When using a compatible EX-series Speedlite, the 7D offers flash configuration from the camera using the Shooting 1 menu. The camera also provides Flash Exposure Compensation to decrease or increase the flash output by up to plus or minus 3 stops in 1/3- or 1/2-stop increments.
- Dioptric adjustment knob. Turn this control forward or backward to adjust the sharpness for your vision by -3 to +1 diopters. If you wear eyeglasses or contact lenses for shooting, be sure to wear them as you turn the dioptric adjustment control. To make the adjustment, point the lens to a light-colored surface such as a piece of white paper or a white wall, and then turn the control until the AF points are perfectly sharp and crisp for your vision.
- Focal plane mark. The mark indicates the equivalent of the film plane and is useful in macro photography when you need to know the exact distance from the front of the image sensor plane to the subject.
- Main dial. The Main dial selects a variety of options. Turn the Main dial to change the first named option on the dual-function buttons, cycle through camera Menu tabs, cycle through autofocus (AF) points when selecting an AF point manually, set the aperture in Av shooting mode, set the shutter speed in Tv and Manual (M) shooting modes, and shift the exposure in Program (P) shooting mode.
- Multi-function button. When you press the AF-point selection button, and then press the Multi-function (M-Fn) button, you can change the AF area selection mode either single-point AF, Zone AF, or 19-point AF. Chapter 3 details AF area selection modes. When using the built-in flash, pressing this button locks the flash exposure at the point you choose and fires a preflash to calculate and retain in memory the required flash output.
- Shutter button. When you press the Shutter button halfway, the 7D automatically meters the light in the scene and focuses on the subject. Completely pressing the Shutter button opens the shutter to make the picture. In High-Speed or Low-Speed Continuous drive mode, pressing and holding the Shutter button starts burst shooting at either 8 or 3 fps, respectively. In Self-timer modes, pressing the Shutter button completely initiates the 10- or 2-second timer, and after the timer delay, the shutter fires to make the picture.
- ► LCD Panel Illumination button. Pressing the LCD Panel Illumination button turns on an amber light to illuminate the LCD panel for approximately 6 seconds.

This is a handy option for making LCD panel adjustments in low light or in the dark.

- ► **ISO/Flash Exposure Compensation button.** Pressing this button enables you to change the ISO sensitivity setting using the Main dial or to change the Flash Exposure Compensation using the Quick Control dial. The ISO options are as follows:
 - **ISO.** You can choose from Auto (ISO 100-3200 in all shooting modes except Bulb and when the flash is used), 100, 125, 160, 200, 250, 320, 400, 500, 640, 800, 1000, 1250, 1600, 2000, 2500, 3200, 4000, 5000, 6400, and with C.Fn I-3 turned on, you can also choose H: 12800.
- ► AF Mode/Drive Mode button. Pressing this button enables you to change the Autofocus mode using the Main dial, or to change the Drive mode using the Quick Control dial. The options for each are listed here:
 - AF modes. The choices are One-shot AF, AI Focus AF, and AI Servo AF.
 - **Drive modes.** The Drive modes you can choose from are Single-shot, Highspeed Continuous (8 fps), Low-speed Continuous (3 fps), and Self-timer (10and 2-second delays).
 - Flash Exposure Compensation. You can choose to adjust this plus or minus 3 stops (EV) in 1/3-stop increments. Or you can make changes in 1/2-stop increments by setting C.Fn I-1 to Option 1.
- Metering Mode/White Balance button. Press this button to change the Metering mode and/or the White Balance settings. To change the Metering mode, turn the Main dial; to change the White Balance, turn the Quick Control dial. The options for each are as follows:
 - **Metering modes.** The choices include Evaluative (63-zone TTL full-aperture metering), Partial (9.4 percent at center frame), Spot (2.3 percent at center frame), and Center-Weighted Average.
 - White Balance. Choices include Auto (3000-7000 degrees Kelvin (K)), Daylight (5200 K), Shade (7000 K), Cloudy (6000 K), Tungsten (3200 K), White Fluorescent (4000 K), Flash (6000 K), Custom (2000-10000 K), and K (Kelvin Temperature, 2500-10000 K).

Back of the camera

The back of the camera includes the 3-inch, 920,000-dot (VGA) LCD monitor that provides a very smooth display of multicolored menus and shooting information. The LCD includes a multi-coating that reduces glare, and protects against smudges and scratches. Here is a look at the back of the 7D:

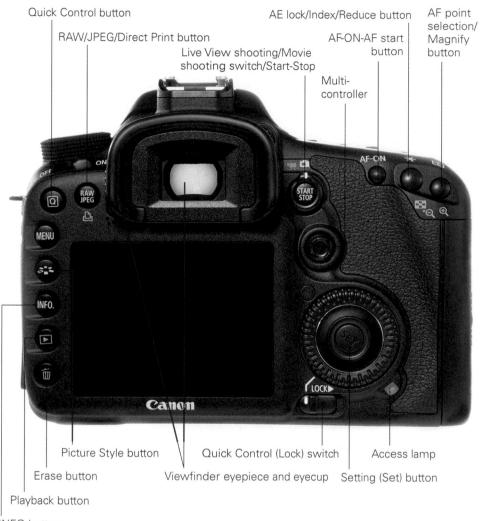

INFO button

1.5 Back of the 7D

One-touch RAW+JPEG button. If the camera was set to only JPEG recording, pressing this button captures a RAW image with the JPEG image. If the camera was set to RAW capture only, pressing this button captures a Large Fine-quality JPEG in addition to the RAW image. If the camera was set to RAW+JPEG, pressing this button has no effect. You must first setup One-touch RAW+JPEG on the Shooting 3 menu before you can use this button.

- Quick Control button. Pressing the Menu button displays the Quick Control screen on the LCD where you can make changes to the most commonly used camera settings.
- Menu button. Pressing the Menu button displays the most recently accessed camera menu and menu option. To move among the menus, turn the Main dial or tilt the Multi-controller.
- Picture Style button. Pressing this button displays the Picture Style screen where you can choose one of six preset Picture Styles or three customizable styles that you can create and register. A Picture Style determines how an image is rendered in terms of color, saturation, sharpness, and contrast. The Picture Style screen shows the currently selected Picture Style along with the sharpness, contrast, saturation, and color tone settings that are in effect.
- INFO. button. During shooting, pressing the Info button displays the Info screen that details the current camera settings, displays the Electronic Level to square horizontal and vertical lines with the frame, and displays shooting functions. When playing back images, pressing the Info button one or more times cycles through four different playback display modes.
- Playback button. Pressing this button displays the last captured or viewed image. To cycle through images on the card, turn the Quick Control dial counterclockwise to view images from last taken to first, or turn the dial clockwise to view images from first taken to last. To change the playback display, press the INFO button one or more times.
- Erase button. Pressing the Erase button during image playback displays options to cancel or erase the currently displayed image as long as it has not had protection applied to it. Batches of images can be erased together by selecting and check-marking images.
- Quick Control (Lock) switch. Setting this switch to the on setting that looks like a hockey stick enables full use of the Quick Control dial for selecting camera options and settings. The Lock position limits use of the Quick Control dial.
- Quick Control dial. The Quick Control dial selects a variety of settings if the Quick Control switch is set to the left position (to the hockey-stick shaped icon). The Quick Control dial selects the second named function for the buttons above the LCD panel. When the camera menus are displayed, turning the Quick Control dial cycles through the options on each menu. When shooting, you can use the Quick Control dial to manually select an AF point after pressing the AF-point Selection button.

- Setting (SET) button. Pressing this button confirms menu selections, opens submenu screens, and, on the Quick Control screen, it opens function screens from which you can change settings such as the ISO, Exposure Compensation, and Exposure Bracketing.
- Access lamp. This light, located to the lower right of the Quick Control dial, lights or blinks red when any action related to taking, recording, reading, erasing, or transferring images is in progress. Whenever the light is lit or blinking, do not open the CF card slot door, turn off the camera, or remove the battery.
- Multi-controller. The eight-way Multi-controller functions as a button when pushed and as a joystick when tilted in any direction. During shooting, you can use it to select an AF point after pressing the AF-point Selection button, move the AF point or magnifying frame in Live View shooting, or to select and set camera menu options. On the Quick Control screen, the Multi-controller provides access to primary shooting and exposure options. Tilt the Multi-controller to move among the functions on the screen. To change a setting, turn the Quick Control or Main dial, or press the Set button to access the function's setting screen. When working with camera menus, the Multi-controller is used to set White Balance shift settings.
- AF-Point Selection/Magnify button. During shooting, pressing this button and M-Fn button enables you to select one of three default AF area modes: Singlepoint AF, Zone AF, or Auto-select 19-point AF and two other modes enabled through C.Fn III-6. Then you can choose an AF point or points displayed in the viewfinder. The Main dial cycles through AF points horizontally. The Quick Control dials cycles through AF points vertically. When playing back images, pressing and holding this button magnifies still images so that you can check focus or details in the image. To move around a magnified image, tilt the Multicontroller. During printing preparation, pressing this button changes the size of the trimming frame.
- AE Lock/FE Lock/Index/Reduce button. During shooting, pressing this button enables you to set and lock the exposure at a point different from where you focus. During image playback, pressing this button displays four images at a time, and pressing it again displays an index of nine images on the LCD monitor. In Playback mode with an image magnified, pressing, or pressing and holding this button, reduces the image magnification. When you are printing images, pressing this button reduces the size of the trimming frame.

- AF-On/AF Start button. Pressing the AF-On button initiates autofocusing in P, Tv, Av, M, and B shooting modes and when you're shooting in Live View or Movie modes in the same way as half-pressing the Shutter button.
- Live View Shooting/Movie Shooting Switch/Start/Stop button. Setting this switch to the Live View (the camera icon) position and pressing the Start-Stop button initiates Live View shooting. The camera raises the camera's reflex mirror to display a current view of the scene on the LCD monitor. Alternatively, set the switch to the Movie (video camera icon), focus, and then press the Start-Stop button to begin shooting movies. Press the Start-Stop button again to stop shooting in Live View or Movie mode.
- ► Viewfinder eyepiece and eyecup. The 7D viewfinder is an eye-level pentaprism with approximately 100 percent vertical and horizontal coverage. The focusing screen cannot be changed.

Side of the camera

On one side of the 7D is the CompactFlash (CF) card slot door. Opening the door reveals the slot for the CF card and the card eject button. The opposite side of the camera houses two sets of camera terminals under individual rubber covers. The rubber covers are embossed with descriptive icons and text to identify the terminals.

Here is an overview of each camera terminal by rows.

PC terminal. This threaded, no-polarity terminal enables connection between the camera and studio flash units that have a sync cord. While Canon recommends using a sync speed of 1/30 to 1/60 second, I have found that the camera syncs with my studio strobes at 1/125 second with no problem, although you should test your system first. With corded non-Canon flash units, the sync speed is 1/250 second.

See Chapter 8 for details on working with flash units.

Remote Control terminal. This N3-type terminal connects with the accessory Remote Switch RS-80N3, Timer Remote Controller TC80N3, or other N3-type EOS accessory. PC terminal

- External microphone IN terminal. This terminal enables stereo sound recording with an accessory microphone that has a stereo mini plug (3.5mm diameter).
- Audio/Video **OUT/Digital** terminal. Use this terminal when you want to connect the camera to a non-HDTV to view images and movies stored on the media card. Be sure to use only the supplied AV cable to make the connection. You can connect the camera directly to а computer to download images from the camera to the computer, or to a PictBridgecompatible printer to print images directly from the CF card.
- HDMI mini OUT terminal. This terminal, coupled with the accessory HDMI Cable HTC-100, enables you to connect the camera to an HDTV. You cannot use the HDMI mini OUT terminal simultaneously with the Video OUT terminal.

HDMI mini OUT terminal Audio/video OUT Digital terminal Remote control terminal (N3 type)

External microphone IN terminal

1.6 EOS 7D terminals

Displaying images on a TV is covered in Chapter 2.

Bottom of the camera

The bottom of the camera houses the battery compartment cover, tripod socket, and the Extension system terminal for connection with the Wireless File Transmitter WFT-E5A/B/C/D.

Canon EOS 7D Digital Field Guide

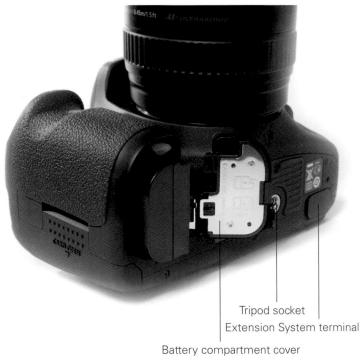

1.7 EOS 7D bottom-of-the-camera components shown with the LP-E6 battery pack

Lens Controls Overview

Lens controls differ according to the lens that you are using. In addition to autofocusing, you can also switch to manual focusing by setting the switch on the side of the lens to MF, or Manual Focusing on lenses that offer manual focusing. Manual focusing includes focus assist. As you adjust the focusing ring on the lens, the focus confirmation light in the lower-right side of the viewfinder lights steadily and the camera sounds a focus confirmation beep when sharp focus is achieved.

While lenses are covered fully in Chapter 9, navigating the camera includes using the lens controls, and so I include them here. Additional lens controls may include the following, depending on the lens.

Lens mounting index. The red or white mark on the lens is where you match up with the red or white mark on the 7D's lens mount to attach the lens to the camera. Canon EF lenses have a red index mark and EF-S lenses have a white mark.

- Focusing distance range selection switch. This switch limits the range that the lens uses when seeking focus. For example, if you choose the 2.5m to infinity focusing distance option on the EF 70-200mm, f/2.8L IS USM lens, then the lens does not seek focus at 2.5m and closer, and this speeds up autofocus. The focusing distance range options vary by lens.
- Zoom ring. Turning this ring zooms the lens to the focal length marked on the ring. On some older lenses, such as the EF 100-400mm f/4.5-5.6L IS USM lens, zooming is accomplished by first releasing a zoom ring, and then pushing or pulling the lens to zoom out or in.

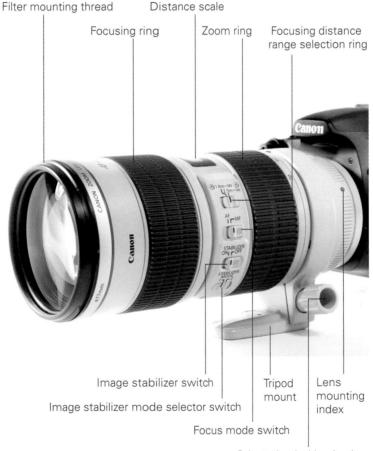

Orientation locking knob

1.8 Lens controls, as shown on an EF 70-200mm f/2.8L IS USM lens

- Distance scale and infinity compensation mark. The distance scale shows the lens's minimum focusing distance through infinity. The scale includes an infinity compensation mark that can be used to compensate for shifting the infinity focus point that results from temperature changes.
- Focusing ring. Turning the focusing ring enables manual focusing or focus tweaking at any time on compatible lenses, even if you are using autofocusing. If the lens switch is set to MF, turn this ring to focus on the subject.
- ► Focus Mode switch. Choose Manual or Autofocus.
- Image stabilizer switch. This switch turns on or off Optical Image Stabilization. Optical Image Stabilization (IS) corrects vibrations at any angle or at only right angles when handholding the camera and lens.
- Image stabilizer mode switch. On some telephoto lenses, this switch enables image stabilization for standard shooting and stabilization when you are panning with the subject movement at right angles to the camera.

Viewfinder display

The eye-level pentaprism viewfinder displays 100 percent of the scene that the camera captures.

The viewfinder includes 19 AF points superimposed on the focusing screen, as well as key exposure and camera setting information.

Looking through the viewfinder during shooting allows you to verify that camera settings are as you want, or to alert you if they need to be changed. In addition, you are alerted when any exposure element you have chosen is beyond the exposure capability of the light in the scene.

The following diagram shows the viewfinder information and what each element represents.

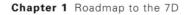

1.9 EOS 7D viewfinder display

Camera menus

The 7D offers 12 menus grouped as tabs in the categories of Shooting, Movie, Playback, Setup, Custom Functions, and a customizable My Menu. Accessing the menus is as easy as pressing the Menu button on the back of the camera.

The menus and options change, based on the shooting mode you select. In the automatic shooting modes, such as CA and Full Auto, the menus are abbreviated and you can make only limited changes to the exposure and camera settings. But in semiautomatic and manual modes such as P, Tv, Av, M, and B the full menus are available. If you find a technique described in this book, but you cannot find the option mentioned on the menu, check camera's shooting mode. By changing to a semiautomatic or Manual Mode, the option you need is displayed.

Table 1.1 through Table 1.12 show the full camera menus and options that are displayed in P Tv, Av, M, and B shooting modes.

Commands	Options
Quality	Large/Fine, Large/Normal, Medium/Fine, Medium/ Normal, Small/Fine, Small/Normal, RAW, M (Medium) RAW, S (Small) RAW
Red-eye On/Off	On, or Off
Веер	On, or Off
Release shutter without a card	Enable, or Disable
Review time	Off, 2 sec., 4 sec., 8 sec., Hold
Peripheral illumin. Correct.	Enable, or Disable
Flash control	Flash firing (Enable/Disable), Built-in flash function setting (E-TTL II, Manual flash, MULTI flash), Shutter sync (1 st curtain, 2 nd curtain, Hi-speed), Flash expo- sure compensation (plus or minus 3 Exposure Values (EV)), E-TTL II (Evaluative or Average), Wireless function (Disable, Ext: Int, Ext only, Ext + Int), External flash funtion setting (available only with flash connected), External flash C.Fn setting (avail- able only with flash connected), Clear external flash C.Fn setting (available only with flash connected)

Table 1.1 Shooting 1 Menu

Table	1.2	Shooting	2	Menu	
-------	-----	----------	---	------	--

Commands	Options
Expo. comp./AEB (Exposure Compensation/Auto Exposure Bracketing)	1/3-stop increments by default, up to plus or minus 5 stops of Exposure Compensation and up to plus or minus 3 stops of AEB
Auto Lighting Optimizer	Disable, Low, Standard, or Strong
White Balance	Auto (AWB), Daylight, Shade, Cloudy, Tungsten, White Fluorescent, Flash, Custom (2500 to 10000K), K (Color Temperature 2500 to 10000K)
Custom WB	Set a manual White Balance

Commands	Options
WB SHIFT/BKT (White Balance shift/bracketing)	White Balance correction using Blue/Amber (B/A) or Magenta/Green (M/G) color bias; White Balance Bracketing using B/A and M/G bias
Color space	sRGB, Adobe RGB
Picture Style	Standard, Portrait, Landscape, Neutral, Faithful, Monochrome, User Defined 1, 2, and 3

Table 1.3 Shooting 3 Menu

Commands	Options
Dust Delete Data	Locates and records dust on the image sensor so you can use the data in the Canon Digital Photo Professional program to erase dust spots on images
One-touch RAW+JPEG	Enables simultaneous capture of RAW, M RAW, or S RAW images and JPEG images at any of the JPEG quality levels

Table 1.4 Shooting 4 Menu

Commands	Options	
Live View shooting	Enable, or Disable	
AF mode	Live Mode, (Face detection) Live mode/Quick mode	
Grid display	Off, Grid 1, Grid 2	
Exposure simulation	Enable, Disable	
Silent shooting	Mode 1, Mode 2, Disable	
Metering timer	4, 16, 30 sec., 1, 10, 30 min.	

Table 1.5 Movie Shooting Menu

Commands	Options
AF mode	Live Mode, (Face detection) Live mode/Quick mode
Grid display	Off, Grid 1, or Grid 2
Movie recording size	1920 × 1080 (30, 25, or 24 fps), 1280 × 721 (60 or 50 fps), 640 × 480 (60 or 50 fps)
Sound recording	On, or Off
Silent shooting	Mode 1, Mode 2, or Disable
Metering timer	4, 15, 30 sec., 1, 10, 30 min.

Table	1.6	Playback	1	Menu
-------	-----	----------	---	------

Commands	Options
Protect images	Marks and protects selected images from being deleted
Rotate	Rotates the selected vertical image clockwise at 90, 270, or 0 degrees
Erase images	Select and erase images, All images in folder, or All images on [CF] card
Print order	Select images to be printed (Digital Print Order Format, or DPOF)
External media backup	Available when the accessory Wireless Transmitter (WFT-E5A/B/C/D) is used along with external media such as a storage device or computer

Table 1.7 Playback 2 Menu

Commands	Options	
Highlight alert	Disable, or Enable. When enabled, overexposed highlights blink in all image-playback displays	
AF-point disp (display)	Disable, Enable. Superimposes the AF point that achieved focus on the image during playback	
Histogram	Brightness, or RGB. Brightness displays a tonal dis- tribution histogram. RGB displays separate Red, Green, and Blue color channel histograms	
Slide show	Setup (Select images, set play time and Repeat [On/ Off]).Start a slide show of all images on the CF card	
Image jump with Main dial	Move through images by: 1, 10, 100 (images at a time), Date, Folder, Movies, or Stills	

Table 1.8 Setup 1 Menu

Commands	Options	
Auto power off	1, 2, 4, 8, 15, 30 min., or Off	
Auto Rotate	On for camera and computer, On for computer only or Off. Turns vertical images to upright orientation for the camera's LCD and/or computer display	
Format	Format and erase images on the CF card	
File numbering	Continuous, Auto reset, Manual reset	
Select folder	Create and select a folder	
WFT Settings	Displays the wireless file transfer settings when an accessory Canon WFT-E5A/B/C/D is in use	
Recording func.+media select	Displayed when an accessory Canon WFT-E5A/B/C/D is used	

Table 1.9 Setup 2 Menu

Commands	Options	
LCD brightness	Auto (three brightness levels), or Manual (seven adjustable levels of brightness)	
Date/Time	Set the date (year/month/day) and time (hour/ minute/second)	
Language	Choose language	
Video system	NTSC, PAL	
Sensor cleaning	Auto cleaning (Enable, Disable), Clean now, or Clean manually	
VF (Viewfinder) grid display	Disable, or Enable. Displays a grid to help you square up vertical and horizontal lines in the scene with the frame	

Table 1.10 Setup 3 Menu

Commands	Options
Battery info	View remaining battery capacity, shutter count, and recharge performance, battery registration, and battery history
INFO. button dispay options	Camera Settings, the Electronic level, or shooting functions. Choose the option you want displayed when you press the INFO. button
Camera user setting	Register or clear camera settings to C1, C2, or C3 shooting modes. Registers the current camera settings to the C1, C2, or C3 mode on the Mode dial
Copyright information	Display copyright information, Enter author's name, Enter copyright details, Delete copyright informa- tion. Enter and save copyright information that's embedded with images
Clear all camera settings	Restores the camera's default settings, does not delete copyright information or change Camera User Settings (C-mode settings) or My Menu settings; this does not restore Custom Function to their original default settings
Firmware Ver. (Firmware version number)	Displays the existing firmware version number, and enables you to update the camera's firmware

Commands	Options
C.Fn I: Exposure	Displays Custom Functions related to exposure such as exposure level increments, ISO increments, ISO expansion, bracketing auto cancel, bracketing sequence, safety shift, and flash sync speed in Av mode
C.Fn II: Image	Displays Custom Functions related to the image noise and tone, including long exposure noise reduc- tion, high ISO speed noise reduction, and highlight tone priority
C.Fn III: Autofocus/Drive	Displays Custom Functions related to autofocus and drive operation, including AI Servo tracking sensitiv- ity, AI Servo first and second image priority, AI Servo AF tracking method, lens drive when AF is impossi- ble, AF Microadjustment, select AF area selection mode, manual AF point selection pattern, VF display illumination, display all AF points, Focus display in AI Servo/MF, AF-assist beam firing, orientation linked AF point, and mirror lockup
C.Fn IV: Operation/Others	Displays Custom Functions related to camera con- trols, including custom controls, dial direction in Tv/ Av shooting modes, add image verification data, and add aspect ratio information
Clear all Custom Func. (C.Fn)	Restores all of the camera's default Custom Function settings

Table 1.11 Custom Functions Menu

Table 1.12 My Menu

Commands	Options
My Menu settings	Save frequently used menu options and Custom Functions

CHAPTER

Camera Setup and Image Playback

The time you spend setting up the EOS 7D pays off in greater ease of use and enjoyment while you're shooting. While some setup options can be set once and forgotten, other options require more frequent changes, depending on the shooting situation. This chapter gives you a look at the settings you'll want to set up on the 7D to ensure great image quality and a smooth workflow.

Choosing Image Format and Quality

Among the first setup considerations are setting up the image file format and quality level, file numbering, and folder organization. Your choices for these camera settings should support the way you work with images on the computer and the way you organize and store images.

One of your first choices should be whether you will shoot JPEG and/or RAW images. Before you choose, consider the options the camera provides for each format and how they affect your image workflow and the overall printed image guality and the size.

JPEG format

JPEG is the most common file format used for digital images, and it is the default file format on the 7D. JPEG offers efficient, high-quality file compression that saves space on the memory card. It also offers quick display of image files on the camera's LCD monitor and on the computer.

The small file sizes that JPEG produces allow you to store many images on the CompactFlash (CF) card. To reduce image file size, JPEG compresses files and, in the process, it discards some image data. The higher the compression level, the more image data is discarded, and the smaller the image file size, and vice versa. Because of this loss of data, JPEG is known as a lossy file format. While data loss isn't ideal, the loss of data at a low compression level is typically not noticeable in prints.

Additionally, JPEG files can be displayed on different computer platforms, on the Web, and in e-mail without the need for special viewing programs or preprocessing.

When you shoot JPEG images, the 7D processes, or edits, the images before storing them on the CF card. This sets the color rendering, contrast, and sharpness so you get a finished file that you can use as is or edit on the computer. With the 7D, you can control JPEG image processing to some extent by choosing among six Picture Styles.

If you edit JPEG images on the computer, and then save them as JPEGs, the data loss continues to occur. To preserve image data during editing, be sure to save JPEG images as TIFFs or in another file format before you begin editing.

Picture Styles and color spaces are described in Chapter 4.

Chapter 2 Camera Setup and Image Playback

Another JPEG advantage is that it provides the 7D's maximum burst rates when you're shooting in a Continuous Drive mode. For example, shooting the highestquality JPEG images, the burst rate is 126 shots at 8 frames per second (fps) using a UDMA card. Thus JPEG capture offers a definite edge for getting the fastest performance from the 7D.

The 7D offers two JPEG compression levels, and you can choose one of three imagerecording sizes: 17.9, 8, or 4.5 megapixels. The greater the compression and the smaller the image size, the more images you can capture in a continuous shooing burst, and the more images will fit on the CF card. As discussed earlier, the downside of high compression and low image size is that image quality suffers proportionally.

Further, every 7D image is captured as a 14-bit file that delivers 16,384 colors in each of the three color channels: Red, Green, and Blue. Because the JPEG file format doesn't support 14-bit files, the 7D automatically converts JPEG images to 8-bit files with only 256 colors per channel. While the conversion from 14- to 8-bit is done judiciously using internal camera algorithms, the fact remains that much of the image color information is discarded in the process.

Combine this data loss with the automatic in-camera editing and JPEG compression, and you get a file that has one-third or more of the image data discarded before it's written to the CF card. Certainly the JPEG image files are smaller, but with the data loss, the files are not as rich as RAW files, and they offer less latitude and stability when you edit them on the computer.

For photographers who seldom edit images on the computer and want small file sizes with maximum portability, JPEG is the best option. However, for photographers who want to preserve all of the rich image data that the 7D captures, RAW capture is worth exploring.

RAW capture

RAW is the option to choose if you want the best images the 7D can deliver. RAW is a designation for image files that are captured and stored on the CF card with little incamera processing and with no loss of data from compression or conversion. RAW files are not converted to 8-bit as with JPEG, but rather are captured and stored as 14-bit images. And unlike pre-edited JPEG files, the only settings the camera applies to RAW images are the aperture, ISO, and shutter speed.

With RAW, you can set or adjust key settings such as white balance, brightness, contrast, and saturation after the image is captured. This means that in addition to getting an image file that contains all the 7D can provide, you also get wide latitude when converting the RAW image. Converting RAW images is done using Canon Digital Photo Professional (DPP), Adobe Camera Raw, or Adobe Lightroom where you adjust the image color, brightness, tonal range, contrast, and color saturation to your liking. If you use Digital Photo Professional, you can also apply a Picture Style, Auto Lighting Optimizer, and other options just as you would apply them in the camera.

In addition, if images have blown highlights or areas where the highlights went to solid white with no image detail, you can often recover some of that image detail during conversion. If an image is underexposed, you can brighten it during conversion. All of the adjustments made during RAW image conversion are non-destructive, as if you made the adjustments in the camera.

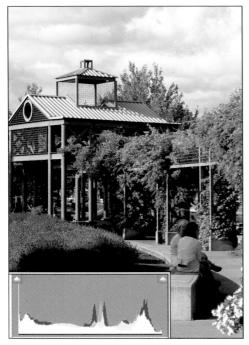

2.1 This is a JPEG image that has the in-camera processing applied as well as the conversion to an 8-bit file. The histogram shows that some of the brightest highlights in the walkway roof are being clipped and that the shadows block up and clip quickly. Exposure: ISO 200, f/11, at 1/125 second.

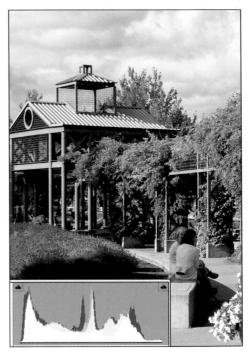

2.2 This is the same scene captured as a RAW file and converted in a RAW processing program. During conversion, I brought in the highlights to avoid clipping. While it may not be visible at this size, I also opened up the shadow areas, and the detail is visible at 100 percent enlargement.

So when image conversion is complete, you have a robust file that you can save as a TIFF or in another file format. Having a robust file is important because when you edit the image in Photoshop or another image-editing program, virtually all the edits are destructive — whether you adjust levels or color balance or set a tonal curve. Less robust JPEG files can suffer posterization, or the loss of smooth gradation among tonal levels, including stretching tonal ranges and the loss of image detail from compressing tonal ranges. By way of contrast, with RAW files, you begin with a rich 14-bit file that you can save as a 16-bit file in a RAW conversion program. Compared to an 8-bit JPEG file, this 16-bit file has much more latitude to withstand destructive image edits.

You can opt to shoot using Canon's medium or small RAW image-recording options, both of which offer the same advantages as full-size RAW files, but at a smaller image size. The 7D offers Medium (M) RAW at 10.1 megapixels (17.1 MB file), or Small (S) RAW at 4.5 megapixels (11.4 MB file).

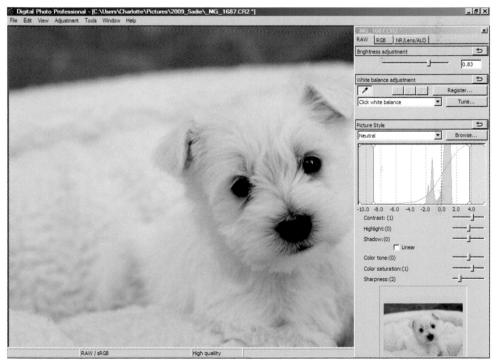

2.3 Canon's Digital Photo Professional, shown here, is included on the EOS Digital Solution Disk, and provides a full-featured program for converting RAW images.

RAW capture has drawbacks, however. First, RAW files lack the portability of JPEG files. RAW files cannot be edited unless you've installed Digital Photo Professional or another RAW conversion program such as Adobe Lightroom or Camera Raw. Second, unless you enjoy working with images on the computer, RAW is not a good option because the files must be converted and saved in another format, such as TIFF, PSD, DNG, or even JPEG. Third, RAW image file sizes are considerably larger than JPEG images.

By knowing the advantages and disadvantages of JPEG and RAW capture, you are in a better position to choose whether you want to shoot JPEG or RAW images. You can choose to take advantage of both types of files and select the size for each type. Table 2.1 details the options that you can select on the 7D and their effect on the burst rate during continuous shooting.

The best of both worlds: shooting RAW and JPEG

To get the best of both worlds, you can choose to shoot both RAW and JPEG. You then have the advantage of getting a pre-edited JPEG file you can post online or print directly with no editing. You also get a RAW file, either full-size or smaller, that you can convert and edit. So when you get a great shot that you want to perfect, or when you get a shot that needs some adjustments, the RAW file gives you the latitude to make adjustments.

One downside of shooting RAW+JPEG is the increased space needed on the CF card. For example, on a 4GB card, you can store 122 full-size RAW and Large/Fine JPEG images. Whereas if you shoot only Large/Fine JPEGs, you can store 593 images on the card. If you capture both JPEG and RAW, the images are saved with the same file number in the same folder. They are distinguished by the file extensions of .JPG for the JPEG image and .CR2 for RAW, M RAW, or S RAW. RAW+JPEG capture also slows down the continuous high-speed shooting burst rate as shown in Table 2.1. (Estimates in Table 2.1 are approximate, and vary according to image factors, including ISO, Picture Style, and Custom Function settings, as well as card brand, type, and speed.)

Canon divides the image quality screen between RAW and JPEG options. You can select RAW options by turning the Main dial, and JPEG options by turning the Quick Control dial.

Image quality		Approximate size in megapixels	File size in megapixels	Maximum burst rate (UDMA card)	
JPEG	Large/Fine	17.9	6.6	94 (126)	
	Large/Normal		3.3	469 (1169)	
	Medium/Fine	8	3.5	454 (1122)	
	Medium/Normal		1.8	2178 (2178)	
	Small/Fine	4.5	2.2	1739 (1739)	
	Small/Normal		1.1	3297 (3297)	
RAW	RAW	17.9	25.1	15 (15)	
	M RAW	10.1	17.1	24 (24)	
	S RAW	4.5	11.4	38 (38)	
RAW + JPEG	RAW+Large/Fine JPEG	17.9 each	25.1 + 6.6	6 (6)	
	M RAW+Large/Fine	10.1 and 17.9	17.1 + 6.6	6 (6)	
	S RAW+Large/Fine	4.5 and 17.9	11.4 + 6.6	6 (6)	

Table 2.1 Image Quality, Size Options, and Burst Rates

To set the image format and quality, follow these steps.

- Press the Menu button, highlight the Shooting 1 tab, highlight Quality, and then press the Set button. The Quality screen appears.
- 2. Turn the Main dial to highlight the RAW option you want. Or, if you are shooting RAW+JPEG, and you want to stop capturing the RAW image, then select the minus sign.

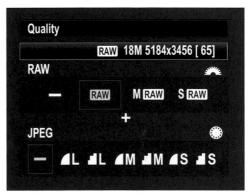

2.4 The Quality screen enables you to select RAW file options by using the Main dial and JPEG options by using the Quick Control dial.

- **3. Turn the Quick Control dial to highlight the JPEG option you want.** Or, if you're shooting RAW+JPEG images and you want to stop capturing a JPEG image, then select the minus sign.
- 4. To shoot RAW+JPEG, do steps 2 and 3.
- **5. Press the Set button.** The options you choose remain in effect for all shooting modes until you change them.

There may be specific times when you may want to capture both RAW and JPEG images without continually capturing both images with every shot. For one-off RAW+JPEG shots, you can set up the camera so that when you press the RAW-JPEG button on the back of the camera, it captures a RAW and a JPEG image. If you have the image quality set to JPEG only, this option enables you to simultaneously capture a RAW image for a single image and vice versa. After the shot, the camera then returns to your regular image-recording setting.

To use the RAW-JPEG button, follow these steps.

- 1. Press the Menu button, and then highlight the Shooting 3 tab.
- Select One-touch RAW+JPEG option, and then press the Set button. The One-touch RAW+JPEG screen appears.
- 3. Turn the Quick Control dial to select Simultaneous RAW or Simultaneous JPEG, and then press the Set button. The Simultaneous RAW or Simultaneous JPEG screen appears depending on your selection.
- 4. Turn the Quick Control dial to select the image quality you want, and then press the Set button.
- 5. When you're ready to shoot, press the RAW-JPEG button on the back of the camera. The image recording quality icon on the LCD blinks to indicate that simultaneous RAW+JPEG capture is active. If you change your mind and want to cancel simultaneous capture, press the RAW-JPEG button again.
- 6. Take the picture. Both the RAW and JPEG images are captured, and then simultaneous recording is cancelled.

Working with Folders and File Numbering

To create consistency in your workflow, think through the folder structure and file naming that you want to use as you set up the 7D. The more consistent you are with your naming conventions, the easier it is to manage your image collection as it grows.

With the 7D, you can set up folders to organize images on the media card and choose the way in which the files are named in the camera. The 7D enables you to set up multiple folders, and it offers three file-numbering options.

Creating and selecting folders

One handy feature of the 7D is the ability to create up to 999 folders on each CF card to store images, with each folder containing up to 9,999 images. New folders must be created within the main folder, and folders can be created either in the camera or on the computer. Here are the folder guidelines using either option:

When image 9999 is recorded within a folder on the CF card, the camera displays an error message, and you cannot continue shooting until you replace the CF card, regardless of whether or not the card contains additional free space. This may sound innocuous, but it can cause missed shots. So if the camera stops shooting, try replacing the CF card.

- Creating folders in the camera. Folders created in the camera are numbered sequentially from the next higher number from the existing folder. The camera automatically creates folder 100EOS7D, so if you create a new folder, the next folder name will be 101EOS7D. When you create folders in the camera, the folder naming structure is preset and cannot be changed. If you insert a CF card from another Canon EOS digital SLR, the folder will retain the folder naming from the other EOS camera until you format the CF card in the 7D.
- Creating folders on the computer. You can also create folders on the computer for more flexibility in file naming. However, you must follow naming conventions. Each folder must be labeled with a unique three-digit number from 101 to 999. Then a combination of up to five letters (upper and/or lower case) and/or numbers can be added with an underscore. No spaces are allowed and the same three-digit number can't be repeated. So, you can create a folder named 102CKL_1, but not one named 102SKL_1.

Unlike image numbering, the 7D does not remember the last highest number when you insert a different media card and create a new folder on the card. And if you format the CF card, the folders you created either in the camera or on the computer are erased along with all images. The only folder that isn't erased is the default 100EOS7D folder.

When you format the CF card, all existing folders except 100EOS7D are deleted. Thus you need to create new folders after you format the card.

To view an existing folder or create a new folder, follow these steps.

- 1. Press the Menu button, highlight the Setup 1 tab, and then highlight Select Folder.
- 2. Press the Set button. The Select folder screen appears with folders and the number of images per folder displayed on the left side and a preview of the first two images in the selected folder on the right.

2.5 Main default folder on the 7D

- 3. To view an existing folder, turn the Quick Control dial to highlight the folder you want. To create a new folder, turn the Quick Control dial to highlight Create folder, and then press the Set button. The camera displays the Select folder screen with a confirmation message to create a folder with the next incremented number.
- **4.** Turn the Quick Control dial to select OK, and then press the Set button. The Select folder screen appears with the newly created folder selected.

Choosing a file numbering option

Changing the way that the camera numbers files may not seem like a top priority to you, but you may find that one of the other file-numbering methods helps you delineate files in different shooting situations to make your workflow more efficient. Here is a look at each option and some of the shooting scenarios where each option could offer an advantage.

Continuous file numbering

Continuous file numbering is the default setting on the 7D, and every file is numbered sequentially beginning with 0001 through 9999. Image files are stored in the 100EOS7D folder located at the top-level on the CF card.

The camera automatically creates the 100EOS7D folder. File numbering continues uninterrupted unless you insert a CF card that has images stored on it. If the highest number on the card is higher than the last image number on the 7D, then file numbering typically continues from the current highest-numbered image on the CF card. That numbering continues even after you insert an empty formatted card. For example,

although I had taken only 200 images with the 7D, when I inserted a CF card from another Canon camera, the next image file number on the 7D was 4521, the next higher number on the CF card.

Likewise, if a CF card contains multiple folders with images in them, then the numbering sequence begins with the highest-numbered existing image in the folder that is being used. But if you insert a card that has a file number that is lower than the last highest

	F 7 7 7 8 0 +
File numbering	Continuous
File numbering	Continuous Auto reset

2.6 File numbering options on the 7D

file number taken on the 7D (stored in the camera's internal memory), then the file numbering continues from the last highest file number recorded on the 7D. In short, the camera uses the last highest number from either the card or the number stored in memory. So if you want pristine, continuous file numbering, then always insert a formatted card and do not insert CF cards from other Canon bodies that have images stored on them.

An advantage of continuous file numbering is that it gives you unique filenames on the computer. This helps you to avoid overwriting images with the same filename and file extension. Of course, if you have a second Canon camera body, and you put files from both cameras in the same folders, there is the potential to have duplicate filenames with the same extension. Hence, good folder and image management is essential for peace of mind.

Auto reset

As the name implies, this option resets image file numbering every time you insert a CF card, and when you create a new folder on the CF card. Using Auto reset, image file numbers reset to begin at 0001.

Auto reset is handy for keeping images organized by shoot when photographing different subjects or assignments on the same day. I create separate folders on the CF card or cards, and then save images from different shoots to individual folders. Because the file numbers reset in each folder, it's easy to check each folder to see the number of images I've taken for the assignment. Additionally, I can more easily keep the images separate when I download them to the computer. But again, the Auto reset option isn't as straightforward as it seems. If you insert a CF card with existing images stored on it, the camera uses the highest existing image number and continues numbering from there. So if you want Auto reset to reset to 0001, be sure to format the CF card in the camera before shooting with it. In short, it pays to start a shooting day with an adequate supply of freshly formatted CF cards, and to not swap CF cards between cameras to make this and other file numbering methods work best.

Transferring Images to the Computer

Canon's EOS Utility enables you to transfer images to the computer using the USB cable.

Before you begin, ensure that you've installed the EOS Digital Solution Disk programs. To transfer images to the computer, follow these steps.

- 1. Turn off the camera, attach the USB cable to the A/V Out/Digital terminal of the camera, and then connect the other end of the cable to a USB port on the computer.
- 2. Turn the camera's power switch to the ON position. The EOS Utility screen appears on the computer.
- 3. On the EOS Utility screen, select:
 - Starts to download images. The Save File screen appears, showing the image transfer progress. Images are downloaded and placed in the Pictures folder (Mac) and the My Pictures folder (PC) sorted by date into folders, and then displayed in the main window of Canon's Digital Photo Professional editing program.
 - Lets you select and download images. A window appears displaying images and folders on the CF card. Click the box on the lower left of the image preview to add a checkmark to the images you want to download, and then click the Download button. In the Download image dialog box, choose the destination folder, and then click OK to start the download. Downloaded images appear in the Quick Preview window, and then Digital Photo Professional starts automatically and displays the images.
- 4. When the transfer is complete, click Quit in the EOS Utility window, turn off the camera, and then disconnect the USB cable from the camera and computer.

Manual reset

This option seems to work around the limitations of the Continuous and Auto reset settings. By its name, it seems that you could force file numbering to reset for a fresh start. However, that's true only if the default 100EOS7D folder is empty. When you select Manual reset, the next image number is set to 0001. But if the 100EOS7D folder has images in it, when you choose Manual reset, the camera creates a new folder, 101EOS7D, and starts image numbering at 0001 in that folder. That behavior is also true for CF cards that have multiple folders with images in each folder.

When would you use Manual reset? I use it anytime I want to quickly create a new folder and begin shooting at image number 0001. For example, if I'm shooting a wedding, and a member of the wedding party asks me to photograph his family during a break, I can select Manual reset and know that the family shots will be kept in a folder separate from the wedding image folder. Of course, I have to remember to switch back to the wedding folder when I go back to shooting the wedding.

After you choose Manual reset, the 7D returns to the File numbering option that was in effect before the numbering was manually reset, either Continuous or Auto reset. Also, the new folder created is the next sequential number from the existing highest folder number on the CF card.

Changing the File numbering option on the 7D is straightforward, as long as you remember the limitations and behavior of each option. Follow these steps to set the file numbering option you want:

- 1. Press the Menu button, highlight the Setup 1 tab, and then highlight File numbering.
- 2. Press the Set button. The camera displays the three File numbering options.
- 3. Highlight the option you want, and then press the Set button. The option remains in effect until you change it, except for Manual reset, which creates a new folder if there are images in the current folder and in any other folders. If there are no images, then image numbers in the current folder begin with 0001. In both instances, the camera then returns to the previously selected file numbering option.

Miscellaneous Setup Options

There is a laundry list of setup options on the 7D that can make your shooting life easier and make the camera work better for you. You may have already implemented these settings, but in case you missed some, here is a list of helpful setup options.

General setup options

Within general options, I include options typically set only once, although there are some you may revisit for specific shooting scenarios.

To change general setup options, press the Menu button, turn the Main dial to choose a menu, and then follow the instructions in Tables 2.2 through 2.8.

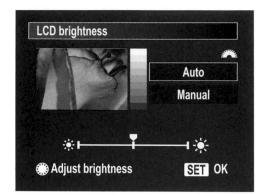

2.7 The LCD brightness screen enables you to monitor brightness with the preview image and the grayscale display on the right.

Turn Quick Control dial to select Menu Option		Turn Quick Control dial to select sub- option, and press Set button
Веер	On, Off	Choose Off for shooting scenarios where noise is intrusive or unwanted.
Release shutter without card	On, Off	Choose Off to prevent inadvertently shoot- ing when no card is inserted. The On set- ting is only useful when gathering Dust Delete Data.
Review Time	Off, 2, 4, 8 sec., and Hold	Longer review durations of 4 or 8 seconds have a negligible impact on battery life except during travel, when battery power may be at a premium.
		I use 4 seconds unless I'm reviewing images with a client or subject; then I choose 8 seconds.
Peripheral illumina- tion correction	Enable, Disable	Choose Enable to correct for vignetting where the four corners of the image are darker than usual. This option works only for JPEG capture.

Table 2.2 Shooting 1 Menu Options

Table 2.3 Shooting 2 Menu Options

Turn Quick Control dial to select Menu Option	Press Set button to display Menu sub-options	Turn Quick Control dial to select Sub- option, and press Set button
Auto Lighting Optimizer	Disable, Low, Standard, or Strong	Enabling this option automatically corrects images that are too dark and/or images with low contrast at the level you choose. Using this option can mask the effects of exposure modification such as Auto Exposure Bracketing and Exposure Compensation.
Color space	sRGB, or Adobe RGB	Sets the color space to the smaller sRGB color space, or to the larger Adobe RGB color space. See Chapter 4 for more information on these options.

Table 2.4 Shooting 4 and Movie Menu Options

Turn Quick Control dial to select Menu Option	Press Set button to display Menu sub-options	Turn Quick Control dial to select sub- option, and press Set button
Grid display	Off, Grid 1, Grid 2	Choosing Grid 1 overlays a 3 x 3 grid on the Live View screen, and choosing Grid 2 overlays a 4 x 6 grid to aid in squaring up horizontal and vertical lines in the scene for better composition.
Exposure simulation	Enable, Disable	Choosing Enable displays the Live View image on the LCD with the same bright- ness that the final image will have includ- ing the effect of Exposure Compensation. Disabling this option displays the Live View image at standard brightness.

To check current battery power, go to the Setup 3 menu tab, highlight Battery info, and then press the Set button. The Battery info screen displays the percentage of remaining capacity, the number of shots taken on the current battery charge, and the relative performance level of the battery's recharge. If you're using dual LP-E6 batteries in the BG-E7 grip, the screen displays battery information for both batteries.

Table	2.5	Playback	2	Menu	Options
-------	-----	----------	---	------	---------

Turn Quick Control dial to select Menu Option	Press Set button to display Menu sub-options	Turn Quick Control dial to select sub- option, and press Set button
Highlight alert	Disable, or Enable	Choosing Enable causes areas of overexpo- sure in the preview image to blink, alerting you to reshoot using negative Exposure Compensation if the blown highlights are in a critical area of the image.
AF point display	Disable, or Enable	Choosing Enable displays in red the AF point used to set focus.
Histogram	Brightness, or RGB	Choosing the Brightness displays a histo- gram showing the distribution and grada- tion of tones through the image, alerting you if exposure modification is necessary. Choosing RGB displays a histogram show- ing the distribution of color in the Red, Green, and Blue color channels, enabling you to evaluate the color saturation and gradation.

Table 2.6 Setup 1 Menu Options

Turn Quick Control dial to select Menu Option	Press Set button to display Menu sub-options	Turn Quick Control dial to select sub- option, and press Set button
Auto power off	1, 2, 4, 8, 15, 30 min., and Off	Choose an option to determine the amount of time before the 7D turns off automati- cally. Shorter durations conserve battery power. Just press the Shutter button half- way to turn on the camera again.
Auto rotate	On for the LCD and computer, On for the computer only, or Off	Choose the On option to automatically rotate vertical images to the correct orien- tation on the LCD and computer monitor, or only on the computer monitor.
		If you choose the first option, the LCD pre- view image is displayed at a reduced size. Choose Off for no rotation on the camera or computer.
Format		Formats the CF card. It's a good idea to format cards often. Always format the CF card in the camera and never on the computer.

Table 2.7 Setup 2 Menu Options

Turn Quick Control dial to select Menu Option	Press Set button to display Menu sub-options	Turn Quick Control dial to select sub- option, and press Set button
LCD brightness	Auto (three bright- ness levels), or Manual (seven levels of brightness)	Watch both the preview image and the grayscale chart as you turn the Quick Control dial to adjust the LCD brightness. As you adjust brightness, ensure that all tonalities on the grayscale chart are clearly distinguishable.
VF grid display	Enable, or Disable	In normal shooting mode, choosing Enable displays a grid in the viewfinder to aid in squaring vertical and horizontal lines in the scene and to aid in composition.

Table 2.8 Setup 3 Menu Options

Turn Quick Control dial to select Menu Option	Press Set button to display Menu sub-options	Turn Quick Control dial to select sub- option, and press Set button
INFO. button display options	Displays camera settings, electronic level, or displays shooting functions	Choose an option to determine which screen is displayed by pressing the INFO. button. Camera settings displays the cur- rent exposure and camera settings on a static screen.
		Choose Electronic level to display a level on the LCD to keep the camera level with the scene. The level displays roll and pitch so you can check horizontal and ver- tical tilt in 1-degree increments.
		Shooting functions displays a summary of exposure and camera settings where you can activate the screen to change settings. This is also known as the Quick Control Screen.

Adding copyright information

Copyright identifies your ownership of images. On the 7D, you can append your copyright information to the metadata that is embedded with each image that you shoot.

While including your copyright is a great first step in identifying ownership of the images you make, the process is not complete until you register your images with the United States Copyright Office. For more information, visit www.copyright.gov.

To include your copyright and the camera owner's name on your images, follow these steps.

Charlotte [®] Lowrie	
.@/:;!?()[]<	>0123456789
abcdefghijklmno	pqrstuvwxyz

2.8 Author's name screen

- 1. Press the Menu button, highlight the Setup 3 tab, and then highlight Copyright information.
- 2. Press the Set button. The Copyright information screen appears.
- 3. Highlight the option you want such as Enter author's name or Enter copyright details, and then press the Set button. A screen appears where you can enter the name or details.
- 4. Press the Picture Styles button to activate the keyboard portion of the screen, and then turn the Quick Control dial or the Multi-controller to move the cursor to the letter you want to enter.
- **5.** Press the Set button to insert the letter in the top portion of the screen. You can also use the Multi-controller to select text on the keyboard. To delete a character, press the Erase (trashcan) button. You can enter up to 63 characters, numbers, and symbols in the text entry area.
- 6. Press the Menu button to return to the previous screen where you can choose the second to enter copyright details or the author name, which-ever you didn't choose in step 3. You can cancel entering text by pressing the INFO. button. To display the copyright, repeat steps 1 and 2, and in step 3, chose Display copyright info.

Image Playback Options

These days, the ability to immediately see the last captured image is a given. In fact, on the rare occasions when I shoot film, I instinctively look at the back of the camera for an instant replay. Of course, there is no image preview, and I feel a little lost. While

image playback isn't the final judge and jury on images, it's the best indicator to know when you need to adjust the exposure, tweak the color or focus, or modify the composition.

To view images on the 7D, just press the Playback button to display the most recently captured image. If you're in Single image display, then basic shooting information appears in a ribbon above the image. If you've turned on the Highlight alert and AF point display options, detailed earlier in this chapter, then the preview image shows these as well, with localized areas of overexposure displayed as blinking highlights.

To move through images on the card, turn the Quick Control dial counterclockwise to view the next most recent image, or clockwise to view the first image. You can change the playback display by pressing the Info button once to cycle through each of these four image-playback displays:

- Single image with basic shooting information. This default playback display gives the largest preview image and provides the shutter speed, aperture, folder number and file number, and media type (CF denotes a CompactFlash card). If you're showing subjects or friends the images you've captured, this display option provides a clean, uncluttered view of the image.
- Single image display with image recording quality. This option builds on the previous display, but it adds the recording quality and the image number relative to the number of images captured (for example, 10/11, or image 10 of 11 stored images).
- ▶ Shooting information display. This display includes a summary of exposure and camera settings along with a histogram either Brightness or RGB, depending on what you selected. The image preview is necessarily reduced in size to accommodate the additional information. With this display, you can check the tonal distribution and bias, and verify key camera settings.
- ▶ **Histogram.** This display option shows the three RGB color channel histograms and a Brightness histogram. It includes basic shooting information, metering mode, white balance, file size, image recording quality, and the current image number relative to the total number of shots on the CF card.

If you're new to using a histogram, be sure to read Chapter 3, where evaluating loss REF exposure using histograms is described.

To check focus and specific details within the image, you can magnify the preview image by pressing the AF-point selection button on the top-right side of the camera back. The button has a magnifying icon under it. If you hold the button, the image

magnifies to the maximum of 10x. You can then tilt the Multi-controller to move around the magnified image. Press and hold the AE Lock button to reduce the image magnification. This button has a magnifying icon (indicated with a minus sign) under it.

Searching for images and moving through multiple images

When you need to quickly find an image, or a series of images, on a CF

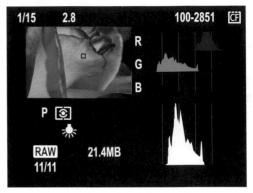

2.9 This is the Shooting information display with the RGB and Brightness histograms.

card that has many stored images, you have two options. First, you can display either four or nine images as an index to move through multiple images quickly. Second, you can jump through images by a specified number of images at a time, and by date, folder, movies, or stills (still images).

Here's how to use both options:

- Display as an index. To display images as an index, press the AE Lock/Reduce button once for a four-image display or twice for a nine-image display. Then turn the Quick Control dial to select a single image, and then press the Set button to display only that image.
- Jump through images. Select the Playback 2 camera menu, select Image jump w/Main dial icon, and then press the Set button. On the Image jump w/Main dial screen, turn the Quick Control dial to select the method for jumping — 1 image, 10 images, 100 images, Date, Folder, Movies, or Stills — and then press the Set button. Now press the Playback button to begin image playback, and then

mage jump w/ 🗯	
1 image	Date
10 images	Folder
100 images	Movies
	Stills

turn the Main dial to display the jump scroll bar and to jump by the method you selected. If you chose Date, you can turn the Main dial to display the date. If you chose Folder, you can select the folder in which to view images.

Displaying images on a TV

Using a TV to view images stored on the CF card is a convenient way to review large images, particularly when traveling. The video cable to connect the camera to a non-HDTV is included in the 7D box. If you want to view images on an HDTV, you'll need to buy an HDMI Cable HTC-100. Before connecting the camera to the TV, you need to set the video system format using the Setup 2 menu on the camera. The following instructions are for both HD (Hi-Definition) and non-HDTVs.

- 1. Press the Menu button, and then highlight the Setup 2 menu.
- 2. Turn the Quick Control dial to select Video system, and then press the Set **button.** The camera displays the NTSC and PAL options.

NTSC is the analog TV system used in the United States, Canada, Japan, South Korea, the Philippines, Mexico, and some other countries, mostly in the Americas. PAL is a color encoding system used in TV systems in parts of South America, Africa, Europe, and other countries.

- 3. Highlight the system you want, and then press the Set button.
- 4. Turn off the TV and the camera.
- 5. Attach the AV cable or the HDMI cable to the terminals detailed below. You cannot use the camera's Video OUT and HDMI OUT terminals simultaneously.
 - For a non-HDTV. Attach the AV cable to the camera's A/V OUT/Digital terminal, and then connect the other end of the video cable to the TV set's Video IN terminal and to the Audio IN terminal.
 - For an HDTV. Connect the HDMI cable to the camera's HDMI OUT terminal with the plug's HDMI MINI logo facing the front of the camera, connect the other end to the TV's HDMI IN port.
- 6. Turn on the TV, and then switch the TV's video input to the connected port.
- 7. Turn the camera's power switch to the ON position.
- 8. Press the Playback button. Images are displayed on the TV but not on the camera's LCD monitor. When you finish viewing images, turn off the TV and the camera before disconnecting the cables.

You can use the previous steps to not only display images stored on the CF card on the TV, but to also use the TV to display what would appear on the LCD during both general and Live View shooting.

Protecting and Erasing Images

Deleting unwanted images quickly frees up space on the media card when you need it. Although it's good to delete only images you're sure you don't want to keep. Protecting images is just good insurance for preserving them.

Protecting images

Applying protection to images helps prevent accidental erasure of images on the CF card, much like setting a document on the computer to read-only status. Protected images can't be deleted using the Erase options detailed in the next section. And when you download a protected image, you're asked to confirm that you want to move or copy read-only files, which indicates that the images have protection applied.

Protected images are erased when you format the CF card.

You can apply protection to an image by following these steps:

- 1. Press the Menu button, and then highlight the Playback 1 menu.
- Turn the Quick Control dial to highlight Protect images, and then press the Set button. The last captured image appears on the LCD. A small key icon and the word Set appear at the top left of the image.
- 3. Press the Set button again to protect the displayed image, or turn the Quick Control dial to move to the image you want to protect. A key icon appears in the information bar above the image to show that it is protected.
- 4. To protect additional images, turn the Quick Control dial to scroll to the image you want to protect, and then press the Set button to add protection.

2.11 The protection key icon is displayed to the left of the folder and file numbers at the top of the screen.

If you later decide that you want to unprotect an image, you can remove protection by repeating steps 1 to 3 and pressing the Set button to remove protection for each image. When protection is removed, the key icon in the top information bar disappears.

Erasing images

With the 7D's large, high-resolution LCD monitor, evaluating images is faster and more accurate than ever before. This makes it easier to decide whether or not an image is a keeper.

It's often wiser to look at images on the computer monitor to evaluate the mer-CAUTION its or faults before deleting them in the camera.

The 7D offers two ways to delete images: one image at a time or by checkmarking multiple images and deleting all marked images at once.

If you want to permanently erase a single image, just navigate to the image you want to delete during image playback, press the Erase button, highlight Erase, and then press the Set button.

To select and erase multiple images at a time, follow these steps (as you go through these steps, you can optionally choose to erase all images on the card or in a specific folder):

- 1. Press the Menu button, and then highlight the Playback 1 menu.
- 2. Turn the Quick Control dial to highlight Erase Images, and then press the Set button. The Erase Images screen appears.
- 3. Highlight Select and erase images, and then press the Set button. The 7D displays the image playback screen with options at the top left of the LCD to check mark the current image for deletion.
- 4. Press the Set button to add a checkmark to the current image, or turn the Quick Control dial to move to the image you want to delete, and then press the Set button. Continue selecting all of the images you want to mark for deletion. A checkmark appears on images marked for deletion. You cannot add a checkmark to images with protection applied.

- 5. Press the Erase button. The Erase Images screen appears.
- 6. Turn the Quick Control dial to highlight OK, and then press the Set button. The 7D erases the marked images, and the Erase Images screen appears.

CHAPTER

Controlling Exposure and Focus

G etting creative control over images begins by choosing a shooting mode. Each shooting mode offers control over one or all elements of exposure, or optionally no control in Full Auto shooting mode. This chapter also details other exposure elements including ISO settings and how to modify exposures in scenes with challenging lighting.

You will also learn about the 7D's new features, including the 7D autofocusing system. Finally, the chapter details selecting various drive modes that determine the number of photos you can get while shooting. While this chapter may seem technical, these details, once mastered, become your tools for realizing your creative vision with the camera.

Working with Exposure

I subscribe to a single exposure philosophy: *Get it right in the camera*. Nowadays, it's easy to see a problem and think: "I'll fix it in Photoshop." But getting the best possible in-camera exposure should never take a back seat to image editing. Certainly many photos can be polished with image editing, but seasoned photographers know that no amount of Photoshop editing can rival the beauty of a spot-on in-camera exposure.

Defining exposure goals

Aesthetically, an excellent exposure captures and expresses the scene as you saw and envisioned it. Technically, an excellent exposure maintains image detail through the bright highlights (or the most important highlights) and in the shadows, displays a full and rich tonal range with smooth tonal transitions, renders visually pleasing and accurate color with good saturation, displays visually pleasing contrast, and has tacksharp focus.

Perfecting exposures can be a challenge, but the fundamental goal of every exposure is to capture the best exposure possible given the dynamics of the light, the subject, and the gear.

Practical exposure considerations

Does that mean that every exposure will meet all the technical criteria of an excellent exposure? Not necessarily. Rather, the exposure ideally serves the purpose of the photographer's creative vision. A classic example of an intentional imperfect exposure is when a photographer overexposes a portrait of a mature woman to minimize facial lines and wrinkles. While the exposure is intentionally imperfect, it flatters the subject and creates a pleasing image. Other examples of imperfect but acceptable exposures are photos of scenes where the range from highlight to shadow is so great that you can properly expose only the most important part of the scene (with a single frame).

In technical terms, exposure is a mathematical expression of a balance among light, intensity (aperture), sensitivity (ISO), and time (shutter speed). When you change one element, such as aperture (f-stop) or shutter speed, it represents a doubling (increase in a setting) or halving (decrease in a setting) of the light reaching the image sensor or,

3.1 In this image, I wanted the very shallow depth of field provided by f/1.4 to bring the main blossom and the gold leaves visually forward in the frame. Exposure: ISO 100, f/1.4, at 1/250 second.

in the case of ISO, of the sensor's sensitivity to light. For example, changing the aperture from f/8 to f/5.6 doubles the amount of light reaching the sensor, while a change from f/5.6 to f/8 halves the amount of light. Given the same ISO sensitivity setting, a change in aperture requires a concurrent and proportional change in shutter speed to achieve a proper exposure.

The starting point for calculating any exposure, of course, is metering the light in the scene. From there, you can control some or all of the exposure settings based on the shooting mode that you choose on the 7D.

Equivalent Exposures

For any exposure, there are different settings that produce the same, or an equivalent, exposure. For example, if the camera meters the light and suggests f/5.6 at 1/60 second as the ideal exposure at any given ISO setting, then there are other aperture and shutter speed combinations that are equivalent, or will provide the same exposure. In this example, two equivalent exposures are f/4 at 1/125 second and f/8 at 1/30 second at the same ISO.

While the exposures are equivalent, the depth of field (DOF) changes with each shift to an equivalent exposure, as illustrated in the following figures. All three images were shot at ISO 100 using the EF 100mm, f/2.8 Macro USM lens.

continued

continued

In the first image, the exposure is f/1.2 at 1/200 second. The shallow DOF renders the background as a blur. In the second image, the equivalent exposure is f/4.5 at 1/20 second and the DOF is more extensive showing more distinct detail in the background elements. In the third image, the equivalent exposure is f/5.6 at 1/13 second and the DOF change renders the background elements with slightly more detail.

For any specific camera and lens combination, the number of possible equivalent exposures is fixed. To find that number, just multiply the number of shutter speeds by the number of possible lens apertures. As a simple illustration, consider a camera with nine shutter speeds (1/4 through 1/1000 second) combined with a lens that has nine full aperture settings (f/1.4 through f/22). There are a total of 81 aperture shutter-speed combinations. Of the 81, a maximum of 9 equivalent exposures provides an accurate exposure for a given lighting situation.

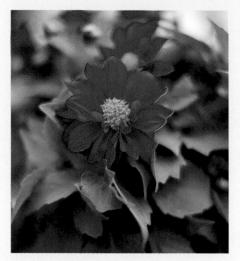

Choosing a Shooting Mode

Creative control begins by choosing a shooting mode, and the 7D offers modes ranging from full manual control to fully automatic shooting. As you encounter different scenes and subjects, choose the shooting mode that gives you control over the exposure element most important to you. For example, if you are shooting a portrait, you want to control the aperture so that you can control the depth of field. Thus Av shooting mode gives you that control. But if you are shooting a soccer match, you want control over the shutter speed to freeze the motion of players; that makes Tv mode the best choice. For quick snapshots, you may want to let the camera control everything, so Full Auto mode is a good choice.

The 7D Mode dial segregates shooting modes by the amount of control over exposure and other camera controls they offer you. Figure 3.2 shows shooting modes on the 7D mode dial.

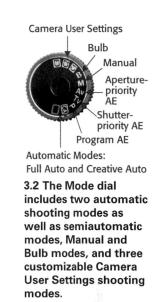

Semiautomatic, Manual, and Bulb shooting modes

The semiautomatic and Manual shooting modes offer the greatest degree of exposure control. These shooting modes give you the most creative control over your images, whether your objective is controlling or maximizing the depth of field or controlling how subject motion is rendered in action shots.

It is also important to know that in these shooting modes, you have control over all of the camera features and functions. For example, you can select the Autofocus (AF) mode, AF-area selection mode, and the AF point, set the Drive mode, adjust the white balance, set the ISO, and modify the exposure using Exposure Compensation, Exposure Bracketing, and Auto Exposure Lock. By contrast, Full Auto and Creative Auto shooting modes allow no or little control over these camera settings.

The following sections summarize the semiautomatic, Manual, and Bulb shooting modes.

Program AE (P) shooting mode

P, or Program AE (Auto Exposure), mode is the *shiftable* shooting mode. In this mode, when you press the Shutter button halfway, the 7D gives you its suggested exposure settings. If you want a different, but equivalent, aperture and shutter speed, you can temporarily change, or *shift*, the camera's suggested settings by turning the Main dial. For example, if the camera initially sets the exposure at f/4.0 at 1/125 second, and you turn the Main dial one click to the left, the exposure shifts to f/3.5 at 1/200 second, which is equivalent to the initial exposure. Turning the Main dial to the right results in a shift to f/5.0 at 1/100 second, and so on.

An advantage of using P mode is that with a single adjustment, you can change the aperture to increase or decrease the depth of field, change the shutter speed to freeze or blur subject motion, or set a fast enough shutter speed to handhold the camera. Exposure shifts are made in 1/3-stop increments by default. However, exposure shifts are temporary. If you shift the exposure, and then release the Shutter button without taking the picture within a few seconds, the camera returns to its original exposure. The shifted exposure then returns to the camera's suggested exposure for the next image. So the changes you make to exposure settings are used for only one image.

To use P mode, set the Mode dial to P, and then half-press the Shutter button. The camera focuses on the subject, meters the light, and calculates the exposure. If you want to shift the camera's suggested exposure, turn the Main dial to the left to make the aperture smaller and the shutter speed longer, or to the right to make the aperture larger and the shutter speed shorter.

Of course, exposure *shifts* are limited by the amount of light in the scene. If the shutter speed 30 and the maximum aperture are blinking in the viewfinder, it means that the image will be underexposed. You can change the ISO to a higher sensitivity setting or use the built-in or an accessory flash. However, if you opt to use the flash, you cannot shift the exposure. Conversely, if the shutter speed shows 8000 and it, along with the lens' minimum aperture, blinks, the image will be overexposed. In this case, lower the ISO sensitivity setting or use a neutral density filter to decrease the amount of light coming into the lens.

Along with the ability to quickly change to an equivalent exposure, P mode gives you full control over all aspects of the camera, including setting the autofocus mode and AF point, setting the metering and drive modes, selecting a Picture Style, and modifying exposure using Exposure Compensation and Auto Exposure Lock (AE Lock).

3.3 In P mode, the 7D's recommended exposure was f/5.6 at 1/40 second (ISO 100). The image has a shallow depth of field, which I wanted, but I also wanted more concentration on the barrel of flowers rather than the bench because its red color is visually dominant.

3.4 I shifted from the recommended exposure to f/2.8 at 1/160 second (ISO 100), and was better able to give the barrel of flowers more emphasis as the bench blurred a bit more.

At first glance, Full Auto and P mode may seem to be the virtually the same. However, P mode gives you full control over the AF point, white balance, metering mode, and so on. In Full Auto mode, you cannot change many camera settings.

Shutter-priority AE (Tv) mode

In shooting situations where your primary concern is controlling the shutter speed, then Tv, or Shutter-priority AE, shooting mode is the mode to use. In this semiautomatic shooting mode, you set the shutter speed and the camera automatically calculates the appropriate aperture based on the current ISO setting and the light-meter reading.

Tv stands for Time Value, also referred to as Shutter-priority AE mode.

In everyday shooting, controlling the shutter speed determines how subject motion is rendered. By choosing a fast shutter speed, you can freeze a moving subject in midmotion. By choosing a slow shutter speed, you can show the subject motion as a blur. Thus, Tv is the mode of choice for sports and action shooting, ranging from football and soccer to rodeos; for rendering the motion of a waterfall as a silky blur; for panning, or moving the camera, with the motion of the subject to create a streaked and blurred background; and for night shooting.

In addition, you can use Tv mode to lock in a shutter speed that is fast enough to handhold the camera and get sharp images — provided, of course, that there is enough light in the scene to get a fast enough shutter speed. For example, if you are shooting in moderate to low light with a non-Image Stabilized lens at a focal length of 150mm, then you can set the shutter speed to 1/150 second — a shutter speed that is fast enough to handhold the camera and get sharp images at this focal length. And in Tv mode, you are assured that the shutter speed will remain constant as you continue shooting.

If you cannot get the shutter speed you need to handhold the camera, increase the ISO incrementally until you get the necessary shutter speed.

On the 7D, you can select shutter speeds from 1/8000 second to 30 seconds or switch to Bulb shooting mode. (Bulb mode is detailed in a following section.) To use Tv mode,

set the Mode dial to Tv, half-press the Shutter button, and then turn the Main dial to change the shutter speed. The camera automatically sets the appropriate aperture based on the current ISO and the light-meter reading.

For shooting sports or action, photographers often use Tv mode combined with AI Servo AF mode (the autofocus mode that tracks focus on a moving subject) and High-speed Continuous drive mode to capture the maximum number of images in a burst. Autofocus and drive modes are detailed later in this chapter.

3.5 A slow shutter speed of 1/6 second shows the motion of the Ferris wheel as well as the motion of people walking. Exposure: ISO 400, f/11, 1/6 second using a -1/3 stop **Exposure Compensation.**

To show fractional shutter speeds, the 7D shows only the denominator of the fraction in the viewfinder. Thus, 1/8000 second is displayed as 8000 and 1/4 second is displayed as 4. Shutter speeds longer than 1/4 second are indicated with a double guotation mark that represents a decimal point between two numbers or following a single number. For example, 1"5 is 1.5 seconds while 4" is 4 seconds (4.0).

Using the Quick Control Screen

From the Quick Control screen, you can change the most frequently used camera settings. In P, Tv, Av, M, and B shooting modes, you can control the most commonly adjusted functions on the 7D, including the ISO, AF area selection mode, metering, and drive modes, AF point selection, white balance, Picture Style, and exposure and flash compensation using Exposure Compensation, and Custom Controls. In Full Auto mode, a less detailed version of the Quick Control screen is displayed, and you can change only the image-recording quality and the drive mode. However, the screen is also useful to see the settings that the 7D automatically sets in this automatic shooting mode.

To display the Quick Control screen on the LCD monitor, press the Q button on the top left back of the 7D. To make changes, tilt the Multi-controller to select the setting you want to change, and then turn the Quick Control or Main dial to change the setting.

The 7D alerts you if the exposure is outside the range of acceptable exposure in Tv shooting mode. If you see the maximum aperture blinking in the viewfinder, it is a warning that the image will be underexposed. You need to set a slower shutter speed or set a higher ISO sensitivity setting. On the other hand, if the lens' minimum aperture blinks, it is an overexposure warning. You need to set a faster shutter speed or a lower ISO sensitivity setting.

If you want to ensure that the exposure is correct in scenes where light changes quickly, you can enable Custom Function (C.Fn) I-6, Exposure Safety Shift. This function is useful in both Tv and Av shooting modes. Custom Functions are discussed in Chapter 5.

In the default 1/3-stop increments, the following shutter speeds are available (in seconds):

1/8000, 1/6400, 1/5000, 1/4000, 1/3200, 1/2500, 1/2000, 1/1600, 1/1250, 1/1000, 1/800, 1/640, 1/500, 1/400, 1/320, 1/250, 1/200, 1/160, 1/125, 1/100, 1/80, 1/60, 1/50, 1/40, 1/30, 1/25, 1/20, 1/15, 1/13, 1/10, 1/8, 1/6, 1/5, 1/4, 0.3, 0.4, 0.5, 0.6, 0.8, 1, 1.3, 1.6, 2, 2.5, 3.2, 4, 5, 6, 8, 10, 13, 15, 20, 25, 30

Shutter speed increments can be changed from the default 1/3-stop to 1/2-stop increments using C.Fn I-1.

Shutter Speed Tips

Tv mode is handy when you want to set a shutter speed that is fast enough to handhold the camera and still get a sharp image, especially if you are using a long lens. If you are *not* using an Image-Stabilized (IS) lens, then a handy guideline for determining the fastest shutter speed at which you can handhold the camera and lens and get a sharp image is 1/[focal length]. Thus if you are shooting at a 200mm focal length, the slowest shutter speed at which you can handhold the camera and get a sharp image is 1/200 second.

If you are shooting action scenes and want a shutter speed fast enough to stop subject motion with no motion blur, then the following guidelines provide a good starting point:

- Use 1/250 second when action is coming toward the camera.
- Use 1/500 to 1/2000 second when action is moving side to side or up and down.
- Use 1/30 to 1/8 second when panning with the subject motion. Panning with the camera on a tripod is a really good idea.
- Use 1 second and slower shutter speeds at dusk and at night to show a waterfall as a silky blur, to capture light trails of moving vehicles, to capture a city skyline, and so on.

You can also use a polarizing or neutral-density filter to capture moving water as a blur earlier in the day, both of which reduce the amount of light to give you a slower shutter speed. Besides reducing the light by 2 stops, a polarizer has the additional benefit of reducing reflections on the water.

Also in regard to shutter speeds, the 7D flash sync speed is 1/250 second or slower for Canon flash units. If you use the 7D with a studio lighting system, Canon recommends using a 1/30- to 1/60-second flash synch speed. However, I have used 1/125 second with my four-strobe Photogenic system with no problems and good results. Just be sure to test the sync speed to see which works best with your studio strobes. Also do not connect strobes that require 250 volts or more to the PC terminal.

In Tv mode, you have full control over camera controls such as autofocus and drive modes, AF point, Picture Style, and flash settings.

Aperture-priority AE (Av) mode

If you want to control the depth of field, whether the background details are shown as sharp or as a soft blur, then use Aperture-priority AE (Av) shooting mode. In Av mode, you select the aperture (f-stop) that you want, and the 7D automatically sets the shutter speed based on the current ISO and the light meter reading. The aperture, or f-stop, that you select is one of the factors that control the depth of field. When you choose a wide aperture from f/5.6 to f/2.8 or wider, the resulting shallow depth of field renders background details as blurred. When you set a narrow aperture from f/8 to f/32, the resulting extensive depth of field renders the background details with acceptably sharp detail.

The range of apertures available to you depends on the lens that you are using. Each lens has a minimum and maximum aperture. And on zoom lenses, the minimum aperture may vary by focal length. For example, the EF 24-105mm, f/4L IS USM lens has a minimum aperture of f/22 at 24mm, and f/27 at 105mm. The maximum aperture is f/4 at all focal lengths. On other lenses, the maximum aperture is variable, based on the focal length.

To use Av mode, set the Mode dial to Av, turn the Main dial to set the aperture you want, and then half-press the Shutter button to meter and focus. Turn the Main dial to the left to set a wider aperture or to the right to set a narrower aperture. The camera automatically calculates the appropriate shutter speed, based on the light meter reading and the ISO.

3.6 To maintain good sharpness in the figures of both the man and the woman, I chose f/8 knowing that by focusing on the couple, the distant water and shoreline would be blurred. Exposure: ISO 100, f/8, 1/125 second using -2/3 Exposure Compensation.

3.7 For this image, I wanted a shallow depth of field to not only blur background details, but also to create an overall soft feel to this blossom. With other flower images, I use a narrow aperture to maintain as much sharp detail throughout the flower as possible. Exposure: ISO 100, f/5.6, 1/80 second.

Practically speaking, you can also control the shutter speed using Av mode, just as you can control aperture in Tv mode. For example, if I am shooting outdoors in Av mode and see a flock of birds coming into the scene, I can quickly open up to a wider aperture and watch in the viewfinder until the shutter speed is fast enough to stop the motion of the birds in flight. The principle is simple: when I choose a wide aperture, the camera sets a faster shutter speed and I can quickly get to motion-stopping shutter speeds. Thus I do not need to switch to Tv shooting mode to change the shutter speed. The same is true for Tv mode, albeit by adjusting the shutter speed to get to the aperture you want.

In 1/3-stop increments, and depending on the lens you use, the apertures are:

f/1.2,1.4, 1.6, 1.8, f/2.0, 2.2, 2.5, 2.8, f/3.2, 3.5, f/4.0, 4.5, f/5.0, 5.6, f/6.3, f/7.1, f/8.0, f/9.0, f/10, 11, 13, 14, 16, 18, f/20, 22, 25, 29, f/32, 36, f/40, 45

In Av mode, you have full control over all the camera settings, Picture Style, white balance, flash settings, and so on.

If you select an aperture and the exposure is outside the camera's exposure range, the shutter speed value blinks in the viewfinder and on the LCD panel. If 8000 blinks, the

image will be overexposed. If 30 blinks, the image will be underexposed. If this happens, adjust to a smaller or larger aperture, respectively, or set a lower or higher ISO setting. If no lens is attached to the camera, 00 is displayed for the aperture setting.

You can preview the depth of field by pressing the Depth of Field preview button on the front of the camera, located below the Lens Release button. When you press the Depth of Field preview button, the lens diaphragm stops down to the current aperture so that you can preview the range of acceptable focus. The more extensive the depth of field, the more of the foreground and background that will be in acceptably sharp focus, the larger the area of darkness in the viewfinder, and vice versa.

Manual (M) mode

As the name implies, Manual (M) mode eliminates the automatic aspects of setting exposure so that you set the aperture and shutter speed (and ISO) yourself. This mode is commonly used when you want to set the exposure by metering on a middle-gray area in the scene or off a photographic gray card (an example of which is available in the back of this book).

The gray-card exposure method is detailed in Chapter 10.

In addition, Manual mode is best to use when you are using a predetermined exposure, such as when you are shooting fireworks, astral photography, and in the studio or when you want to intentionally underexpose or overexpose a part of the scene or want a consistent exposure across a series of photos, such as for a panoramic series.

To use M mode, follow these steps:

 Set the Mode dial to M, and verify that the Quick Control dial on the back bottom of the camera is set to the icon that resembles a hockey stick.

3.8 For fireworks and celestial images, I always switch to Manual mode because I know ahead of time what exposure I want to use, although I usually adjust it slightly after a few test shots. Exposure: ISO 100, f/11, 1/8 second.

- 2. Press the Shutter button halfway to initiate metering and focusing.
- 3. Turn the Main dial to select the shutter speed.
- 4. Turn the Quick Control dial to select the aperture you want.
- 5. To use the camera's recommended exposure, turn the Main dial to adjust the shutter speed and/or turn the Quick Control dial to adjust aperture until the tick mark is at the center of the Exposure Level meter. Or you can adjust the aperture or shutter speed to the exposure indicated by metering on a middle-gray reading, or to a predetermined exposure for fireworks or astral subjects. If you want to use a specific aperture, then you can adjust the shutter speed and ISO setting until you get the aperture you want. The same is true if you want a specific shutter speed, where you then adjust the aperture and ISO as necessary.

If Auto Lighting Optimizer, a feature that automatically adjusts exposures that are too dark or that have flat contrast, is turned on, the image may not reflect the actual exposure settings. I recommend turning off Auto Lighting Optimizer on the Shooting 2 menu.

You can overexpose or underexpose up to +/- 3 Exposure Values (EV), and the amount of exposure variance from the metered exposure is displayed on the exposure level indicator. If the amount of exposure is greater than +/-3 EV, then the Exposure Level shows an arrow on one or the other side. Then you can adjust the aperture, shutter speed, or ISO sensitivity setting until the exposure is within range.

For digital cameras in general, an Exposure Value (EV) is an expression of the ISO, shutter speed, and aperture taken together as the amount of light given the sensor. In traditional terms, EV is the amount of exposure required by the subject luminance and the ISO. EVs are represented by whole numbers, with each sequential step doubling or halving the exposure. So if you halve the amount of light that reaches the image sensor by either reducing the aperture or increasing the shutter speed, the EV increases by 1. When you are in Manual shooting mode, you cannot use Auto Exposure Lock, Exposure Compensation, or Auto Exposure Bracketing. If you use the built-in flash, the 7D sets the flash exposure automatically based on the current aperture.

The aperture and shutter speed values detailed in the preceding sections are also available in Manual mode, and you have full control over all the camera controls, Picture Style, and flash settings.

Bulb

Bulb on the Mode dial enables you to keep the shutter open as long as the Shutter button is fully depressed. Bulb is handy for some night shooting, fireworks, celestial shots, and other long-exposure renderings.

Bulb exposure times can be as long as 2.5 hours, so be sure that you have a fully charged battery before you begin an extended exposure. To ensure rock-solid stability during Bulb exposures, you can use the RS-80N3 Remote Switch or the TC-80N3 Timer Remote Control to hold the shutter open. You can also enable mirror lockup to reduce the chance of blur caused by the reflex mirror action. Mirror lockup can be chosen by setting C.Fn III-13 to option 1: Enable.

To make a Bulb exposure, turn the Mode dial to B (Bulb). With the camera on a tripod, select the aperture you want by turning the Main or Quick Control dial, and then press and hold the Shutter button for the length of time you want or use a remote release to hold the shutter open. The elapsed exposure time is shown in seconds on the LCD panel.

Because long exposures introduce digital noise and increase the appearance of grain, consider setting C.Fn II-1, Long exposure noise reduction, to option 2: On.

C modes

One of the handiest options that the 7D offers is the ability to program three shooting modes with your favorite shooting settings and preferences. The C1, C2, and C3 modes on the Mode dial enable you to set up the camera with your most commonly used settings — including a shooting mode, white balance setting, color space, Picture Style, Custom Functions, and more — and then register those settings as C1, C2, or C3 mode. Then, when you want to use those specific settings again, you simply turn the Mode dial to C1, C2, or C3.

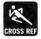

Because the C modes are customizable, they are detailed in Chapter 5.

Automatic shooting modes

The two automatic modes, Full Auto and Creative Auto, enable quick shooting with no or few changes to the camera settings. Full Auto, denoted by a green rectangle icon on the Mode dial, provides point-and-soot functionality while Creative Auto is designed to help photographers transitioning from using fully automatic cameras to digital SLR cameras by providing simple descriptions and controls for traditional photographic functions.

Both Full Auto and Creative Auto share the same default camera settings. The following sections detail Full Auto and Creative Auto shooting modes.

Full Auto mode

The Full Auto mode name describes its functionality — full automation leaving little for you to do except to point and shoot.

In Full Auto mode, the camera sets the following:

- ▶ Auto ISO that ranges from 100 to 3200
- ► High ISO speed noise reduction
- Standard Picture Style
- Auto white balance
- ▶ sRGB color space
- Auto Lighting Optimizer
- ► AI Focus AF, which means that if the subject begins to move, the camera automatically switches to AI Servo AF to maintain focus on the subject as it moves
- ► Automatic AF point selection
- Evaluative metering mode
- Single-shot drive mode, but you can choose to use the 10-second Self-timer/ Remote control mode
- Automatic flash use, but you can choose to turn on Red-eye reduction

You can choose to shoot in Live View or to shoot movies in Full Auto shooting mode as well. If you display the Quick Control screen by pressing the Q button on the back of the camera, you can reset the image-recording quality and select either single-shot or the 10-sec. Self-timer/Remote Control drive mode from the screen.

Creative Auto mode

Creative Auto (CA) shooting mode displays visuals and text on the LCD to help you understand the results that you get from making various adjustments. This shooting mode also offers more control than Full Auto shooting mode, but it offers less control than the semiautomatic and manual modes.

To use CA mode, turn the Mode dial to CA and press the Q button. Tilt the Multicontroller to highlight an option on the LCD screen and turn the Quick Control or Main dial to adjust the setting. To move to the next control, tilt the Multi-controller to select the control, and then repeat the process.

Some areas of the Creative Auto screen display the current settings such as the aperture and ISO, battery status, maximum burst, and remaining shots. Other parts of the screen display elements that you can adjust including:

- **Flash firing.** With this control, you can choose to have the built-in flash fire automatically when the light is too low to get a sharp, handheld image; choose to have the flash fire for every image: or choose to turn off the flash completely. If you choose to turn off the flash, and if the light is low, be sure to stabilize the camera on a tripod or solid support before shooting. Also keep in mind that if you turn off the flash, the flash unit may pop up anyway, so that the camera can use the flash's autofocus assist light to help the camera focus in low light. Even if this happens, the flash will not fire during the exposure.
- Blur or sharpen the background. This control enables you to determine whether the background is softly blurred, or rendered with more distinct

3.9 The Creative Auto screen offers a visual gateway to make exposure and other camera changes without needing to understand photographic exposure concepts.

detail, by adjusting the slide control to the left or right, respectively; in other words, it changes the aperture (f-stop) to change the depth of field.

Adjust image brightness. This control enables you to modify the standard exposure to a lighter or darker rendering by moving the slide control to the right or left, respectively. In effect, the control sets Exposure Compensation to +/- 3 EV. The brightness control is also affected by Auto Lighting Optimizer, a feature that brightens images that are too dark, and adjusts contrast. Auto Lighting Optimizer is detailed later in this chapter.

- Picture Style (Image effects). You can choose from four of the seven Picture Styles offered on the 7D. A Picture Style determines the look of images much as different films have characteristic looks. Picture Styles are described in Chapter 4. In CA mode, you can choose the Standard, Portrait, Landscape, or Monochrome (black-and-white) Picture Styles.
- Image recording quality. You can change the image recording quality and the file format by highlighting this control, and then pressing the Set button. On the Quality screen, you can adjust quality and file format, as detailed in Chapter 2. In this mode, you can choose all of the image qualities offered on the 7D.
- Drive mode. The speed at which the camera shoots is determined by the drive mode. You can choose Single-shot mode, where each press of the Shutter button makes one image; Low-speed Continuous drive mode, where pressing and holding the Shutter button shoots at 3 frames per second (fps); the 10-second Self-timer/Remote control drive mode that delays shooting by 10 seconds so that you can be in the picture; or avoid shake by pressing the Shutter button when you are shooting long exposures, macro images, or using a long telephoto lens.

In CA shooting mode, the camera automatically sets or uses:

- Auto ISO to Auto which ranges from 100 to 3200
- ▶ High ISO speed noise reduction
- Auto white balance
- sRGB color space
- Auto Lighting Optimizer
- AI Focus AF, which means that if the subject begins to move, the camera automatically switches to AI Servo AF to maintain focus on the subject as it moves
- Automatic AF point selection
- Evaluative metering mode

Setting the ISO Sensitivity

Choosing P, Tv, Av, M, or B shooting modes give you control over two of the elements of exposure — aperture and shutter speed. The third element of exposure is the ISO sensitivity. In simple terms, the ISO determines the image sensor's sensitivity to light. In digital photography, increasing the ISO amplifies the output of the image sensor. Most often, photographers increase the ISO sensitivity to get faster shutter speeds that are needed to shoot in lowlight scenes. But there is a tradeoff: the higher the ISO, the higher the amplification and the higher the level digital noise in the image. Certainly the 7D improves performance by reducing digital noise at higher ISO sensitivity settings, but you should be aware of the effects of digital noise in your images.

If the digital noise is visible and aesthetically objectionable in an 8x10- or 11x14-inch print when viewed at a distance of 1 foot or more, then the digital noise has degraded the image quality to an unacceptable level. This standard emphasizes the need to test the 7D at each of the higher ISO sensitivity settings, and then process and print images at the size you typically use. Evaluate the prints to see how far you want to take the 7D's ISO settings.

In P, Tv, Av, M, and B (Bulb) shooting modes, you can set the ISO sensitivity in 1/3stop increments, or in 1-stop increments by setting C.Fn I-2 to option 1. The 7D's standard range is ISO 100 to 6400, but you can expand the range to include ISO 12800 by setting C. Fn I-3 to option 1: On., then ISO 12800 appears as H on camera displays.

3.10 The inset in this image shows the balloon anchor team and the digital noise that is prevalent at ISO 800. This type of digital color noise becomes more apparent and objectionable when the image is sharpened in Adobe Photoshop, as it was here. Exposure: ISO 800, F/2.8, 1/400 second using -1/3 stop Exposure Compensation.

If you are concerned about controlling digital noise in images, and if you use Auto ISO, then be sure to check the ISO setting in the viewfinder to ensure that it is acceptable, based on the shooting circumstances and your tolerance for digital noise. If it is not, you can reduce the ISO by setting it manually. You can also turn on Standard, Low, or Strong noise reduction at high ISO settings, by using C.Fn II-2.

Typically you increase the ISO sensitivity because to get a faster shutter speed so you can handhold the camera in low light scene. When the light is low, even with an increased ISO sensitivity setting, the exposure may be long. Long exposures also cause digital noise and may reveal hot pixels. If your shooting scenario lends itself to using the Long exposure noise-reduction option (C.Fn II-1), then I recommend using it along with High ISO speed noise reduction (C.Fn II-2). The Long exposure noise-reduction option slows down shooting because the 7D takes a second dark frame after the first exposure, and then the camera uses this dark frame to remove digital noise in the original image. The dark frame exposure is the same duration as the first exposure, and you cannot continue shooting until the dark frame exposure is completed.

To change the ISO on the 7D, press the ISO speed setting button above the LCD monitor, and then turn the Main dial to the ISO sensitivity setting that you want. If you select A for Auto, the 7D will set the ISO from 100 to 3200 in P, Tv, Av, M, CA, and Full Auto shooting modes. In Bulb mode and when using the flash, the ISO is automatically fixed at 400. With bounce flash using an accessory Speedlite in P, Full Auto and CA shooting modes, the ISO is set between 400 and 1600.

My camera is set to ISO 100 as a matter of course. I increase the ISO only when the light conditions force me to, and then I increase it just enough to get the shutter speed that I need to either handhold the camera with the lens I am using, or to freeze subject motion in action shooting.

Here are general recommendations for setting the ISO:

- In bright to moderate daylight, set the ISO to 100 unless you need a faster shutter speed to handhold the camera with the lens you are using.
- At sunset and dusk and in overcast light, set the ISO from 100 to 400. At this time of day, shadows are deep, and keeping the ISO low helps minimize digital noise that is inherent in shadow areas.
- Indoors (including gymnasiums, recital halls, and night music concerts), and for night shooting, set the ISO from 400 to 1600. From ISO 3200 to 6400 and with the expanded 12800 setting, blurring of fine details becomes evident. At 6400

and 12800 fine details blur, coarse grain appears, and chroma noise is evident. I recommend using 6400 and 12800 only when the light is dismally dark and there is no other way to get the image. Also use C.Fn II-2 to set high ISO digital noise reduction. Venue light can vary dramatically, so keep an eye on the shutter speed and raise the ISO only enough to give you the shutter speed you need to achieve your shooting needs.

Metering Light and Modifying Exposure

The starting point of all exposures, of course, is the light in the scene. The 7D uses a new and improved onboard reflective light meter to measure the light reflected from the subject or scene back to the camera. The camera uses the light meter reading to determine its ideal recommended exposure and equivalent exposures.

For years, I've explained to students that camera light meters are color blind — they see only in black-and-white brightness levels or luminosity. But the 7D's new meter is no longer colorblind. An all-new dual-layer meter that is tightly linked to the camera's 19 AF points, measures the full spectrum of Red, Green, and Blue (RGB). As a result, the meter makes more informed decisions about metering to potentially avoid problems that plagued digital cameras previously. Canon has dubbed the new autoexposure (AE) system as Intelligent Focus Color Luminosity metering, or, IFCL.

A side benefit of the IFCL metering system is that it helps the focusing sensor to identify objects and their distances, and to improve focusing accuracy in unusual light such as sodium light.

In the default Evaluative metering mode, the 7D evaluates the light and color throughout 63 zones within the viewfinder, and since the AF zones are aligned with the Auto Exposure zones, the camera receives exposure information from all the AF points. The 7D uses the subject distance information provided by the lens and the AF sensor to assist in making exposure decisions. For example, the metering system looks at objects that are in close proximity to the subject — using both the AF point that achieved focus and those that nearly achieved focus. Then it combines those meter readings with readings from the other zones to provide more consistent exposures even in difficult lighting situations. The bottom line is that you can expect precise and consistent exposures regardless of the metering mode that you select. In general, when the camera meters the light in a scene, it measures the light reflected from the subject back to the camera, and it assumes that all tones will average to 18 percent, or a middle gray tone. This assumes an "average scene" that has a fairly even distribution of light, medium, and dark tones. And with the new metering system, the meter also takes into account the subject colors. But not all scenes are average because some objects reflect more or less light than others. For example, a white wedding gown reflects more light than a medium-gray dress, and a black tuxedo reflects less light. So if the camera meters a subject that reflects more or less light than average, the result can be either under- or overexposure, respectively.

While the new metering system helps to overcome some metering challenges such as this, the meter can still be fooled by very light and very dark subjects. In those scenes, you can choose among the four metering modes to get more precise metering results, or you can opt to use any of several exposure modification techniques, all of which are detailed in the following sections.

Using metering modes

The 7D provides four metering options that you can choose from when you are shooting in P, Tv, Av, M, and B shooting modes. Here is a look at each of the four metering modes:

- Evaluative metering. This is Canon's venerable metering system that partitions the viewfinder into 63 zones. Evaluative metering evaluates each zone, and it considers distance, light intensity, and color. It also biases metering toward the subject position as indicated by the active AF point or points and objects that are covered by adjacent AF points at distances that nearly achieved focus, and it takes into account back or front lighting. As a result of extensive evaluations, Evaluative metering mode works well in scenes with an average distribution of light, medium, and dark tones, and it functions well in backlit scenes and for scenes with reflective surfaces, such as glass or water.
- Partial metering. This metering mode hones in on a much smaller area of the scene, or approximately 9.4 percent of the scene at the center of the viewfinder. By concentrating the meter reading more specifically, this mode gives good exposures for backlit and high-contrast subjects and when the background is much darker than the subject.

3.11 This is Evaluative metering. Exposure: ISO 100, f/4.5, 1/500 second.

3.12 This is Partial metering. Exposure: ISO 100, f/4.5, 1/640 second.

- Spot metering. In this metering mode, the metering concentrates on a small 2.3 percent area at the center of the viewfinder the circle that is displayed in the center of the viewfinder when the camera is set to Spot metering mode. This mode is great for metering a middle gray area in the scene or a metering from a photographic gray card to calculate exposure. Spot metering is useful when shooting backlit subjects, and subjects against a dark background.
- Center-weighted average metering. This mode weights exposure calculation for the light read at the center of the frame, and then evaluates light from the rest of the viewfinder to get an average for the entire scene. The center area encompasses an area larger than the 9.4 percent Partial metering area. As the name implies, the camera expects that the subject will be in the center of the frame.

In the automatic modes, the camera always uses Evaluative metering mode, and you cannot change it.

3.13 This is Spot metering. Exposure: ISO 100, f/4.5, 1/640 second.

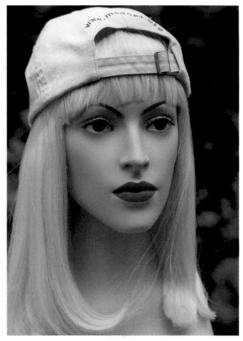

3.14 This is Center-weighted average metering. Exposure: ISO 100, f/4.5, 1/800 second.

Partial, Spot, and Center-weighted average metering all assume that the subject is at the center of the viewfinder. Thus, to meter with these modes, move the camera so that the center AF point is over the area you want to meter, such as a middle-gray photographic card or tonal value in the scene, and then use AE Lock (described later) to lock the exposure.

Evaluating exposures

After you make a picture, the next step is to evaluate the exposure, and the 7D's Brightness and RGB histograms are good tools for this task. With the histogram, you can immediately see if the highlights retain image detail or are blown out and the shadows retain detail or are blocked (go completely black with no detail). With a quick look at the histogram, you know immediately if you need to reshoot with modified exposure settings, or if you can move onto the next shot.

A *histogram* is a bar graph that shows the distribution and number of pixels captured at each brightness level. The horizontal axis shows the range of values, and the vertical axis displays the number of pixels at each location.

Brightness histogram

The Brightness histogram is a snapshot of the exposure bias and the overall tonal distribution within the image. The brightness values are shown along the horizontal axis of the histogram. Values range from black (level 0 on the left side of the histogram) to white (level 255 on the right side of the histogram). Note that although the 7D captures 14-bit RAW images, the image preview and histogram are based on an 8-bit JPEG rendering of the RAW file.

The Brightness histogram shows at a glance whether the image has blown highlights or blocked-up shadows. Blown highlights are indicated by a spike of pixels against the right side of the histogram. Once the highlight detail is blown, it is gone for good. Blocked-up shadows are indicated by a spike of pixels against the left side of the histogram. If the shadows are blocked up, you can, of course, lighten them in an editing program. However, digital noise is virtually always present in the shadows, and light-ening the shadows reveals the digital noise.

Overall underexposure is shown when there is a large gap between where the highlight pixels end and the right edge of the graph. Overexposure is indicated by a spike of pixels on the right side of the graph. If any of these exposure problems are indicated, you can reshoot using an exposure modification technique described later in this section.

The 7D's Highlight alert causes blown highlights to appear as blinking areas on the image preview during playback. You can turn on Highlight alert in the Playback 2 menu.

The Brightness histogram simply reflects the tones in the image. In an average scene, the pixels are distributed fairly even across the histogram. In a scene with predominately light tones, such as in a high-key image of a child in a white dress against a white background, the majority of the image pixels are concentrated to the right side of the histogram. Likewise in an image with predominately dark tones, or a low-key image, the pixels will be concentrated toward the left side of the graph.

3.15 The histogram for this image shows an excellent exposure with detail in the highlights and open shadows. Exposure: ISO 200, f/11, 1/60 second using -1/3 stop of Exposure Compensation.

RGB histogram

RGB histograms show the distribution of brightness levels for the red, green, and blue (RGB) color channels. Each color channel is shown separately so that you can evaluate the color channel's saturation, gradation, and bias. As with the Brightness histogram, the horizontal axis shows how many pixels exist for each color brightness level and the vertical axis shows how many pixels exist at that level.

More pixels to the left indicate that the color is darker and less prominent, while more pixels to the right indicate that the color is brighter and denser. If pixels spike on the left or right side, then color information is either lacking or oversaturated with no detail, respectively.

Both types of histograms are accurate for evaluating JPEG images because the histograms are based on the JPEG format. However, if you shoot RAW images, the histogram is based on a less robust JPEG version of the RAW image. The nature of the RAW image data does not make it feasible to display a histogram of the linear image data, so a JPEG version of the image is used for previews. So if you shoot RAW, just know that the RAW image is richer than the data you see on the histogram. Despite the JPEG rendering, the histogram is still an invaluable tool for evaluating exposure in the field. In fact, you can set the Picture Style setting to a lower contrast to get a better overall sense of what a RAW histogram would be.

Depending on your needs, you can choose to display only the Brightness histogram during image playback, or you can display the RGB and Brightness histograms simultaneously to get a complete view of the tonal and color distribution in the image.

To display a histogram, press the Playback button, and then press the INFO. button two to three times until the Brightness and RGB histograms or just the Brightness histogram are/is displayed with the image preview.

You can set the type of histogram that is displayed by default when you review images during playback, and if you like to see all of the histograms, this can save you a couple of presses of the Info button to change displays.

Differences in JPEG and RAW Exposure

When you shoot JPEG images, it is important to expose images to ensure that highlight detail is retained. You cannot recover highlight detail that is not recorded in a JPEG exposure. To ensure that images retain highlight detail, you can use exposure modification techniques such as Auto Exposure Lock or Exposure Compensation, which are detailed later in this chapter.

However, for RAW exposure, the goal is to ensure that you capture the first full f-stop of image data. CMOS sensors are linear devices in which each f-stop records half the light of the previous f-stop. The majority of image data is recorded in the first f-stop of light. In fact, the first f-stop contains fully half of the total image data. Thus it is very important to capture the first f-stop and to avoid underexposure that sacrifices image data. Thus with RAW capture, exposure should be biased toward the right of the histogram.

A right-biased exposure results in a histogram with highlight pixels just touching or nearly touching, but not crowded against the right edge of the histogram. With a right-biased exposure, the image preview on the LCD may look a little light, but you can adjust the brightness during image conversion — and with the assurance that you have captured all of the image data the 7D image sensor can deliver.

In addition, you have more latitude with RAW images because slight overexposures can be recovered during image conversion in Canon Digital Photo Professional, Adobe Camera Raw, Lightroom, or other conversion programs. To change the default histogram display, follow these steps:

- 1. Press the Menu button, and turn the Main dial to highlight the Playback 2 tab.
- 2. Turn the Quick Control dial to highlight Histogram, and then press the Set button. The Brightness and RGB options appear.
- 3. Turn the Quick Control dial to highlight the option you want, and then press the Set button.

Modifying and bracketing exposures

With the ability to immediately review the image histogram, you know right away whether the original exposure is correct or whether you need to modify the exposure to prevent blown highlights or to open the shadows.

If you need to make exposure modifications, the 7D offers several options to modify exposure, including Auto Lighting Optimizer, Highlight Tone Priority, Safety Shift, Auto Exposure Lock, Exposure Compensation, and Auto Exposure Bracketing.

Auto Lighting Optimizer

One of the 7D's automatic exposure adjustments is Auto Lighting Optimizer, which brightens images that are too dark and/or that have low contrast. Auto Lighting Optimizer is applied by default to all JPEG images that you shoot in all shooting modes. The automatic correction is not applied to RAW images. You can apply the optimization in Canon's Digital Photo Professional program. You can turn off Auto Lighting Optimizer for images you shoot in P, Tv, Av, and M shooting modes. In addition, you can change the level of optimization.

If you most often print images directly from the CF card, then Auto Lighting Optimizer can help you get better prints. However, if you prefer to control exposure yourself, then Auto Lighting Optimizer can mask the effects of exposure modifications, including Exposure Compensation, Auto Exposure Bracketing (AEB), and Auto Exposure Lock.

One downside of Auto Lighting Optimizer is that as it brightens the shadowed areas in the image, digital noise becomes visible, just as it does when shadows are lightened in an image-editing program. If your shooting involves long exposures and/or using high ISO settings, you can help avoid digital noise by setting C.Fn II-1, Long exposure noise reduction, to Option: 1 or 2, and C.Fn II-2, High ISO speed noise reduction, to Option 1: Low, or to Option 2: Strong.

You can adjust the level of Auto Lighting Optimizer from the default standard setting to low or strong, or you can turn off optimization entirely for images shot in P, Tv, and Av shooting modes. Just go to the Shooting 2 menu, and choose Auto Lighting Optimizer to change the setting. In CA and Full Auto shooting modes, Auto Lighting Optimizer is automatically applied at the Standard level to JPEG images, and you cannot change it.

Highlight Tone Priority

Highlight Tone Priority is a Custom Function designed to improve and maintain highlight detail in bright elements in the scene. When you enable this Custom Function, highlight detail is improved by extending the range between 18 percent middle gray and the maximum highlight tones in the image, effectively increasing the dynamic range. Using Highlight Tone Priority also makes the gradations between gray tones and highlights smoother.

This option is especially useful when shooting very light objects such as a wedding dress or white tuxedo, bright white sand on a beach, or shots of light-colored products. If you enable Highlight Tone Priority, the lowest ISO is adjusted to 200.

Highlight Tone Priority takes advantage of the higher ISO baseline so that the image sensor pixel wells do not fill, or saturate. Also, with the 7D's 14-bit analog/digital conversion, the camera sets a tonal curve that is relatively flat at the top in the highlight area to compress highlight data. The result is almost a full f-stop increase in dynamic range (the range from highlight to shadow tones in a scene as measured in f-stops). The tradeoff, however, is a more abrupt move from deep shadows to black — a reduced range of shadow tones that also increases the potential for digital noise in the shadows.

If you enable Highlight Tone Priority, it is denoted in the viewfinder and on the LCD panel as D+, with the D indicating Dynamic range. Highlight Tone Priority is disabled by default.

To turn on Highlight tone priority, follow these steps.

- 1. Set the Mode dial to P, Tv, Av, M, or B, press the Menu button, and then turn the Main dial to highlight the Custom Functions tab.
- Turn the Quick Control dial to select C.Fn II: Image, and then press the Set button. The last Custom Function you chose in this group is displayed.

- 3. Turn the Quick Control dial until the number 3 in the Custom Function number control in the upper-right corner of the screen, and then press the Set button. The C.Fn II: Highlight tone priority screen appears with two options.
- **4. Turn the Quick Control dial to select Option:1 Enable.** Or to turn it off, select Option: 0 Disable. With the function enabled, the lowest ISO setting is 200. The setting remains in effect until you change it.

Safety Shift

Safety Shift also falls into the category of automatic exposure modifications. Although this function is turned off by default, you can enable Safety Shift so that the camera automatically changes the exposure settings if the light changes dramatically enough to make your current exposure setting in Av or Tv shooting modes inaccurate.

Safety Shift may be annoying to photographers who have carefully set up the depth of field and/or shutter speed they want for a shot, as having the camera change the exposure settings seems intrusive.

But there is virtue in this function in some scenarios, such as action shooting. Sports and action shooting requires the photographer's single-minded concentration on capturing the peak moments, and having the 7D automatically shift the exposure if a break in the clouds suddenly sheds more light on the athlete can be welcome assistance. The photographer can continue concentrating on the action and composition with the assurance that the exposure will be correct.

If you want to enable Safety Shift, follow these steps:

- 1. Set the Mode dial to Tv, or Av shooting mode, press the Menu button, and then turn the Main dial to highlight the Custom Functions menu tab.
- 2. Turn the Quick Control dial to highlight C.Fn I: Exposure, and then press the Set button. The last accessed Custom Function screen appears.
- 3. Turn the Quick Control dial until the number 6 appears in the Custom Function number control in the upper-right corner of the screen, and then press the Set button. The first option is activated.
- 4. Turn the Quick Control dial to highlight the option you want, either Disable or Enable (Tv/Av), and then press the Set button. The option you select remains in effect until you change it. Safety Shift is used only when you are shooting in Tv and Av shooting modes.

Auto Exposure Lock

With Auto Exposure Lock (AE Lock), you can meter on an area of the scene, retain the exposure settings, and then focus on a different area of the scene. For example, you can meter on a middle tone area in the scene, retain the metered exposure settings, and then move the camera to recompose and focus on another area of the scene. Since the camera retains the metered exposure settings for a few seconds, you can continue using the same locked exposure settings for subsequent shots.

In Evaluative metering mode with manual AF point selection, the selected AF point is also where the camera locks the exposure. In Evaluative metering mode with automatic AF point selection, AE lock is set at the AF point that achieves focus. In Partial, Spot, and Center-weighted Average metering modes, the exposure is locked at the center AF point. So point the center AF point over the part of the scene or subject you want to base the meter reading on, and then

3.16 With the bright white filaments inside this plant, I wanted to ensure that the highlights in the white areas retained image detail, and so I metered on a middle gray tone — a darker area of the blue sky and locked the exposure using AE Lock. Exposure: ISO 100, f/2.8, 1/2000 second.

press the AE Lock button on the back-right top of the camera. The camera stores the meter reading for a few seconds while you move the camera to recompose the image, focus on the subject using the center or another AF point, and make the picture.

While AE Lock has many uses, there are some limitations, as outlined in Table 3.1. In addition, you cannot use AE Lock in Basic Zone modes such as CA, Portrait, Landscape, and so on.

Table 3.1 Using AE Lock in Metering Modes

Metering modes	Manual AF-point selection	Automatic AF-point selection	Using Manual focus
Evaluative	AE Lock is set at selected AF point	AE Lock is set at AF point or points that achieved focus	AE Lock is set at the center AF point
Partial, Spot, Center- weighted averaging	AE Lock is set at the center AF point		

Exposure Compensation

Another way to modify the camera's metered exposure is by increasing or decreasing the exposure by a specific amount. Using Exposure Compensation, you can set the compensation up to +/-5 stops in 1/3-stop increments.

While the 7D offers an impressive 5 stops of compensation, the LCD panel and view-finder can only display 3 stops of compensation. So to set the full 5 stops, use the Auto Exposure Bracketing (AEB) screen detailed in the next section.

A classic use of Exposure Compensation is to override the camera's meter so that whites and blacks in the image are truly white and black rather than gray. In scenes with large expanses of white or dark tones, the camera's onboard meter averages the tones to 18 percent gray so that both white and black objects are rendered as middle gray. To get true whites and blacks, you can use Exposure Compensation to brighten or darken the image from the camera's recommended exposure. For example, for a snow scene, a +1 or +2 stop of compensation renders snow as white. For a jet-black train engine, a -1 or -2 stop compensation renders it as true black.

Exposure Compensation is also useful when you want to modify the camera's metered exposure for a series of shots. Here are some points to know about Exposure Compensation:

- Exposure Compensation can be used in P, Tv, and Av shooting modes, but it cannot be used in Manual or Bulb mode.
- In Tv mode, setting Exposure Compensation changes the aperture by the specified amount of compensation. In Av mode, it changes the shutter speed. In P mode, compensation changes both the shutter speed and aperture by the exposure amount you set.

- The amount of Exposure Compensation you set remains in effect until you change it, regardless of whether you turn the camera off, change the lens, or replace the battery.
- Automatic exposure correction features such as Auto Lighting Optimizer can mask the effect of compensation. I recommend turning off Auto Lighting Optimization before setting Exposure Compensation.
- Exposure Compensation is set by turning the Quick Control dial, and, as a result, it is easy to inadvertently set or change compensation. If you want to avoid this, set the Quick Control Dial switch to the Lock position instead of the leftmost position. This disables use of the Quick Control dial for making Exposure Compensation

3.17 This is a scene in which Exposure Compensation is used to ensure that the snow is white instead of gray. Here I used a +1 1/3-stop compensation. Exposure: ISO 100, f/8, 1/40 second.

changes, but the dial continues to function when working with the camera menus and making changes on the LCD panel. If you want to set Exposure Compensation, you can set it on the Shooting 2 menu.

You can set Exposure Compensation by following these steps:

- 1. Set the Mode dial to P, Tv, or Av, and then set the Quick Control Dial switch on the back of the camera to the leftmost position.
- 2. Turn the Quick Control dial to the left to set negative compensation, or to the right to set positive compensation. As you turn the Quick Control dial, the tick mark on the Exposure Level meter moves in 1/3-stop increments up to +/-3 stops. If you want to set 4 or 5 stops of compensation, go to the next section on AEB. Also if you set more than 3 stops of compensation, the Exposure Level Indicator in the viewfinder displays left and right arrows.

To cancel Exposure Compensation, repeat these steps, but move the tick mark back to the center position of the Exposure Level meter.

Auto Exposure Bracketing

Auto Exposure Bracketing (AEB) enables you to capture a series of three images at different exposures. Traditionally, the bracketing sequence is one image at the camera's standard metered exposure, one 1/3-stop above the standard exposure, and one 1/3-stop below the standard exposure up to +/- 3 stops. Thus, if the scene has high contrast, highlight detail will be better preserved in the darker exposure than in either the standard or lighter exposure. Conversely, the shadows may be more open in the brighter exposure than in either two.

But the 7D adds flexibility to AEB by enabling you to shift the entire bracketing range to below or above zero on the Exposure Level meter. As a result, you can set all three

bracketed exposures to be brighter or darker than the camera's recommended exposure and skip capturing the camera's standard exposure.

You can use the Exposure comp./AEB setting screen, accessed from the Shooting 2 menu, to set Exposure Compensation up to +/- 5 stops. Just turn the Quick Control dial to set Exposure Compensation, and turn the Main dial to set AEB.

Exposure bracketing provides a way to cover the bases — to get at least one printable exposure in scenes with challenging lighting, for scenes that are difficult to set up again, and in scenes where there was only one opportunity to capture an elusive subject. But today, exposure bracketing is very often used for high-dynamic range imaging.

3.18 This series of images shows the effect of using AEB with a 1-stop bracketing amount. This image is at a +1-stop of exposure modification. Exposure: ISO 100, f/4.5, 1/250 second.

High-dynamic range imaging (HDR) captures bracketed frames of the same scene, with one exposure set for the highlights, one for the midtones, and one for shadow detail. In some cases, five to seven bracketed frames are made to merge into the final composite image. The images are bracketed by shutter speed rather than by aperture to avoid shifts in focal-length rendering. The final images are composited in Photoshop or another HDR program to create a single image that has a dynamic range far beyond what the camera can capture in a single frame.

With the 7D, you can combine both Exposure Compensation and AEB to set exposure values of up to 8 stops from the metered exposure. And in practical application, the combined Exposure Compensation and AEB options are adequate for most HDR work.

Another popular use of bracketing that is less involved than HDR imaging is to composite the best areas of the three bracketed exposures in an image-editing program.

3.19 This is the standard exposure. Exposure: ISO 100, f/4.5, 1/500 second.

3.20 This is the exposure with -1-stop exposure modification. Exposure: ISO 100, f/4.5, 1/1000 second.

Regardless of how you use the bracketed exposures, here are some points to keep in mind when using AEB:

- AEB is only available in P, Tv, and Av shooting modes.
- ► AEB cannot be used with the built-in or any accessory flash unit.
- Settings for AEB are good only for the current shooting session. If you turn off the camera, attach a flash, or pop up the built-in flash, then AEB is cancelled. If you want to retain the AEB settings even after turning off the camera, you can set C.Fn I-4: Bracketing auto cancel to option 1 to retain the settings. However, the settings are temporarily cancelled if you use a flash.
- In High-speed and Low-speed Continuous drive modes, pressing the Shutter button once takes all three bracketed exposures. Likewise, in 10- or 2-second Self-timer modes, the bracketed shots are taken in succession after the timer interval elapses.
- In One-Shot drive mode, you must press the Shutter button three separate times to get the bracketed sequence.
- The order of bracketed exposures begins with the standard exposure, followed by the decreased and increased exposures. You can change the order of bracketing using C.Fn I-5: Bracketing sequence.
- You can change the default 1/3-stop exposure increment to 1/2 stop using C.Fn I-1: Exposure level increments.

You can combine AEB with Exposure Compensation. If you combine them, then the bracketed exposures are based on the amount of Exposure Compensation that you set.

To set AEB, follow these steps:

- 1. With the camera in P, Tv, or Av shooting mode, press the Menu button, and then turn the Main dial to highlight the Shooting 2 tab.
- 2. Turn the Quick Control dial to highlight Expo. comp./AEB, and then press the Set button. The Exposure comp./AEB setting screen appears.
- **3. Turn the Main dial clockwise to set the bracketing amount that you want.** If you want to shift the bracketing sequence above or below zero, turn the Quick Control dial, and then press the Set button. As you turn the Main dial, two additional tick marks appear and move outward from the center in 1/3 stops increments.

Using the 7D Autofocus System

Whether you are shooting one image at a time, or you are blasting out the maximum burst of images as players move across a soccer field, the 7D's autofocus is quick and accurate. The 7D offers three autofocus modes and an array of new focusing options suited for different subjects and situations.

At the heart of the system is a new autofocus sensor that is tightly integrated with the onboard metering system. The autofocus system is designed to make focusing more precise in a variety of shooting scenarios. The autofocus sensor improves horizontal and vertical line detection with f/5.6 or faster lenses. At the center of the viewfinder are diagonally placed sensors that form an "X" so that these f/2.8 sensors do no overlap the f/5.6 sensors as they would in a horizontal/vertical arrangement. Thus while the f/5.6 sensors offer fast tracking, the f/2.8 center sensor affords extra focusing precision.

To increase accuracy when the camera tracks focus on a moving subject, Canon gave the center top, middle, and bottom sensors (with the camera held in landscape orientation) a dual zigzag horizontal line sensor. This arrangement uses two focusing sensors that are slightly offset from each other. The two lines sample slightly different areas that contribute to the AF calculations and increase focusing resolution. The result is more precise focus as well as responsive AF tracking. In addition, the sensor is less sensitive to temperature changes that can affect the AF system accuracy, and a duallayer sensor can more accurately adjust for chromatic aberration — or colorful outlines that appear around the edges of objects in an image, especially high-contrast objects.

The following sections will help you get the best performance from the 7D's new autofocus system.

Choosing an autofocus mode

The 7D's three autofocus modes are designed to help you achieve sharp focus based on the type of subject you are photographing. Here is a summary of the autofocus modes and when to use them.

One-shot AF. This mode is designed for photographing stationary subjects that are still and will remain still. Choose this mode when you are shooting still subjects, including landscapes, macro, portraits, architecture, and interiors. Unless you are shooting sports or action, One-shot AF is the mode of choice for everyday shooting. In this autofocus mode, the camera does not allow you to make the image until focus is achieved. Al Servo AF. This mode is designed for photographing action subjects. The camera tracks focus on the subject regardless of changes in subject distance from side to side or approaching or moving away from the camera. The camera sets both the focus and the exposure at the moment the image is made. The 7D includes many Custom Functions that are designed to fine-tune focus in Al Servo AF mode for specific scenes and subject. These functions are detailed in Chapter 5.

You can use a manually selected AF point in this mode, although it may not be the AF point that achieves final sharp focus. Or, you can use automatic AF selection. In P, Tv, Av, M, and B shooting modes, you can initiate focusing by pressing the AF-ON button on the back of the camera. You can also set the AI Servo tracking sensitivity to one of five levels by setting C.Fn III-1, fine-tune subject, shooting speed, and/or shutter release as priorities by setting AI Servo mode using C.Fn III-2 to one of four options. And with C.Fn III-3, you can set the focus tracking priority. Custom Functions are detailed in Chapter 5. With the new AF system, the predictive focusing calculations are improved to better calculate the subject's trajectory. And there is no warm-up time required for speedier focus locking and tracking.

Al Focus AF. This mode is designed for photographing stationary subjects that may begin moving. This mode starts out in One-shot AF mode, but then it automatically switches to AI Servo AF if the subject begins moving. Then the camera maintains focus on the moving subject. When the switch from One-Shot AF to Al Servo AF happens, a soft beep sounds, and the focus confirmation light in the viewfinder is no longer lit. (The beeper sounds only if you have turned on the beeper on the Shooting 1 menu.) This is the mode to choose when you shoot wildlife, children, or athletes who alternate between stationary positions and motion. In this mode, focus tracking is activated by pressing the Shutter button halfway.

If you routinely set focus and then keep the Shutter button pressed halfway, you should know that this shortens battery life. To maximize power, anticipate the shot and press the Shutter button halfway just before making the picture.

While Drive modes and Autofocus modes are set independently — in other words, you can set any Drive mode/Autofocus mode combination — the way the camera performs in any given combination varies. (Drive modes, detailed later in this chapter, determine how many shots you take when you press the Shutter button.)

Here is how to select an Autofocus mode.

- 1. Set the lens switch to AF, and set the Mode dial to P, Tv, Av, M, or B.
- 2. Press the AF-Drive button above the LCD panel, and then turn the Main dial to select the autofocus mode you want. Each mode is represented by text displayed to the side of the LCD panel. The selected autofocus mode remains in effect until you change it.

Choosing an AF area

In addition to the traditional technique of choosing a single AF point, the 7D adds the ability to choose autofocus areas. Canon dubs these as *AF area selection modes*, and they enable you to refine focusing based on the scene and subject. For example, to provide better subject focus tracking in AI Servo AF mode, the AF point can be expanded to include adjacent AF points. Using more than one AF point makes it easier for the camera to maintain focus on a moving subject.

You can also enable Spot AF that provides a smaller focusing area for pinpoint focusing. Spot AF is good for macro shooting or for honing in on a subject that is surrounded by other objects that might throw off focus when using a larger AF point.

Set AF-point Orientation and More

One of the new autofocus options on the 7D is the ability to set three AF points based on whether you're shooting in landscape or portrait orientation. Thus, when you rotate the camera, the manually selected AF point and AF point selection mode you've set are automatically chosen.

For example, if you're shooting an event, you might choose the center AF point when you're shooting in landscape format and the top center AF point when you turn the camera vertically to shoot portraits of participants. You can also switch to an alternate set of AF settings by pressing one of the customizing buttons and controls on the 7D (detailed in Chapter 5).

And you can register AF points to switch to when you use the Multi-controller. These and more autofocus options are detailed in Chapter 5.

Initially, you can select the first three of the following AF Area Selection modes. You can then add two more modes by using Custom Function (C.Fn) III-6. Here is a summary of the five modes:

- Single-point AF (Manual selection). This is the standard AF-point selection method where you manually select a single AF point for focusing. You have option for customizing the display of the 19 AF points in the viewfinder using C.Fn III-9. You can also set up the AF-point selection pattern by using the options in C.Fn III-7. Custom Functions are detailed in Chapter 5.
- Zone AF (Manual AF-zone selection). In this mode, you can select any of five zones for focusing based on subject position and orientation. Then the camera automatically selects the AF point or points from within the selected zone for focusing. This is an option that speeds up focus

3.21 Zone AF groups the 19 AF points into five selectable zones.

on moving subjects of various types including sports, events, birds, and wildlife. The 7D tends to focus on the subject or object that is closest to the lens, so selecting one bird flying in a flock is more difficult than with Single-point AF selection. However, this option is more accurate than using the Auto select 19-point AF mode simply because the number of AF points is more precisely targeted within the subject area even when the subject is off the center of the frame. If you're using One-shot AF mode, the 7D displays the AF point that achieves focus in the viewfinder.

- Auto select 19-point AF. In this mode the camera automatically selects the AF point or points to use for focusing. This is also the mode that is used in both Full Auto and Creative Auto shooting modes. In One-shot AF mode, the camera focuses on the subject or object that is closest to the lens, and then the AF point or points that achieve focus are displayed in the viewfinder. In AI Servo AF mode, you can manually select the AF point that will start the focus tracking.
- Spot AF (Manual selection). (Enabled using C.Fn III-6.) Normally, the AF point is larger than the rectangle shown in the viewfinder. With Spot AF, a smaller

area is used for focusing. This enables you to hone in on an area during macro shooting. Plus if you're shooting a portrait, there is less chance that the focus will be on the subject's eyebrow or eyelash rather than on the eye. While you can use Spot AF with Al Servo shooting, ensure that you can keep the AF point precisely where it needs to be on the subject. With telephoto lenses, Spot AF does not correct extreme defocus quickly.

AF-point expansion (Manual selection). (Enabled using C.Fn III-6.) This mode enables the camera to use AF points adjacent to the AF point that you manually select to achieve focus. The increased focus area makes it easier for the camera to track focus on moving subjects and to

focus more easily on subjects that normally present focusing challenges. If you're using AI Servo, then the AF point you select manually starts the focus tracking. In One-shot AF mode, both the manually selected AF point and the expanded AF point are displayed in the viewfinder.

In low light, you can use the AF-assist beam to make focusing easier without firing the flash. Just go to the Shooting 1 menu and select Flash control. Then select Flash firing and choose Disable. Then when you press the Shutter button halfway to focus, a series of flash assist beams fire to help the camera focus.

To set the AF-area selection mode, follow these steps.

- 1. With the camera to your eye, press the AF point selection/Magnify button.
- 2. Press the M-Fn button to the left of the Shutter button one or more times to cycle through the AF-area selection modes. If you've changed the AF-area selection modes using C.Fn III-6, Select AF area selec. mode, then only the modes that you enabled are displayed when you press the M-Fn button.

You can also include or exclude AF-area selection modes. This is useful when you want to limit the number of selections to the ones you use most frequently.

Improving Autofocus Accuracy and Performance

Autofocus speed depends on factors including the size and design of the lens, the speed of the lens-focusing motor, the speed of the autofocus sensor in the camera, the amount of light in the scene, and the level of subject contrast. Given these variables, here are some tips for getting the best autofocus performance and focus.

- Light. In low-light scenes, the autofocus performance depends in part on the lens speed and design. In general, the faster the lens, the faster the autofocus performance. Provided that there is enough light for the lens to focus without an AF-assist beam, lenses with a rear-focus optical design, such as the EF 85mm f/1.8 USM, focus faster than lenses that move their entire optical system, such as the EF 85mm f/1.2L II USM. Regardless of the lens, the lower the light, the longer it takes for the system to focus.
- Contrast. Low-contrast subjects and subjects in low light slow down focusing speed and can cause autofocus failure. With a passive autofocus system, autofocusing depends on the sensitivity of the AF sensor. Autofocusing performance is always faster in bright light than in low light, and this is true in both One-shot and AI Servo AF modes. In low light, consider using the built-in flash or an accessory EX Speedlite's AF-assist beam as a focusing aid using C.Fn III-11.
- Focal length. The longer the lens, the longer the time required to focus because the range of defocus is greater on telephoto lenses than on normal or wideangle lenses. You can improve the focus time by manually setting the lens in the general focusing range, and then using autofocus to set the sharp focus.
- AF-point selection. Manually selecting one AF point provides faster autofocus performance than using automatic AF-point selection because the camera does not have to determine and select the AF point(s) to use first.
- Subject contrast. Focusing on low-contrast subjects is slower than on highcontrast subjects. If the camera cannot focus, shift the camera position to an area of the subject that has higher contrast.
- **EF Extenders.** EF Extenders reduce the speed of the lens-focusing drive.
- Wide-angle lenses and small apertures. Sharpness can be degraded by diffraction when you use small apertures with wide-angle or wide-angle zoom lenses. Diffraction happens when light waves pass around the edges of an object and enter the shadow area of the subject, producing softening of fine detail. To avoid diffraction, avoid using apertures smaller than f/16 with wide-angle prime (single-focal length) and zoom lenses.

To set up the 7D with the AF area selection modes that you want to use during shooting, follow these steps.

- 1. With the camera set to P, Tv, Av M, or B mode, press the Menu button, and then turn the Main control dial to highlight the Custom Functions tab.
- 2. Turn the Quick Control dial to select C.FnIII: Autofocus/Drive, and then press the Set button. The last accessed Custom Function screen appears.
- 3. Turn the Quick Control dial until the number 6 appears in the control box at the top right of the screen, and then press the Set button. The C.FnIII: Autofocus/Drive Select AF area selec. mode screen appears.
- Turn the Quick Control dial to select Register, and then press the Set button. The AF area selection modes are activated, and a description of each icon appears at the bottom of the screen.
- 5. You can enable or disable specific area selection modes as follows:
 - To enable additional area selection modes, turn the Quick Control dial to select each of the modes you want, and press the Set button for each mode. A checkmark appears next to the options. Turn the Quick Control dial to select Apply, and then press the Set button. Turn the Quick Control dial to select Enable, and then press the Set button.
 - Or to exclude area selection modes, turn the Quick Control dial to select each of the modes you want to exclude, and then press the Set button. The checkmark next to the option is removed. Turn the Quick Control dial to select Apply, and then press the Set button. Turn the Quick Control dial to select Disable, and then press the Set button.

To manually select an AF point, follow these steps:

- 1. Set the camera to P, Tv, Av, M, or B shooting mode, and then press the AF-point Selection/Magnify button on the back top-right side of the camera.
- 2. If you have set an AF area selection mode, press the M-Fn button to select Single-point AF (Manual selection) area selection mode.
- 3. Tilt the Multi-controller in the direction of the AF point you want to select. You can also turn the Main dial to move through AF points horizontally and the Quick Control dial to move vertically. If you are using the Multicontroller, you can also press the controller in the center to select the center AF point.

4. Press the Shutter button halfway to focus using the selected AF point, and then press the Shutter button completely to make the picture. The camera beeps when focus is achieved, and the autofocus light in the viewfinder is lit continuously. If you do not hear the beep or see the autofocus light, focus on a higher-contrast area.

SECONDARY IN	
TIP	

To set the AF-point selection pattern when you're manually selecting the AF point, you can set C.Fn III-7 to stop the AF selection pattern at the outer edge of the pattern or have it continue to the opposite edge.

Selecting a Drive Mode

One of the compelling aspects of the 7D is its speed. The EOS 7D offers ample opportunity for capturing action shots, depending on the drive mode you choose: Single, High-speed or Low-speed Continuous Shooting, or one of the two Self-timer modes. You can choose among these drive modes when you are shooting in P, Tv, Av, M, or B shooting mode.

In Full Auto shooting mode, the camera automatically chooses the drive mode, but you can optionally choose the 10-second Self-timer mode.

Here is a summary of each mode:

- Single Shooting. In this mode, one image is captured with each press of the Shutter button. This is a good choice for still subjects and any other unhurried shooting scenarios.
- ▶ High-speed Continuous. In this mode, you can keep the Shutter button depressed to capture approximately 94 Large/Fine JPEGs with a standard CF card or 126 JPEGs with a UDMA CF card (or 15 RAW images, or 6 RAW+JPEG [Large/Fine] images). The actual number of frames in a burst depends on the shutter speed, Picture Style, ISO speed, brand and type of CF card, battery level, lens, and light.
- Low-speed Continuous. This mode also delivers a maximum of 3 fps when you keep the Shutter button completely depressed.
- Self-timer modes (10- and 2-second). In Self-timer modes, the camera delays taking the picture for 2 or 10 seconds after the Shutter button is fully depressed. The 10-second mode is effective when you want to include yourself in a picture. In addition, you can choose a 2-second Self-timer mode. The 2-second mode is

useful in nature, landscape, and close-up shooting, and can be combined with mirror lockup (C.Fn III-13) to prevent any vibration from the reflex mirror action and from pressing the Shutter button. You have to press the Shutter button once to lock the mirror, and again to make the exposure.

If you do not have the camera to your eye during Self-timer modes, slip the eyepiece cover over the viewfinder to prevent stray light from entering the viewfinder, which can alter the exposure.

Canon uses *smart buffering* to deliver large bursts of images. The images are first delivered to the camera's internal buffer. Then the camera immediately begins writing and offloading images to the CF card. The time required to empty the buffer depends on the speed of the card, the complexity of the image, and the ISO setting. JPEG images that have a lot of fine detail and digital noise tend to take more time to compress than images with less detail and low-frequency content.

Thanks to smart buffering, you can continue shooting in one, two, or three-image bursts almost immediately after the buffer is filled, and offloading begins and frees up buffer space. In Continuous shooting mode, the viewfinder displays a Busy message when the buffer is full, and the number of remaining images shown on the LCD panel blinks. You can press the Shutter button halfway and look at the bottom-right area of the viewfinder to see the current number of available shots in the maximum burst.

The 7D is set to Single-shot drive mode by default in P, Tv, Av, M and B shooting modes. In Full Auto shooting mode, the camera automatically sets the Drive mode to Single shooting, and you can only select the 10-second Drive mode. In CA shooting mode, you can choose Single-shot, Low-speed Continuous, or the 10-second Selftimer mode

To switch to a different drive mode, follow these steps:

- 1. Press the AF-Drive button above the LCD panel. The camera activates Drive mode selection in the LCD panel. In P, Tv, Av, M, and B shooting modes, all Drive modes are available. In the CA mode, only Single-shooting, Low-speed Continuous, and the 10-second Self-timer modes are available.
- Turn the Quick Control dial to select a Drive mode. When you turn the Quick Control dial clockwise, the mode sequence begins with Single Shooting and progresses through High-speed Continuous, Low-speed Continuous, Self-timer 10 seconds, and Self-timer 2 seconds. The Drive mode remains in effect until you change it. If you want to cancel a Self-timer exposure, press the AF-Drive button above the LCD panel.

CHAPTER

hatever light you may encounter, the EOS 7D can deliver accurate and pleasing color.

Great color does not come without any effort from the photographer. But with a few adjustments, you can fine-tune color for any scene, regardless of light, and get excellent color from the 7D.

To set the stage for getting great color, it helps to know that there are three settings on the 7D that affect image color: Color Space, White Balance, and Picture Style.

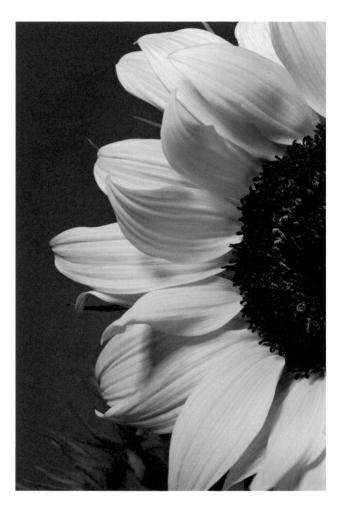

- Color space. This determines the breadth of colors that are captured in images. Some color spaces encompass a broad range of colors, and others encompass fewer colors. Choosing a color space also factors into the overall image workflow because it provides a color space that can be used not only for capture an image but also for editing and printing images. The Color Space option is one that most photographers set at once and seldom change.
- White Balance setting. This setting is what gets the image color accurate. To get accurate color, the camera must know what kind of light is in the scene. The White Balance setting gives the camera that information so that the camera can, in turn, adjust colors correctly. The White Balance setting is one that changes each time the light in the scene changes.
- Picture Styles. These determine whether the image colors are vivid and saturated, or less vivid and more subdued, and they affect image sharpness and contrast. How often you change the Picture Style depends on your preferences and the type of scene or subject that you are photographing.

Each of these settings plays a unique role in determining image color. The following sections provide more detail on using these settings in every day shooting.

Choosing a Color Space

A color space defines the range of colors, or gamut, that can be reproduced, and the way that a device such as a digital camera, monitor, or printer reproduces color. In very simple terms, color spaces encompass large to smaller ranges.

When an image moves from a large color space to a smaller color space, the device, a computer or printer, for example, must decide which colors to keep and which to alter or throw out. I want to get all the 7D image data possible, which is, after all, why I bought a high-resolution camera like the 7D, and so I avoid settings that discard image data, including color. And using the same color space on the camera, in your image-editing program, and on the printer helps lessen the changes that colors will be lost or altered in color-space conversions.

The 7D has two color space choices: Adobe RGB and sRGB. Adobe RGB is a color space that supports a wider gamut of colors than sRGB. And, as is true with all aspects of image capture, the more data you capture in the camera, the richer and more robust the image will be. And the more robust the file, the better it can withstand image editing.

Another important consideration when choosing color space is that the 7D has 14-bit files. That translates to color-rich image files that have 16,384 colors for each of the three color channels (Red, Green and Blue) when you shoot in RAW capture. (In contrast, 8-bit files offer only 256 values per color channel.) And even if you shoot JPEG, which automatically converts 14-bit files to 8-bit files in the camera, the conversion to 8-bit files is better because it is based on color-rich. 14-bit files.

The 7D's 14-bit RAW files can be processed in a conversion program, such as Adobe Camera Raw or Lightroom, as 16-bit files that offer robust color data, subtle tonal gradations, and a higher dynamic range.

To illustrate the difference between color spaces, consider Figures 4.1 and 4.2. They show the effect that changing color space has on an image histogram.

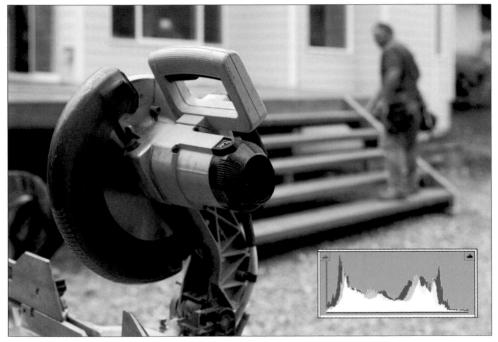

4.1 This is a RAW image with its histogram as displayed in Adobe Camera Raw. Here the image is shown in the Adobe RGB color space. Exposure: ISO 100, f/4.5, at 1/50 second.

A spike on the right side of the histogram indicates image data that will be *clipped* or discarded from the image. The higher the spike on the far left and right sides of the

histogram, the more color data that will be clipped. Ideally, you do not want colors to clip, or at the very least, you want to reduce clipping as much as possible. The larger the color space, the less clipping that occurs.

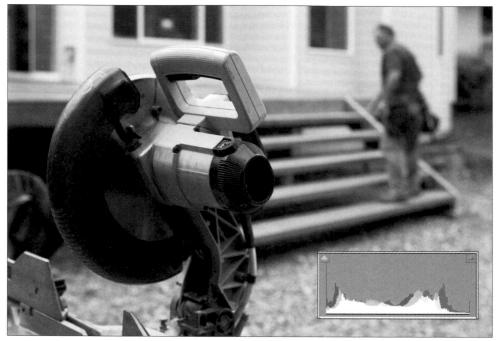

4.2 This is the same image with the histogram as displayed in Adobe Camera Raw and with the color space set to sRGB.

While Adobe RGB is a great color space for capturing a wide range of colors, it isn't the color space that provides the best image color for online display. In fact, when you view an image that's in the Adobe RGB color space outside of an image-editing program or online, the image colors look dull and flat. For online display, the sRGB color space provides the best color. Another important consideration is that some commercial services require the sRGB color space for printing.

For those who shoot RAW, the process is to capture images in Adobe RGB and then convert to sRGB after the images are converted, edited, and sized for Web display. For example, I use Adobe RGB for capture, editing, and printing. And when I need an image for online display, I make a copy of the image and then convert it to sRGB in an editing program such as Adobe Photoshop.

Here are some things to consider when choosing a color space:

- ▶ You can choose a color space when you are shooting in P, Tv, Av, M, and B shooting modes, and the color space you choose is used for both JPEG and RAW files.
- ▶ In P, Tv, Av, M, and B shooting modes, files shot with Adobe RGB are appended with MG.
- ▶ The 7D does not embed the ICC profile in files. You can embed the ICC profile in Adobe Photoshop 6.0 or later. An ICC profile can be read by monitors and printers that support ICC profiles so that colors are consistent when viewed and printed on different devices.

ICC is an abbreviation for International Color Consortium, an organization that NOTE promotes the use and adoption of open, vendor-neutral, cross-platform color management systems.

To choose a color space, follow these steps:

- 1. Set the Mode dial to P, Tv, Av, M, or B, and then press the Menu button.
- 2. Turn the Main dial to highlight the Shooting 2 menu.
- 3. Turn the Quick Control dial to highlight Color space, and then press the Set **button.** The sRGB and Adobe RGB options appear.
- 4. Turn the Quick Control dial to highlight the option you want, and then press the Set button. The color space you choose remains in effect until you change it.

Setting the White Balance

For great out-of-the-camera color, choosing the correct White Balance setting for the light that's in the scene is the best and fastest way to get it. A White Balance setting tells the camera what the color or temperature of the light in the scene is so that the camera accurately reproduces the colors in the scene. The 7D offers seven White Balance settings, including preset options for common light sources, in addition to a Custom White Balance option to set the light temperature to the specific light in the scene, and an option to set a specific color temperature.

Your choice of White Balance options may be affected by the amount of time you have to shoot a scene, the type and consistency of light, and whether your shoot RAW or JPEG capture. Here are some approaches for setting white balance:

Use a preset White Balance option. A preset White Balance setting is a good choice when there is a single light source in the scene that clearly matches one of the preset White Balance options. The preset White Balance options, including Daylight, Cloudy, Fluorescent, and Flash, have good color accuracy and saturation.

You can set the white balance in P, Tv, Av, M, and B shooting modes. However, in Full Auto and Creative Auto shooting modes, the 7D automatically sets the white balance, and you cannot change it. If you are new to using white balance, Figures 4.3 and 4.4 illustrate the difference it makes to have the correct white balance set.

Set a Custom white balance. A Custom white balance sets image color for the specific light

4.3 This image was taken using the Shade White Balance setting and the Neutral Picture Style. The image has accurate color. Exposure: ISO 100, f/3.5, at 1/40 second.

in the scene, whether it's a single light source or mixed light. This is the option to use with mixed lighting and when the light source doesn't clearly match one of the preset White Balance options. Setting a Custom white balance takes more time, but it provides very accurate color, and it is worth the extra steps when you are shooting a series of images in the same light, especially if you are shooting JPEG. If you are shooting RAW, then shooting a white or gray card and balancing images during RAW image conversion is often faster than setting a Custom white balance.

Set a specific color temperature. With this option, you set the specific light temperature on the 7D. This is good for studio shooting when you know the temperature of the strobes or continuous lights. And if you are fortunate enough to have a colortemperature meter, setting the specific color temperature is a good option.

To change to a preset White Balance option such as Daylight, Tungsten, Shade, and so on, follow these steps:

 Set the Mode dial to P, Av, Tv, M, or B, and then press the WB-Metering mode button

4.4 This image was taken using the Daylight White Balance setting. The color shifts to blue. Exposure: ISO 100, fg/3.5, at 1/40 second.

above the LCD panel. The White Balance screen appears.

2. Turn the Quick Control dial to select a White Balance setting. The White Balance settings are shown with icons that represent different types of lights. The White Balance option that you set remains in effect until you change it or until you switch to CA or Full Auto shooting modes.

Setting a Custom white balance and shooting a white or gray card are similar techniques. The main difference is that you set a Custom white balance while you are shooting. When you shoot a white or gray card, you set the white balance during RAW image conversion on the computer.

Getting Accurate Color with RAW Images

If you are shooting RAW images, a great way to ensure accurate color is to photograph a white or gray card that is in the same light as the subject, and then use the card as a reference point for balancing color when you convert the RAW images on the computer.

For example, when you take a portrait, ask the subject to hold the gray card under or beside his or her face for the first shot, and then continue shooting without the card in the scene. If the light changes, take another picture with the gray or white card. When you begin converting the RAW images on the computer, open the picture that you took with the card. Click the card with the White Balance tool to correct the color, and then click Done to save the corrected White Balance settings.

If you are using a RAW conversion program such as Adobe Camera Raw or Canon Digital Photo Professional, then you can copy the White Balance settings from the image you just color balanced, select all of the images shot under the same light, and then paste the White Balance settings to them. In a few seconds, you can color balance 10, 20, 50, or more images.

There are a number of white and gray card products you can use, such as the gray card included in the back of this book, or the WhiBal cards from RawWorkflow.com (www.rawworkflow.com/whibal). There are also small reflectors that do double duty by having one side in 18 percent gray and the other side in white or silver. The least expensive option, and one that works well, is a plain, white, unlined index card.

Setting a Custom white balance adjusts image color precisely for the light that is in the scene. Thus a Custom white balance is the ticket for getting the most accurate color in scenes with a mix of different types of light, and in scenes where the light doesn't match any of the preset White Balance settings. You can set a Custom white balance in P, Tv, Av, M, and B shooting modes.

By now, you may be asking why you can't just use Auto White Balance (AWB) for all images, particularly in mixed light. Certainly AWB works well for many scenes, but it is not as accurate as Custom white balance, nor is the color as visually pleasing in scenes where a preset White Balance setting clearly matches the light in the scene.

4.5 This phone and Bluetooth remote were shot for stock submission. In this image, I used studio strobes and set the White Balance setting to Flash. I wanted a neutral gray with no warm overtones, which the color has in this image. Exposure: ISO 100, f/20, at 1/125 second.

4.6 In this image, I used a Custom white balance, and the color is neutral and accurate. Exposure: ISO 100, f/20, at 1/125 second.

The following steps show you how to set a Custom white balance. A word of caution is in order, though. You must complete all of these steps to ensure the Custom white balance is used by the camera. Most photographers who are new to this technique forget to complete step 8, in particular.

1. Set the camera to P, Av, Tv, M, or B, and ensure that the Picture Style is not set to Monochrome. To check the Picture Style, press the Picture Style button on the back of the camera. The Picture Style screen displays. To change from Monochrome, turn the Quick Control dial to select another style, and then press the Set button.

It's best to have the white balance set to anything except Custom white balance when you begin these steps.

- 2. In the light that will be used for the subject, position a piece of unlined white paper so that it fills the center of the viewfinder, and take a picture. If the camera cannot focus, switch the lens to MF (manual focusing) and focus on the paper. Also ensure that the exposure is neither under exposed nor over-exposed, such as by having Exposure Compensation set.
- 3. Press the Menu button, and then turn the Main dial to highlight the Shooting 2 tab.
- 4. Turn the Quick Control dial to highlight Custom WB, and then press the Set button. The camera displays the last image captured (the white piece of paper) with a Custom White Balance icon in the upper-left corner of the display. If the image of the white paper is not displayed, turn the Quick Control dial until it is.
- **5. Press the Set button again.** The 7D displays a confirmation screen asking if you want to use the White Balance data from this image for the Custom white balance.
- **6.** Turn the Quick Control dial to choose OK, and then press the Set button. A second screen appears, reminding you to set the white balance to Custom.
- 7. Press the Set button one last time, and then press the Shutter button to dismiss the menu. The camera imports the white balance data from the selected image and returns to the Shooting 2 menu.
- 8. Press the Metering Mode-WB button above the LCD panel, and then turn the Quick Control dial to select Custom White Balance. The Custom White Balance icon is denoted by two triangles on their sides with a black square between them. The Custom white balance remains in effect until you change it by setting another white balance.

When you finish shooting in the light for which you set the Custom white balance, be sure to reset the White Balance option.

Setting a specific color temperature

Anytime you know the color temperature of the light in the scene, you can set that temperature using the K White Balance option. For example, I know that the temperature of my studio lights is 5300K, and so I use the K White Balance setting to set this temperature. I can continue shooting without further adjustments to the white balance because the light temperature remains constant.

If you have a color temperature meter, you can set the specific color temperature on the 7D. You can set a color temperature in the range of 2500 to 10,000K in 100K increments.

Here is how to set a specific color temperature for the K White Balance setting:

 With the camera set to P, Tv, Av, M, or B, press the Menu button.

4.7 In this image, I used the K White Balance setting and set the color to 5300K to match the temperature of my studio strobes. Exposure: ISO 100, f/14, at 1/125 second.

- 2. Turn the Main dial to highlight the Shooting 2 tab, and then turn the Quick Control dial to highlight White Balance.
- 3. Press the Set button. The White Balance screen appears.
- **4. Turn the Quick Control dial to highlight the K 5200 option.** If you have previously changed the temperature for the K setting, the screen reflects the last used temperature.
- 5. Turn the Main dial to the left to decrease the color temperature number or to the right to increase it, and then press the Set button. The Shooting 2 menu appears, with the white balance K temperature you set displayed.

If you use a color temperature meter, you may need to do some testing to adjust readings to compensate for differences between the camera's temperature settings and the meter's reading. And if you are setting a known temperature for a venue light, you may need to modify the white balance toward magenta or green using White Balance Correction, which is described in the next section.

Fine-tuning white balance

With the range of different types of lights both for household use and commercial use, it can be difficult to get color that is accurate. And even in images where the color is accurate, you may want a warmer or cooler rendering than a preset White Balance option provides. To compensate for dif-

ferences in specific light temperatures and to fine-tune a preset White Balance setting, you can use one of two options: White Balance Auto Bracketing or White Balance Correction.

Both options enable you to bias image color in much the same way that a color-correction filter does when you are shooting film.

Using White Balance Auto Bracketing

White Balance Auto Bracketing biases the color toward magenta/green or blue/amber. White Balance Bracketing works much like exposure bracketing does: You take a set of three images that vary the color toward a blue/ amber or magenta/green bias at +3 levels in one-step increments.

As you would expect, White Balance Bracketing reduces the camera's maximum burst rate by one-third. In fact,

4.8 This and the next two images were shot with window light and a silver reflector to camera left. I used the Auto White Balance setting and set White Balance Auto Bracketing at a +3 level. This is a standard white balance image with no color bias. Exposure: ISO 100, f/2.8, at 1/200 second.

you can combine exposure bracketing with White Balance Bracketing. If you do this, a total of nine images are recorded for each shot. This is a way to not only fill up a memory card quickly, but also to slow down shooting to a crawl. However, in scenes that you can't go back to and where image color is critical, both exposure and White Balance Bracketing can be good insurance. If you are shooting JPEG capture in P, Tv, Av, M, or B modes and use the Standard, Portrait, or Landscape Picture Styles, bracketing can be a good choice to get a visually pleasing color bias in a scene.

White Balance Auto Bracketing and White Balance Correction involve similar steps. See the steps in the next section to set White Balance Auto Bracketing.

4.9 This is the image with a +3 blue bias that cools the color. The changes in White Balance Bracketing are reasonably subtle, and with the commercial printing of this book, you may not be able to detect significant differences.

4.10 This is the image with a +3 amber bias that adds more warmth to the color.

Using White Balance Correction

White Balance Correction sets a single and specific color bias rather than bracketing in multiple directions as White Balance Bracketing does. This is the technique to use when you know how much bias or shift is needed to get the image color you want. White Balance Correction is similar to using color-compensation and color-correction filters with film, with the advantage of not needing to buy and carry multiple filters.

You can correct color in any of four directions: blue, green, amber, and magenta. Each level of color shift is equivalent of 5 *mireds* of a color temperature conversion filter. A mired is a unit of measure that indicates the density of a color temperature conversion filter. As you make the shift, you can see on the screen the direction and intensity of the correction.

To set White Balance Auto Bracketing or White Balance Correction, follow these steps:

- 1. Press the Menu button, and then turn the Main dial to highlight the Shooting 2 tab.
- 2. Turn the Quick Control dial to highlight WB SHIFT/BKT, and then press the Set button. The WB correction/WB bracketing screen appears.
- 3. To set White Balance Auto Bracketing, turn the Quick Control dial clockwise to set a blue/amber bias, or counterclockwise to set a magenta/green bias. As you turn the dial, three tick marks appear and separate to indicate the direction and amount of bracketing. The bracketing amount is also displayed on the WB correction/WB bracketing screen under the BKT block.

To set White Balance Correction, tilt the Multi-controller in the direction of the shift you want. The direction and amount of shift is displayed in the SHIFT section on the screen.

4. Press the Set button. If you change your mind and want to start over, press the INFO. button. Bracketed images are taken with the Standard white balance first, followed by the blue (or magenta) bias, and then the amber (or green) bias. If you set White Balance Correction, a WB+/ icon is displayed in the viewfinder and on the LCD panel as you shoot.

Working with Picture Styles

Picture Styles are a digital version of the characteristic "looks" of different films. For example, Kodak's PORTRA film is characterized by its subdued color and contrast. On the other hand, saturated blues and greens and snappy contrast are hallmarks of FujiFilm's Velvia film. Just as films are chosen for their rendering characteristics, you can choose Picture Styles on the 7D for their unique looks.

Behind each Picture Style are parameters that set the tonal curve, color rendering and saturation, and sharpness for the images that you shoot with the 7D. The default Picture Style is Standard, and it is characterized by snappy contrast, vivid colors, and moderate-to-high saturation. Other Picture Styles modify the contrast, color saturation and tone, and sharpness to give images a different look or rendering as described in Table 4.1. Default settings are listed in order of sharpness, contrast, color saturation, and color tone.

Picture Style	Description	Contrast	Color saturation	Default settings
Standard	Vivid, sharp, crisp	Higher contrast	Medium-high satura- tion	3, 0, 0, 0
Portrait	Enhanced skin tones, soft texture render- ing, low sharpness	Higher contrast	Medium saturation, rosy skin tones	2, 0, 0, 0
Landscape	Vivid blues and greens, high sharp- ness	Higher contrast	High saturation for greens/blues	4, 0, 0, 0
Neutral	Allows latitude for conversion and pro- cessing with low sat- uration and contrast	Subdued contrast	Low saturation, neu- tral color rendering	0, 0, 0, 0
Faithful	True rendition of col- ors with no increase in specific colors. No sharpness applied.	Subdued contrast	Low saturation, calo- rimetrically accurate	0, 0, 0, 0
Monochrome	Black-and-white or toned images with slightly heightened sharpness	High contrast	Yellow, Orange, Red, and Green Filter effects are available. Sepia, Blue, Purple, and Green Toning effects are also available.	3, 0, NA, NA

Table 4.1 EOS 7D Picture Styles

In Full Auto shooting mode, the camera automatically selects the Standard Picture Style, which you cannot change. In CA shooting mode, you can select Standard, Portrait, Landscape, or Monochrome Picture Styles. With the Monochrome Picture Style, only the sharpness and contrast parameters are adjustable, but you can add toning effects, as detailed in the sidebar.

Using Monchrome Filter and Toning Effects

You can customize the Monochrome Picture Style, but only the Sharpness and Contrast parameters can be changed. However, you have the additional option of applying a variety of Filter and Toning effects:

- Monochrome Filter effects. Filter effects mimic the same types of color filters that photographers use when shooting black-and-white film. The Yellow filter makes skies look natural with clear white clouds. The Orange filter darkens the sky and adds brilliance to sunsets. The Red filter further darkens a blue sky and makes tree leaves look crisp and bright and renders skin tones realistically.
- Monochrome Toning effects. You can choose to apply a creative toning effect when shooting with the Monochrome Picture Style. The Toning effect options are Non, Sepia (S), Blue (B), Purple (P), and Green (G).

To apply a Filter or Toning effect, follow these steps:

- 1. Press the Picture Style button on the back of the camera.
- 2. Turn the Quick Control dial to select Monochrome.
- 3. Press the INFO. button and then turn the Quick Control dial to highlight either Filter effect or Toning effect.
- 4. Press the Set button. The camera displays options that you can choose.
- 5. Turn the Quick Control dial to highlight the option you want and then press the Set button. The effect is applied until you change it.

RAW images captured in Monochrome can be converted to color using the software bundled with the camera. However, in JPEG capture, Monchrome images cannot be converted to color. Whether you modify an existing style or create one of your own, the 7D provides good latitude in setting parameters with seven adjustment levels for sharpness, and eight levels of adjustments for contrast, saturation, and color tone. Picture Styles are designed to produce classic looks that need little or not post-processing so that you can print JPEG images directly from the CF card. If you shoot RAW capture, you can't print images directly from the CF card, but you can apply Picture Styles either in the camera or during conversion using the Canon Digital Photo Professional conversion program.

You can also use the Picture Style Editor to modify and save changes to Picture Styles for captured images. The Picture Style Editor is included on the Canon EOS Digital Solution Disk that comes with the camera, and it is described later in this chapter.

Choosing and customizing Picture Styles

To get the color, contrast, and saturation results you want out of the camera, you can customize Picture Styles to best suit your creative vision and needs. The following are parameters that you can modify for each Picture Style in P, Tv, Av, M, and B shooting modes:

Sharpness: 0 to 7. Level 0 (zero) applies no sharpening and renders a very soft look (due largely to the anti-aliasing filter in front of the image sensor that helps ward off various problems, including moiré, spectral highlights, and chromatic aberrations).

At high sharpness levels, images are suitable for direct printing from the memory card. However, if you prefer to edit images on the computer, then a 0-2 level is adequate and helps to prevent sharpening halos when you sharpen images in an image-editing program.

Contrast: -4 to +4. The Contrast parameter represents the image's tonal curve. If the setting is too high, then image pixels can be clipped (discarding highlight and/or shadow pixels). A negative adjustment produces a flatter look but helps to prevent clipping. A positive setting increases the contrast and stretches the tonal range. Higher settings can lead to clipping.

I prefer to get a slightly flatter look out of the camera and reduce clipping, knowing that the highlight data is being preserved. To get snappier contrast, I can always set a curve in Photoshop during image editing. You can evaluate the effect of the tonal curve on RAW images in the histogram shown in the Canon Digital Photo Professional program.

Saturation: -4 to +4. This setting affects the strength or intensity of the color with a negative setting, producing low saturation, and vice versa. As with the Contrast parameter, a high Saturation setting can cause individual color channels to clip. A +1 or +2 setting is adequate for snappy JPEG images destined for direct printing.

For images that you will edit on the computer, a 0 (zero) setting allows ample latitude for post-capture edits.

Color Tone: -4 to +4. This setting modifies the hue of the image. Negative settings produce tones that are more red and more blue, while positive settings produce more yellow tones.

Figures 4.11 through 4.16 show the effect of each Picture Style on color, saturation, and contrast. Exposure for these images is ISO 100, f/18, at 1/80 second.

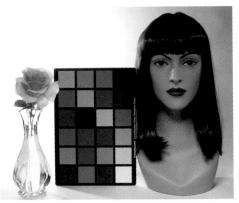

4.11 This image was taken using the Standard Picture Style.

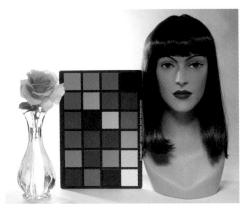

4.12 This image was taken using the Portrait Picture Style.

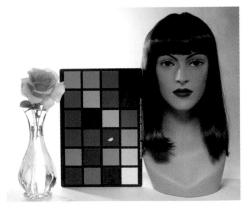

4.13 This image was taken using the Landscape Picture Style.

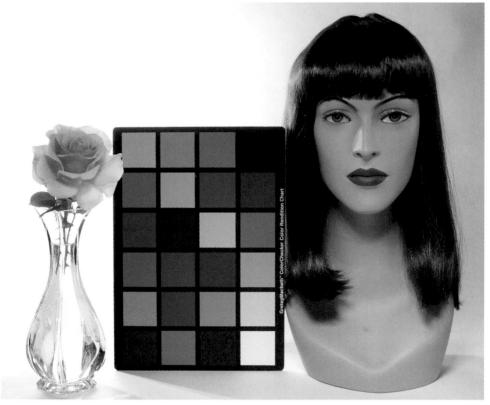

4.14 This image was taken using the Neutral Picture Style.

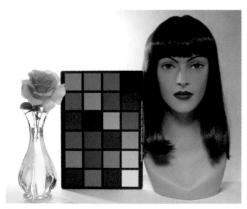

4.15 This image was taken using the Faithful Picture Style.

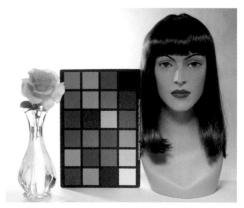

4.16 This image was taken using the Monochrome Picture Style with an Orange Filter effect.

In CA shooting mode, you can also choose any of four Picture Styles from the Quick Control screen displayed on the LCD. To display the Quick Control screen, set the Mode dial to CA and then press the Q button on the back top left of the camera.

After evaluating and printing with different Picture Styles, you can change the default parameters to get the rendition that you want. You may also want to create your own style. You can create up to three Picture Styles that are based on an existing style.

For most of my photography, I use a modified Neutral Picture Style. I use this modified style for a couple of reasons: First, I always edit images on the computer and this style gives me latitude for interpreting the color tone and saturation of images to my liking; and second, in portraits, it creates subdued, lovely skin tones with a nice level of contrast.

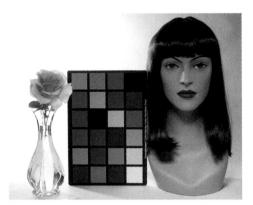

4.17 This image was taken with my modified Neutral Picture Style. This modified style gives me latitude for interpreting color tone and saturation and creates subdued, lovely skin tones in portraits.

Here is how I set the modified Neutral Picture Style for my work. These settings work best when the lighting isn't flat and the image isn't underexposed. The settings are: Sharpness +2, Contrast +1, Saturation +1, Color tone 0.

To modify a Picture Style, follow these steps:

- 1. With the Mode dial set to P, Tv, Av, M, or B, press the Picture Styles button on the back of the camera. The Picture Style selection screen appears.
- Turn the Quick Control dial to select the Picture Style you want to modify, and then press the INFO. button. The Detail Set screen for the selected style appears.
- 3. Turn the Quick Control dial to select the parameter you want to adjust, and then press the Set button. The camera activates the control.

- 4. Turn the Quick Control dial to change the parameter, and then press the Set button. Negative settings decrease sharpness, contrast, and saturation, and positive settings provide higher sharpness, contrast, and saturation. Negative color tone settings provide reddish skin tones, and positive settings provide yellowish skin tones.
- 5. Turn the Quick Control dial to select the next parameter, and then press the Set button.
- 6. Repeat steps 4 and 5 to change additional parameters.
- **7. Press the Menu button.** The modifications are saved and remain in effect until you change them. The Picture Style selection screen appears.

Registering a new Picture Style

If you want a greater range of Picture Styles for your work, you can create three User-Defined styles. Each style is based on one of the Canon Picture Styles, and you can modify the style to suit your preferences. With this approach, you can retain the preset Picture Styles either unchanged or modified, plus you can have three additional modified (or User-Defined) styles to extend your choices.

There are several approaches that you can take to create new styles, depending on your needs. You can use each of the three User-Defined styles for specific venues in which you shoot often. For example, you can set up one style for nature and land-scape shooting (a modification of the Landscape or Standard style), one for studio portraits (a modification of the Portrait style), and one for a sports arena (a modification of the Standard style). Or you can use the User-Defined style for a style that you create using the Canon Picture Style Editor, a program included on the EOS Digital Solution Disk that comes with the camera. This technique is described in the next section of this chapter.

Here's how to create and register a User-Defined Picture Style:

- 1. With the Mode dial set to P, Tv, Av, M, or B, press the Picture Style button on the back of the camera.
- 2. Turn the Quick Control dial to User Def. 1, and then press the INFO. button. The Detail set. User Def. 1 screen appears with the base Picture Style, Standard.
- 3. Press the Set button. The camera activates the base Picture Style control.

- **4. Turn the Quick Control dial to select a base Picture Style, and then press the Set button.** You can select any of the preset Picture Styles, such as Standard, Portrait, and so on, as the base style.
- 5. Turn the Quick Control dial to select a parameter, such as Sharpness, and then press the Set button. The camera activates the parameter's control.
- 6. Turn the Quick Control dial to set the level of change, and then press the Set button.
- **7. Repeat steps 5 and 6 to change the remaining parameters.** The remaining parameters are Contrast, Saturation, and Color tone.
- **8. Press the Menu button to register the style.** The Picture Style selection screen appears. The base Picture style is displayed to the right of User Def. 1. This Picture Style remains in effect until you change it.

You can repeat these steps to set up User Def. 2 and 3 styles.

Using the Picture Style Editor

Choosing and modifying Picture Styles is handy, but it is not especially efficient because it requires experimentation to determine the style and modifications you like best. Canon offers a more efficient approach to fine-turning Picture Styles with the Picture Style Editor, a program included on the EOS Digital Solution Disk.

Canon offers a more efficient approach to fine-tuning Picture Styles with the Picture Style Editor. This program enables you to apply a Picture Style to a RAW image, and then modify the style on the computer, where you can watch the effect of the changes. Once you have perfected your modified style, you can install it in the 7D.

The Picture Style Editor is deceptively simply, but it offers powerful and exact control over the style. For example, you can make color changes and minute adjustments to hue, saturation, luminosity, and *gamma* (tonal curve) characteristics. You can select up to 100 color points in the color specifications, and three color display modes — HSL (Hue, Saturation, Luminosity), Lab, and RGB — are available. You can also set the color workspace display, such as Adobe RGB.

A histogram shows the distribution of tones and color in the sample image. If you are familiar with the Canon Digital Photo Professional program, then the color tones will be familiar because the Picture Style Editor uses the same algorithms for image processing.

You can set up to ten points anywhere on the tone curve and watch the effect of the change to the image in the main window. In addition, you can compare before and after adjustments in split windows with magnification up to 200 percent.

Because the goal of working with the Picture Style Editor is to create a Picture style file that you can register and use in the camera, the adjustments that you make to the RAW image are not applied to the image. Rather, the adjustments are saved as a file with .pf2 extension, and then you use the EOS Utility to register the file in the camera and apply it to images. You can also apply the style in Digital Photo Professional after saving the settings as a PF2 file. Additionally, if you use more than one Canon EOS dSLR, you can register the style and use it on all your cameras.

Here is a brief introduction to using the Picture Style Editor. Before you begin, be sure you install the program from the EOS Digital Solution Disk.

- Choose Start→All Programs→Canon Utilities→Picture Style Editor. On a Mac, choose Applications→Canon Utilities→Picture Style Editor→Picture Style Editor.app. The Picture Style Editor main window appears, as shown in Figure 4.18.
- 2. Click and drag a RAW image onto the main Picture Style Editor window. RAW files have a .CR2 extension. You can also choose File → Open image and navigate to a folder that contains RAW images, double-click a RAW file, and then click Open. When the file opens, the Picture Style Editor displays the Tool palette.
- 3. Click the arrow next to Base Picture Style to select a Picture Style other than Standard.
- 4. At the bottom left of the main window, click one of the split screen icons to show the original image and the image with the changes you make side by side. You can choose to split the screen horizontally or vertically. If you want to switch back to a single image display, you can click the icon at the far-left bottom of the window.
- 5. Click Advanced in the Tool palette to display the Picture Style parameters for Sharpness, Contrast, Color saturation, and Color tone. These settings that you can change are the same as those on the camera, but with the Picture Style Editor, you can watch the effect of the changes as you apply them.

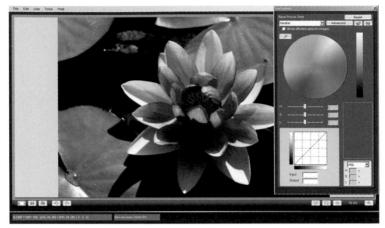

4.18 The Picture Style Editor offers many controls for modifying a Picture Style.

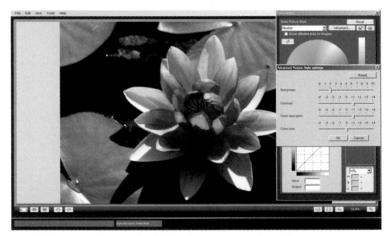

4.19 This is the Picture Style settings screen that allows you to change parameters much as you can do on the camera.

- 6. Make the changes you want, and then click OK.
- 7. Adjust the color, tonal range, and curve using the Tool palette controls. If you are familiar with image-editing programs or with Digital Photo Professional, most of the tools will be familiar. Additionally, you can go to the Canon Web site at web.canon.jp/imaging/picturestyle/editor/functions.html for a detailed description of the functions.

When you modify the style to your liking, you can save it and register it to use in the 7D. However, when you save the PF2 file, I recommend saving two versions of it. During the process of saving the file, you can select the Disable subsequent editing option, which prevents disclosing the adjustments that have been made in the Picture Style Editor.

This is the option to choose when you save a style for use in the 7D and in the Digital Photo Professional Program. However, when you turn on the Disable subsequent editing option, the style file can no longer be used in the Picture Style Editor. For that reason, you may want to save a second copy of the PF2 file without turning on the Disable subsequent editing option in the Save Picture Style File dialog box. That way, if you later decide to modify the style, you can use the Picture Style Editor to make adjustments to this copy of the PF2 file.

To save a Custom Picture Style, follow these steps:

- 1. Click the Save Picture Style File icon at the top far right of the Picture Style Editor Tool palette. The Save Picture Style File dialog box appears.
- 2. Navigate to the folder where you want to save the file.
- **3.** To save a file to use in the 7D, click the Disable subsequent editing option at the bottom of the dialog box. To save a file that you can edit again in the Picture Style Editor, do not select this option.
- **4.** Type a name for the file and click Save. The file is saved in the location you specified, with a .pf2 extension.

To install the Custom Picture Style on the 7D, follow these steps:

- 1. Ensure that the EOS Digital Solution Disk programs are installed on your computer, and you have the USB cable that came with the camera handy.
- 2. Connect the camera to the computer using the USB cable.
- Choose Start→All Programs→Canon Utilities→EOS Utility. On a Mac, choose Applications→Canon Utilities→EOS Utility→EOS Utility.app. The EOS Utility screen appears.
- 4. Click Camera settings/Remote shooting under the Connect Camera tab in the EOS Utility. The capture window appears.
- Click the camera icon in the red tool bar and then click Picture Style. The Picture Style window appears.

- 6. Click User Def. 1, 2, or 3. If a Picture Style file was previously registered to this option, the new style overwrites the previous style. When you choose User Defined, additional options appear.
- 7. Click Register User Defined style. The Register Picture Style File dialog box appears.
- 8. Click the Open folder icon on the right and then navigate to the folder where you saved the Picture Style file that you modified in the Picture style Editor, click it, and then click Open. The Register Picture Style File dialog box appears.
- 9. Click OK. The modified style is registered in the 7D.

It is a good idea to verify that the style was copied by pressing the Picture Style button on the back of the 7D and selecting the User Defined Style you registered to see if the settings match how you adjusted them. In addition to creating your own styles, you can download additional Picture Styles from the Canon Web site at web.canon.jp/ imaging/picturestyle/index.html.

CHAPTER

Customizing the 7D

One of the best ways to increase your shooting efficiency and enjoyment with the EOS 7D is to customize it for your everyday shooting as well as for specific shooting situations. The 7D offers three major categories of customization:

- Custom Functions. These enable you to change camera controls and behavior as well as to set up the camera for both general and venue-specific shooting situations.
- C modes or Camera User Settings. These enable you to set up virtually everything on the camera and then save all the settings as C1 or C2 shooting mode.
- ▶ My Menu. This is a menu tab where you can place your six most frequently used menu items for quick access.

I can tell you from personal experience that all three features will save you time and offer shooting advantages that are well worth the time it takes to make the adjustments.

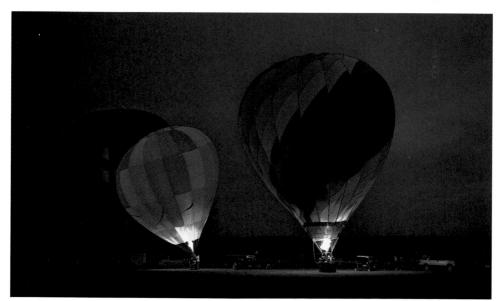

Exploring Custom Functions

The major advantage of Custom Functions is that they enable you to customize camera controls and operation to suit your shooting style. As a result, they save you time and make shooting more enjoyable. For example, you can change the pattern for selecting AF points manually using Custom Function III-7 to suit your preferences.

Before you begin, you should know that Custom Functions can be set only in P, Tv, Av, M, and B shooting modes. Also, after you set a Custom Function option, it remains in effect until you change it.

Canon refers to Custom Functions using the abbreviation C.Fn [group Roman numeral]-[function number]; for example, C.Fn II-3.

The 7D offers 25 Custom Functions. Some Custom Functions have a broad range of uses, and others are useful for specific shooting specialties or scenes.

Custom Function groupings

Canon organized the 25 Custom Functions into four groups denoted with Roman numerals, all of which are listed on the Custom Function camera menu. The following tables delineate the groupings and the C.Fns that fall within each group. It is worth-while to become familiar with the groupings because you must choose a group from the Custom Functions menu to find and change a specific function.

Custom Function Group I: Exposure. Detailed in Table 5.1, this group essentially sets any function that has to do with exposure settings and flash sync speed.

Option number	Function name
1	Exposure level increments
2	ISO speed setting increments (available in Movie mode only with manual exposure)
3	ISO expansion
4	Bracketing auto cancel (unavailable in Movie mode)
5	Bracketing sequence (unavailable in Movie mode)
6	Safety shift (unavailable in Movie mode)
7	Flash synchronization speed in Av mode (unavailable in Movie mode)

Table 5.1 Custom Function Group I: Exposure

Custom Function Group II: Image. I think of this group, shown in Table 5.2, as the NR (noise reduction) and dynamic range group.

Table 5.2 Custom Function Group II: Image

Option number	Function name	
1	Long exposure noise reduction (Movie stills only)	
2	High ISO speed noise reduction (Movie stills only)	
3	Highlight tone priority	

Custom Function group III: Autofocus/Drive. The majority of functions in this group are related to working with autofocus and it includes Mirror lockup. See Table 5.3.

Table 5.3 Custom Function Group III: Autofocus/Drive

Option number	Function name
1	Al Servo tracking sensitivity *
2	Al Servo 1st/2nd image priority *
3	AI Servo AF tracking method *
4	Lens drive when AF impossible (available in Live View and Movie shooting when using AF Quick focusing mode)
5	AF microadjustment (available in Live View and Movie shooting when using AF Quick focusing mode)
6	Select AF area selection mode (available in Live View and Movie shooting when using AF Quick focusing mode)
7	Manual AF point selection pattern (available in Live View and Movie shooting when using AF Quick focusing mode)
8	VF display illumination *
9	Display all AF points *
10	Focus display in AI SERVO/MF *
11	AF-assist beam firing (available in Live View shooting when using AF Quick focusing mode, unavailable in Movie mode)
12	Orientation linked AF point (available in Live View and Movie shooting when using AF Quick focusing mode)
13	Mirror lockup *

Functions marked with an * are not available for Live View and/or Movie shooting.

Custom Function Group IV: Operation/Others. I think of this group as "everything else." If I can't find what I want in the other groups, I choose this option on the Custom Function menu. See Table 5.4.

Option number	Function name	
1	Custom Controls (available in Movie mode only with manual exposure)	
2	Dial direction during Tv/Av (available in Live View mode and for Movie stills)	
3	Add image verification data (available in Live View mode and for Movie stills)	
4	Add aspect ratio information (available in Live View mode and for Movie stills)	

Table 5.4 Custom Function Group IV: Operation/Others

Custom Functions specifics

This section includes a description of each Custom Function and the options that you can set. I will provide instances where the C.Fn would be useful in general, but also consider how you could use them to simplify or customize your specific shooting situations.

I encourage you to use Custom Functions to the fullest extent. I think that you will be pleasantly surprised at how much more you will enjoy the 7D after you customize it for your shooting needs.

If you set Custom Functions and later want to return to the camera defaults, you can do that easily by using the Clear all Custom Func. (C.Fn) option on the Custom Functions camera menu.

C.Fn I: Exposure

The Exposure Custom Functions are described here followed by the options that you can choose for each function.

C.Fn I-1: Exposure-level increments

With this function, you can set the increment that is used for shutter speed, aperture, exposure compensation, and Auto Exposure Bracketing (AEB) changes. The exposure increment you choose is displayed in the viewfinder and on the LCD as marks at the bottom of the Exposure-level Indicator.

- Option 0: 1/3 stop. By default, the 7D uses 1/3 stop as the exposure-level increment for changes in shutter speed, aperture, exposure compensation, and AEB.
- Option 1: 1/2 stop. This option sets 1/2 stop as the exposure-level increment for shutter speed, aperture, exposure compensation, and AEB changes. It gives you a larger exposure change and is useful when you bracket images for later compositing in an image-editing program.

C.Fn I-2: ISO speed setting increments

With this function, you can set the increment level that is used when you change the ISO sensitivity setting.

- Option 0: 1/3 stop. This is the default increment. With this option set, the ISO speeds are Auto, 100,125, 160, 200, 250, 320, 400, 500, 640, 800, 1000, 1250, 1600, 2000, 2500, and 3200, as well as H (12800) when C.Fn I-3 is set to On.
- Option 1: 1 stop. This option sets 1 f-stop as the ISO adjustment-level increment. With this option set, the ISO speeds are the traditional settings of Auto, 100, 200, 400, 800, 1600, 3200, as well as H (12800) when C.Fn I-3 is set to On.

C.Fn I-3: ISO expansion

With this function, you can choose the additional ISO sensitivity setting of H, which is equivalent to ISO 12800. To determine if you want to use the high ISO setting, including the expansion setting of 12800, be sure to shoot test shots at the high level, and then examine the images to ensure that you can get good prints with acceptable noise levels at the size you most often use to make prints. And even then, to always get the highest image quality in terms of color, fine detail, and smooth tones, I recommend shooting at the lowest possible ISO setting given light, lens, and other factors.

- Option 0: Off. At this default setting, you cannot select the expanded ISO setting of H (12800).
- Option 1: On. You can select the expanded ISO setting of H (12800). With this option set, you can select H as an ISO option in the same way that you select other ISO settings.

C.Fn I-4: Bracketing auto cancel

With this function, you can choose when AEB and White Balance Bracketing (WB-BKT) are cancelled. Very often, AEB and WB-BKT are specific to a scene, and, therefore, not settings that you want to retain. It is also easy to forget that you have set either bracketing option, and you end up shooting with the bracketing inadvertently set. Unless you most often shoot with AEB and WB-BKT, I recommend using the default option 0.

- Option 0: On. Both AEB and WB-BKT are cancelled when you turn the camera power switch to Off, when you have the flash ready to fire, and if you clear camera settings.
- Option 1: Off. Choosing this option retains AEB and WB-BKT settings even after you turn off the camera. When the camera's flash is ready, the bracketing is cancelled, but the camera remembers the AEB amount for use after you use the flash.

C.Fn I-5: Bracketing sequence

Use this function when you want to change the sequence of images that are bracketed by shutter speed or aperture. It also enables you to change the sequence for WB-BKT. For exposure bracketing, I find that the Option 1 sequence makes it much easier to identify which image is which in a series of bracketed images after I download them to the computer.

- Option 0: 0 (Standard exposure or standard white balance), (Decreased exposure or less blue or less magenta white-balance bias), + (Increased exposure or more amber and more green white-balance bias)
- Option 1: (Decreased exposure, or less blue or less magenta white-balance bias), 0 (Standard exposure or standard white balance), + (Increased exposure or more amber and more green white-balance bias)

C.Fn I-6: Safety shift

If you enable this function, the camera automatically shifts the aperture or shutter speed in both Shutter-priority AE (Tv) and Aperture-priority AE (Av) shooting modes if there is a sudden shift in lighting that would cause an improper exposure at the current settings.

While photographers are watchful for lighting changes, this function can be very helpful in stage and theater lighting venues where overhead spotlights can dramatically shift as speakers or actors move around the stage in and out of spot-lit areas.

- Option 0: Disable. This option maintains the exposure you have set even if the subject brightness changes.
- ► Option 1: Enable (Tv/Av). In Shutter-priority AE (Tv) and Aperture-priority AE (Av) shooting modes, the shutter speed or aperture automatically shifts if the subject brightness suddenly changes so that you get an acceptable exposure.

C.Fn I-7: Flash sync. speed in Av mode

This function provides options for setting the flash sync speed automatically, to 1/250-1/60 second, or to a fixed 1/250 second in Av mode. With these options, you can control whether the flash light balances with existing light or provides primary illumination for the scene. It can also help ensure a fast enough camera handholding speed.

- Option 0: Auto. This option automatically syncs Speedlites at 1/250 second or slower. This option uses both existing light and the flash to illuminate the scene.
- Option 1: 1/250-1/60 sec. auto. This option provides a fast enough shutter speed in Av mode to handhold the camera and get a sharp image depending on the lens you're using. This option does not balance the flash with existing light, so the background will be dark.
- ▶ Option 2: 1/250 sec. (fixed). Automatically sets the highest flash sync speed of 1/250 second in Aperture-priority AE (Av) mode. With this option, less existing light is used for the exposure and more of the flash light is used. As a result, the background goes darker than with Option 1.

C.Fn II: Image

This group of functions enable you to set noise reduction for long exposures and high ISO sensitivity settings. And you can choose to use Highlight Tone Priority as well.

C.Fn II-1: Long-exposure noise reduction

This function offers options to turn noise reduction on or off, or to set it to automatic for long exposures. With noise reduction turned on, the reduction process takes the same amount of time as the original exposure. In other words, if the original image exposure is 1.5 seconds, then noise reduction takes an additional 1.5 seconds. This means that you cannot take another picture until the noise reduction process finishes.

I keep the 7D set to Option 1 to automatically perform noise reduction if it is detected in long exposures, which I consider to be good insurance.

- Option 0: Off. No noise reduction is performed.
- Option 1: Auto. The camera automatically performs noise reduction when it detects noise from 1-second or longer exposures.

Option 2: On. The camera performs noise reduction on all exposures of 1 second or longer regardless of whether the camera detects noise. Obviously, the second exposure duration reduces the continuous shooting burst rate dramatically. But this is a good option for night scenes and lowlight still-life subjects. If you're shooting at a low-light music concert or a sports event, this option slows down shooting too much for it to be a practical option.

If you use Live View and you have Option 2 set, then the current view on the LCD is suspended during the time that the camera performs the noise reduction.

C.Fn II-2: High ISO speed noise reduction

With this function, you can choose to apply more aggressive noise reduction to shadow areas in particular when you shoot at high ISO sensitivity settings. (The camera applies some noise reduction to all images.) If you turn this option on, noise in low-ISO images is further reduced.

Because Canon has a good noise-reduction algorithm, this setting is more likely to retain fine image details, and reducing shadow noise is advantageous. However, it pays to check your images to ensure that the blurring of fine image detail resulting from noise reduction is not too heavy handed.

- Option 0: Standard. This is the default setting that applies some color (*chroma*) and luminance noise reduction to images shot at all ISO sensitivity settings. If you seldom use high ISO settings, this is a good option to choose, and it is effective even at relatively high ISO sensitivity settings.
- Option 1: Low. The camera performs noise reduction on all images, not just high-ISO images. You may not see much difference between this option and Option 0: Standard.
- Option 2: Strong. More aggressive noise reduction is applied, and a loss of fine detail may be noticeable. In addition, the burst rate in Continuous drive mode is reduced.
- Option 3: Disable. No noise reduction is applied.

C.Fn II-3: Highlight Tone Priority

One of the most interesting and useful functions is Highlight Tone Priority, which helps ensure good detail in bright areas such as those on a bride's gown. With the function turned on, the high range of the camera's dynamic range (the range measured in f-stops between deep shadows and highlights in a scene) is extended from 18 percent gray (middle gray) to the brightest highlights.

Further, the gradation from middle gray tones to highlights is smoother with this option turned on. The downside of enabling this option is increased digital noise in shadow areas and not being able to select ISO 100.

But if you are shooting weddings or any other scene where it is critical to retain highlight detail, then the tradeoff is worthwhile. If noise in the shadow areas is objectionable, you can apply noise reduction in an editing program.

However, if you turn on Highlight Tone Priority, the default ISO speed range is reduced to 200 to 6400 so that you lose the ISO 100 and (H) 12,800 settings. The ISO display in the viewfinder, on the LCD panel, and in the Shooting information display adds a D+ to indicate that this option is in effect.

- **Option 0: Disable.** This is the default setting with no highlight tone expansion.
- Option 1: Enable. This option turns on Highlight Tone Priority, improving the detail in bright highlights and in gradation of detail from middle gray to the bright-est highlights. The lowest ISO setting available is 200 and the highest is 6400. With Auto Lighting Optimizer turned on, the 7D applies an automatic correction to images that are too dark and/or have flat contrast. This option turns off the automatic optimization.

C.Fn III: Autofocus/Drive

This group of functions enables you to control various lens and camera autofocusing tasks. This is also where you can set mirror lockup.

C.Fn III-1: AI Servo tracking sensitivity

This function enables you to set focus tracking (AI Servo autofocus mode) so that when obstructions come between the camera and the subject, the focus is less easily thrown off making subject tracking easier. If you choose a fast setting, it's more difficult for the autofocus system to track a specific subject, but it is easier to switch focus to a subject that comes into the frame from the side. Conversely, a slow setting makes it easier to track a single subject.

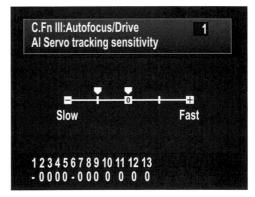

5.1 The AI Servo tracking sensitivity screen

Slow to Fast. Tilt the Multi-controller to move the tick mark to the position you want on the scale.

C.Fn III-2: AI Servo 1st/2nd image priority

This function is useful when you use AI Servo autofocus mode (focus tracking) and a Continuous shooting drive mode. With that combination, you can prioritize subject focusing, shutter release, focus tracking, or shooting speed for the first image during continuous shooting. And you can set the priorities for the second and subsequent images.

Your choice depends on your priorities and on the subject. If the subject is moving across the frame at approximately the same distance through the series, then you may choose to give priority to subject focus for the first shot and shooting speed for the second shot. But if the subject distance varies, then you may want subject focus as the first shot priority and focus tracking to be the priority for subsequent shots.

- Option 0: AF priority/Tracking priority. For the first image, subject focus is the priority. For subsequent shots, shooting speed and focus tracking are given priority.
- Option 1: AF priority/Drive speed priority. Focusing is the priority in the first image, and shooting speed gets the priority over focus tracking of the subject for the second image.
- Option 2: Release/Drive speed priority. For the first image, shutter release has priority over focusing. For the second and subsequent images, shooting speed has priority.
- Option 3: Release/Tracking priority. Shutter release has priority for the first shot while focus tracking is the priority for the subsequent images.

C.Fn III-3: AI Servo tracking method

Use this function to set AI Servo AF mode to focus-track a subject — the camera identifies the subject by the focus point that started the focusing or the active focus point — or to switch to tracking a subject that enters the frame and that is closer than the first subject. Your choice depends on the subject and situation. If you are focusing on a specific athlete in a game, then you can choose to maintain focus on the athlete regardless of players who are closer to the camera. Alternately if you are shooting a flock of birds, then you may prefer to have the camera switch focus to the closest bird.

Note that with 19-point AF auto selection and with AF point expansion, the main focus point is the first AF point that started focus tracking. With Zone AF, the main focus point is the active AF point. Autofocus modes and AF areas/zones are detailed in Chapter 3.

- Option 0: Main focus point priority. The camera switches the active AF point to focus on the closest subject.
- Option 1: Continuous AF track priority. If another subject enters the frame and is closer than the target subject, this additional subject is ignored and focus continues on the target subject. If necessary, the camera switches to an adjacent AF point (with AF point expansion) based on the preceding focusing result/ pattern. In short, this option prevents focus switching off the subject when an obstruction comes between the camera and the subject.

C.Fn III-4: Lens drive when AF impossible

This is a handy function to explore if you often shoot in scenes where the lens simply cannot focus. You have likely been in situations where the lens seeks focus seemingly forever and goes far out of focus range while attempting to find focus, particularly with telephoto and super-telephoto lenses. Setting this function to Option 1 stops the lens from seeking to find focus and going into an extensive defocus range.

- Option 0: Focus search on. The lens continues to seek focus.
- Option 1: Focus search off. This stops the lens drive from going into extreme defocus range.

C.Fn III-5: AF Microadjustment

This function is designed to overcome the front- and back-focusing tendencies of some lenses. Using microadjustment shifts the camera's sharpest plane of focus forward or backward and applies the adjustment to the internal AF system to compensate for front or back focus.

The camera identifies lenses by their focal length and maximum aperture, and up to 20 lenses can be adjusted. Until now, lens adjustments were made by the factory or by Canon, but this function enables you to approximate that tuning. The process for making microadjustments requires using a target pattern, and the process is not for the faint of heart. If you choose to use AF Microadjustment, then you can set the microadjustment in plus or minus 20 steps forward or backward and register the adjustments.

- Option 0: Disable. No adjustment is used.
- Option 1: Adjust all by same amount. This option adjusts all lenses by the same amount. If you find that all lenses are off by the same amount, then this is the option to select.

Option 2: Adjust by lens. With this option, you can test a single lens, make the adjustment, and then register the results in the camera. Then when you mount a lens that has a registered adjustment, the camera automatically applies the focus adjustment and shifts the point of focus per the adjustment.

You can learn more about AF Microadjustment in Chapter 9.

C.Fn III-6: Select AF area selection mode

In broad terms, AF area selection modes determine where, how many, and which of the 19-point AF points are used for focusing. The 7D has three default AF area selection modes, and with this function, you can add two more: Spot AF for pinpoint focusing, and AF point expansion. Chapter 3 details AF area selection modes and includes steps for making selections on this Custom Function screen.

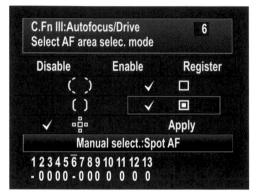

5.2 The Select AF area selection mode screen

This function enables you to register, and then include or exclude AF areas selection modes. The modes that you enable are available for you to select when you are shooting. The AF area selection modes you can enable or disable are:

- Auto select: 19 point AF. In this mode, the camera automatically selects the AF point or points for focusing.
- Manual select: Zone AF. In this mode, you can manually select five different AF zones based on the subject position and orientation.
- Man. Select: AF point expansion. This mode enables the 7D to use AF points that are adjacent to the manually selected AF point to focus.
- Manual select: Single point AF. This is the standard AF point selection method where you can manually select any one of the 19 AF points.
- ► Manual select: Spot AF. This option enables pinpoint focusing using an area that is smaller than the size of the AF point shown in the viewfinder.

C.Fn III-7: AF point selection pattern

Use the options of this function to set whether the manual AF point selection pattern stops at the outer edge or moves to the opposite AF point. If the AF point selection pattern stops at the outer edge, then you have to turn the Main or Quick Control dial (depending on the direction of AF-point selection) to move the AF point to the next row of AF points.

If you choose Continuous, then turning the Main or Quick Control dial moves the AF point from the top or bottom AF point to the opposite AF point on the same row. Options that you choose here don't apply when you're using the 19-point AF auto selection and Zone AF area selection modes.

- Option 1: Stops at AF area edges. Prevents the AF point from jumping from one side of a row to the opposite side of the same row of AF points. If you are selecting an AF point within an area of the screen, this option keeps you in the same area.
- Option 2: Continuous. When you reach the edge of an AF_crow and turn the Main or Quick Control dial (depending whether you're selecting in the horizontal or vertical direction), the AF point jumps to the opposite side of the same row.

C.Fn III-8: VF display illumination

These options determine whether and when the viewfinder elements including the AF point, grid, and so on are lit in red.

- ▶ Option 1: Auto. Viewfinder elements are automatically illuminated in low light.
- Option 2: Enable. Viewfinder illumination is always on.
- Option 3: Disable. Viewfinder elements are never illuminated.

C.Fn III-9: Display all AF points

You can chose to have the 19 AF points displayed during AF-point selection and have only the active AF point displayed during shooting, or have all AF points displayed during shooting.

Option 0: Disable. All 19 AF points are displayed during manual AF point selection, but only the active AF point is displayed in the viewfinder during shooting.

Option 1: Enable. This option is the same as above except that all 19 AF points are displayed during shooting.

C.Fn III-10: Focus display in AI SERVO/MF

With this function, the AF point or points that achieve focus will track focus on the subject when you are using AI Servo AF mode with Zone AF and 19-point AF auto selection. However, no focus confirmation can be selected.

- Option 0: Enable. In AI Servo AF mode using Zone AF or 19-point AF auto selection, the AF point or points that achieve(s) focus will track focus on the subject. If you're using Manual Focus, the focus confirmation indication will be the same as with autofocus.
- Option 1: Disable. No focus indication is displayed when focus is achieved even with Manual Focus. With AI Servo AF and AF point expansion, Zone AF, or 19-point AF auto selection, the AF point or points that are tracking subject focus are not displayed.

C.Fn III-11: AF-assist beam firing

With this function you control whether the 7D's built-in flash or an accessory EX Speedlite's autofocus assist light is used to help the camera establish focus. The AF-assist beam is very helpful in speeding up focusing and in ensuring sharp focus.

- Option 0: Enable. The camera uses the built-in flash or an accessory Canon EX Speedlite's AF-assist beam to establish focus. This beam helps the camera establish focus in low light or when the subject contrast is low. The flash also fires.
- Option 1: Disable. The AF-assist beam is not used.
- Option 2: Enable external flash only. Only the Speedlite's AF-assist beam is used to help establish focus.
- Option 3: IR AF assist beam only. This option limits use of the assist beam firing to only Canon Speedlites that feature an infrared AF-assist beam. This option also prevents external Speedlites that use a series of quick assist beams from firing the assist beams.

C.Fn III-12: Orientation linked AF point

This is one of the coolest and most useful of the new Custom Functions related to focusing. With Option 2, you can set a specific AF selection mode and AF point for the camera to use in horizontal orientation and another when the camera is in vertical orientation.

Thus, if you're shooting a wedding ceremony in landscape orientation, and then turn the camera to portrait orientation to shoot a portrait of the bride and groom, the AF point and AF selection mode are automatically chosen when you turn the camera vertically. And when you return to horizontal orientation, the AF selection mode and AF point that you preset are automatically chosen.

- Option 0: Same for both vertical/horizontal. In this default setting, the camera maintains the same AF selection mode and AF point regardless of camera orientation.
- Option 1: Select different AF points. With this option, you can set up different AF selection modes and AF points for horizontal and vertical camera orientation. The camera recognizes these orientations:
 - Horizontal
 - Vertical with the camera grip at the top
 - Vertical with the camera grip at the bottom

To use Option 1, you have to set up the AF point and Area selection mode for each of the three orientations in the order above, and then choose Option 1. The steps for setting Custom Functions are detailed later in this chapter.

C.Fn III-13: Mirror lockup

Option 1 for this function prevents blur that can be caused in close-up and telephoto shots by the camera's reflex mirror flipping up at the beginning of an exposure. For nature and landscape photographers who often use mirror lockup, you can make this function more accessible by adding this Custom Function to My Menu. Customizing My Menu is detailed later in this chapter.

- **Option 0: Disable.** This prevents the mirror from being locked up.
- Option 1: Enable. This option locks up the reflex mirror for close-up and telephoto images to prevent mirror reflex vibrations that can cause blur. When this option is enabled, you press the Shutter button once to swing up the mirror, and then press it again to make the exposure.

The mirror remains locked for 30 seconds and then automatically flips down if you do not press the Shutter button to make the image. If you combine mirror lockup with the 10- and 2-second Self-timer modes, the optional Timer Remote Controller TC-80N3 or the Remote Switch RS-80N3, and a tripod, you can ensure rock-solid shooting.

When you use mirror lockup with bright subjects such as snow, bright sand, the sun, and so on, be sure to take the picture right away to prevent the camera curtains from being scorched by the bright light.

C.Fn IV: Operation/Others

This group of functions enables you to change the functionality and behavior of some camera buttons. It also includes options for adding image verification data and aspect ratio information.

C.Fn IV-1: Custom Controls

For any photographer who wants to customize virtually everything on the camera, this function is a wish come true. With a diagram of the camera provided on this Custom Function screen, you can change the function of AF, exposure, image, and operation buttons on the camera at will.

Following are brief descriptions of the changes you can make. The 7D Instruction Manual provides more detail and a chart that is useful in reassigning button functions.

5.3 The Custom Controls main screen

Because this screen is different from the majority of other Custom Function screens, here are the steps for making choices for Custom Control:

- 1. Set the Mode dial to P, Tv, Av, M, or B, and then press the Menu button.
- Turn the Main dial to highlight the Custom Functions tab, turn the Quick Control dial to highlight C.FnIV:Operation/Others, and then press the Set button. The last Custom Function you accessed in this group is displayed.
- Turn the Quick Control dial until the number 1 is displayed in the number control box in the upper right corner of the screen. The C.FnIV:Operation/ Others Custom Controls screen appears.
- **4. Press the Set button to activate the Custom Controls.** A camera diagram with controls and functions is displayed.

- 5. Turn the Quick Control dial to highlight the name of the button or dial you want to customize, and then press the Set button. The camera button or dial screen appears with the functions that you can assign to the button or dial.
- 6. Turn the Quick Control dial to select the function you want to assign to the button or dial, and then press the Set button.
 - a. If the INFO. button appears, press the INFO. button on the back of the camera to display a second screen with additional options you can set.
 - b. On the second screen, select the options you want, and then turn the Quick Control dial to select OK. If the OK button displays a right-pointing arrow, select the OK button by pressing the Set button to display a third screen with additional options that you can set. Repeat this process until the OK button no longer displays a right-pointing arrow.
- 7. Press the Set button to exit the screen and continue setting additional Custom Controls.

Here are the Custom Controls that you can reassign and the functions that you can assign to them:

- Shutter button half-press (Metering and AF start). Instead of metering and focusing when you half-press the Shutter button, you can assign a half-press of the Shutter button to only meter, or to set AE Lock. You can also add the function to switch to a registered AF point (detailed later in this section).
- AF-ON button. Instead of metering and focusing when you press the AF-ON button, you assign the AF-ON button functionality to AE lock, AF-OFF, FEL (Flash Exposure Lock), or OFF (disable the button use). If you choose metering and AF start, you can press the INFO. button to set the AF start point as either a manually selected AF point or the registered AF point. To set a registered AF point, see the sidebar in this chapter.
- AE Lock button. Instead of setting AE Lock when you press the AE Lock button, you can assign the AE Lock button functionality to start metering and focusing, AF stop, Flash Exposure Lock, or choose OFF to disable the button entirely.
- Depth of field preview. Instead of previewing the depth of field (DOF) when pressing the Depth of field button, you can assign this button to AF-OFF (AF stop), AE Lock, One Shot/AI Servo switching, IS (Image Stabilization) start, or to switch to the registered AF func. (function).

If you assign One-shot/Al Servo functionality to a button, you can hold down the button to switch from the current autofocus mode to the other mode. If you're in Al Servo mode, the camera switches to One-shot AF only while the button is depressed.

If you choose to switch to a Registered AF function, then press the INFO. button to register one of the following AF functions: Manual select.: Spot AF; Manual select.: Single point AF; Man. Select.: AF point expansion; Manual select.: Zone AF, or Auto select.: 19 point AF.

When you choose OK, you can continue by setting the Al Servo tracking sensitivity to Slow, Medium slow, Standard, Medium fast, or Fast, Choose OK, and then you can set Al Servo 1st/2nd img (image) priority. The options you can choose are AF priority/Tracking priority, AF priority/Drive speed prio (priority), Release/Drive speed priority, or Release/Tracking priority. Click OK, and then you can set the AI Servo AF tracking method to either Main focus point priority or Continuous AF track (tracking) priority. Then click OK to return to the DOF preview button screen

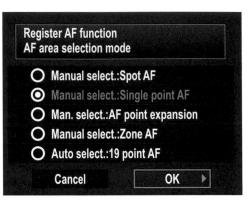

5.4 The Register AF function AF area selection mode options screen

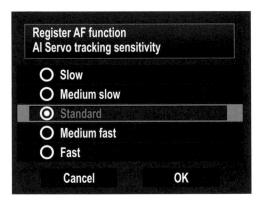

5.5 The Register AF function Al Servo tracking sensitivity options screen

Lens AF Stop button. The AF stop button is found only on super telephoto IS lenses. You can change the default AF-OFF button functionality to metering and AF start, AE Lock, to switch between One Shot/AI Servo focusing modes, to start IS (Image Stabilization on the lens), or to switch to a registered AF function. If you choose to switch to a registered AF function, you can press the INFO. button to register AF functions as well as the additional options that are described in the previous depth of field preview description.

How to Register an AF Point

To register an AF point, follow these steps:

- 1. Set the AF area selection mode to Single point AF, Spot AF, or AF point expansion. You cannot register an AF point using Zone AF or 19-point AF auto area selection modes.
- 2. Press the AF-point selection/Magnify button on the back top right of the camera, and then turn the Main dial to manually select the AF point you want to register.
- **3. Hold the AF-point selection/Magnify button and press the LCD panel illumination button above the LCD panel.** A beep sounds to indicate that the AF point is registered. The registered AF point is displayed as a small square. If you set C.Fn III-12, Orientation linked AF point to Option 2 to automatically select the AF area selection mode and AF point for vertical and horizontal camera orientation, you can register the AF point for each camera orientation.
- 4. Press the AF-On or AE Lock button that's been assigned to this function to have the camera switch to the registered AF point in the current AF area selection mode. In Zone AF area selection mode, the camera switches to the zone that contains the registered AF point. To cancel AF point registration, choose clear all Camera settings on the Setup 3 menu.
- M-Fn (Multi-function) button. You can assign the M-Fn (Multi-function) button to AE lock, (One-touch) RAW-JPEG, or VF electronic level.
- Set. You can assign the Set button to display the Image quality screen, Picture Styles screen, camera menu, begin image playback, or to display the Quick Control screen (the Q button functionality).
- Main dial. You can change the function of the Main dial in Manual mode from setting the shutter speed to setting the aperture.
- Quick Control dial. You can change the function of the Quick Control dial in Manual mode from setting the aperture to setting the shutter speed or to select the AF point manually.
- Multi-controller. You can set the Multi-controller to use it for selecting an AF point without first pressing the AF-point selection/Enlarge button. If you choose AF point selection, then press the INFO. button to display options for the

functionality of the Multi-controller when you press the center of the controller. You can choose to have it switch to the center AF point or to the registered AF point. See the sidebar in this section to register an AF point.

C.Fn IV-2: Dial direction during Tv/Av

This function offers options that allow you to reverse the direction for setting shutter speed and aperture in Tv and Av modes. And in Manual mode, you can reverse the dial direction of both the Quick Control and Main dials.

- ► Option 0: Normal. When you turn the Main dial clockwise in Tv or Av mode, the shutter speed or aperture increases. In Manual mode, the Main dial changes the shutter speed and the Quick Control dial changes the aperture.
- Option 1: Reverse direction. In Tv and Av shooting modes, the Main dial direction is reversed for setting shutter speed and aperture. In Manual mode, the directions of the Main and Quick Control dials are reversed. In other shooting modes, the Main dial direction is reversed. However, the Quick Control dial direction is not changed in Manual mode and for setting Exposure Compensation.

C.Fn IV-3: Add image verification data

When this option is turned on, data is appended to verify that the image is original and has not been changed. This is useful when images are part of legal or court proceedings. The optional Data Verification Kit OSK-E3 is required.

- Option 0: Disable. No verification data is appended.
- Option 1: Enable. This option appends data to verify that the image is original or not. During image playback, a lock icon denotes verification data. To verify the image originality, the optional Original Data Security Kit OSK-E3 is required.

C.Fn IV-4: Add aspect ratio information

This function allows you to set an aspect ratio to images shot in Live View to simulate medium- and large-format film sizes. As a composition aid for the selected aspect ratio, the camera displays vertical lines on the LCD Live View image. The vertical lines also display during image playback. If you choose to add aspect ratio information, images are not altered, but when you open them in Canon's Digital Photo Professional program, it will display the image in the selected aspect ratio.

- **Option 0: Off.** No aspect ration information is added to Live View images.
- Option 1: Aspect ratio 6:6
- Option 2: Aspect ratio 3:4

- Option 3: Aspect ratio 4:5
- Option 4: Aspect ratio 6:7
- Option 5: Aspect ratio 10:12
- Option 6: Aspect ratio 5:7

Live View shooting is detailed in Chapter 6.

Setting Custom Functions

After reviewing the functions and options, there may be specific functions that you can identify immediately as being helpful for your daily shooting. Other functions such as mirror lockup are ones that you will use in scene-specific shooting. Still others you can set and forget about, or change based on specific shooting circumstances.

You may also find that combinations of functions are useful for specific shooting situations. Whether used separately or together, Custom Functions can significantly enhance your use of the 7D.

To set a Custom Function, follow these steps:

- 1. Set the Mode dial to P, Tv, Av, M, or B.
- 2. Press the Menu button, and then turn the Main dial to display the Custom Functions menu.
- 3. Turn the Quick Control dial to highlight the Custom Functions (C.Fn) group you want, and then press the Set button. The Custom Functions screen with the function group that you selected appears.
- 4. Turn the Quick Control dial until the Custom Function number you want is displayed in the number control box at the top right corner of the screen, and then press the Set button. The first Custom Function option is activated.
- 5. Turn the Quick Control dial to highlight the option you want, and then press the Set button. You can refer to the descriptions earlier in this chapter to select the function and option number that you want. Repeat steps 3 and 4 to select other Custom Function groups, functions, and options.

If you want to reset one of the Custom Functions, repeat these steps to change it to another setting or the default setting.

However, if you want to restore all the Custom Functions to the default settings, repeat steps 1 and 2, and in step 3, highlight Clear all Custom Functions (C. Fn), press the Set button, and then choose OK. All Custom Functions are restored to their defaults.

Registering Camera User Settings

With Camera User Settings, denoted as C1, C2, and C3 on the Mode dial, you can preset the EOS 7D with your favorite shooting mode, exposure settings, drive and autofocus modes, and Custom Functions, and then make only minimal adjustments when you are ready to start shooting. The C modes enable you to use those specific settings by simply switching to the C1, C2, or C3 mode on the Mode dial. And you are not locked into the setting that you register because you can still change the settings as you shoot.

It does not take long to think of a plethora of ways to use C modes. For example, C1 mode could be set up for shooting nature and landscape with the camera preset to Av mode, exposure bracketing, mirror lockup, as well as to your favorite drive, autofocus, and exposure modes, and Picture Style. Then C2 mode is open for presetting the camera for portraits, weddings, concerts — you name it. Without question, C modes offer a way to spend less time adjusting camera settings and more time shooting.

If you have forgotten what settings you registered for any of the C modes, just press the INFO. button to display the current camera settings.

When you register camera settings, the following settings are saved and recalled when you set the Mode dial to the C mode under which you registered them:

Shooting settings. These shooting settings are saved in C modes:

Shooting mode, ISO, aperture, shutter speed, AF mode, AF point, AF area selection mode and setting, AF-point Selection mode, metering and drive mode, exposure compensation, and flash exposure compensation.

• Menu settings. These menu settings are saved in C modes:

Image quality, red-eye setting, beep, release shutter without card, review time, Peripheral illumination correction, flash control settings, exposure compensation, AEB, Auto Lighting Optimizer, white balance, Custom White Balance, white balance shift and bracketing, color space, Picture Style,

One-touch RAW+JPEG, highlight alert, AF point display, histogram, slide show, image jump settings, auto power off, auto rotate, file numbering, LCD brightness, sensor cleaning, VF grid display, INFO. button display options, and Custom Function settings.

Live View shooting settings. These menu settings are saved in C modes:

Live View shooting, AF mode, Grid display, exposure simulation, Silent shooting, and metering timer

Movie mode settings. These settings are saved in C modes:

AF mode, Grid display, movie recording size, sound recording, Silent shooting, and metering timer

Here is how to register camera user settings to C1 or C2 mode:

- With the camera set to P, Tv, Av, M, or B mode, choose all the settings on the camera that you want to register. In addition to shooting, exposure, metering, focus, drive, and menu settings, you can set Custom Functions for specific shooting scenarios as detailed previously in this chapter.
- 2. Press the Menu button, and then turn the Main dial to highlight the Setup 3 tab.
- **3.** Turn the Quick Control dial to highlight Camera user setting, and then press the Set button. The Camera User setting screen appears.
- 4. Turn the Quick Control dial to highlight Register, and then press the Set button. The Register screen appears.
- **5. Turn the Quick Control dial to highlight the Mode dial option you want.** Your options are Mode dial: C1, Mode dial: C2, or Mode dial: C3.
- 6. Press the Set button. A second Register screen appears.
- 7. Turn the Quick Control dial to highlight OK, and then press the Set button. The Set-up 3 menu appears. The camera registers the settings except for the My Menu settings. Lightly press the Shutter button to dismiss the menu.
- 8. To shoot with the registered settings, turn the Mode dial to the C1, C2, or C3 mode depending on the option you selected in step 5. When you shoot in a C mode, neither the clear all Camera settings on the Set-up 3 menu nor the clear all Custom Func. (C.Fn) option on the Custom Function menu can be used. To use these menu options, switch to P, Tv, Av, M, or B shooting mode first.

If you want to clear the registered user settings, follow these steps:

- 1. Set the camera to P, Tv, Av, M, or B shooting mode, and then repeat steps 2 to 3 in the previous set of steps.
- 2. Turn the Quick Control dial to highlight Clear settings, and then press the Set button. The Clear settings screen appears.
- **3. Turn the Quick Control dial to highlight the C mode that you want to clear, and then press the Set button.** For example, select Mode dial: C2 to clear the C2 Mode dial settings. The Clear settings screen appears.
- **4.** Turn the Quick Control dial to highlight OK, and then press the Set button. The camera clears the registered settings for the C mode that you selected.

Customizing My Menu

Customization of the 7D includes the ability to set up My Menu with your most frequently used six menu items and options. In addition to frequently used menu items, you can also add your most-often used Custom Functions to My Menu. This will save you a lot of time.

In addition to adding and deleting items to and from My Menu, you can change the order of registered items by sorting them. You can also set the 7D to display My Menu first when you press the Menu button. The only drawback to My Menu is that you can only register six items. So before you begin registering, evaluate the menu items and Custom Functions and carefully choose your six favorite items.

As an example, here is what I have registered on My Menu: Custom WB, Format, Grid display, Flash control, Camera user settings, and High ISO speed noise reduction. I have also set up My Menu as the first menu that is displayed when I press the Menu button.

Here is how to add items to My Menu:

- 1. With the camera in P, Tv, Av, M, or B mode, press the Menu button, and then turn the Main dial to highlight the My Menu tab. The My Menu tab is the last tab.
- 2. If necessary, turn the Quick Control dial to highlight My Menu settings, and then press the Set button. The My Menu settings screen appears.

- 3. Turn the Quick Control dial to highlight Register, and then press the Set button. The My Menu registered item screen appears. This screen is a scrollable list of all menu items available on the camera. You can scroll through the list by turning the Quick Control dial.
- 4. Turn the Quick Control dial to highlight the menu item you want to register, and then press the Set button. The My menu registered item screen appears.
- 5. Turn the Quick Control dial to highlight OK, and then press the Set button. The My Menu registered item screen reappears so that you can select the next item. To find individual Custom Functions, keep scrolling past the C.Fn group names, and you see the individual Custom Functions by name (the function numbers are not listed).
- 6. Repeat step 5 until all the menu items you want are registered, and then press the Menu button. The My Menu settings screen appears. If you want to sort your newly added items, jump to step 2 in the following set of steps.

To sort your registered camera Menu items and Custom Functions, follow these steps:

- 1. Repeat steps 1 and 2 in the previous list if necessary.
- 2. On the My Menu settings screen, turn the Quick Control dial to highlight Sort, and then press the Set button. The Sort My Menu screen appears.
- **3.** Press the Set button if you want to move the first menu item to a different position in the list. The camera activates the sort control represented by a arrows to the right side of the menu item.
- 4. Turn the Quick Control dial to move the item's placement within the menu, and then press the Set button. Turn the Quick Control dial to move the selected item up or down in the list.
- 5. Repeat steps 3 and 4 to move other menu items in the order that you want.
- **6.** Press the Menu button twice to display your customized menu. Or lightly press the Shutter button to dismiss the menu.

You can follow these general steps to access My Menu settings where you can delete one or all items from the menu, and to have My Menu displayed each time you press the Menu button.

Now you have a good idea of how you can set up the 7D not only to make it more comfortable and efficient for your preferences, but also to have the camera ready in advance for different shooting scenes and subjects.

CHAPTER

Shooting in Live View and Tethered

Live View shooting enables you to view, compose, and focus using a real-time view of the scene on the camera's 3-inch LCD monitor. Alternately, you can shoot with the 7D connected (*tethered*) to the computer, and then control image settings ranging from focus and exposure to white balance and Picture Style on the computer by using the EOS Utility program from Canon. Live View and tethered shooting give you added flexibility in shooting scenarios that normal shooting doesn't provide.

Live View offers a view that can be magnified up to 10x to ensure tack-sharp automatic or Manual Focus as well as a face-detection focusing option. Live View also offers two Silent modes to reduce shutter noise. While Live View shooting is not the best choice for all shooting scenes, it is a good choice in controlled and close-up shooting scenarios such as macro and still-life shooting as well as in scenes where you cannot get the shot by looking through the viewfinder.

With tethered shooting, you have the advantage of using a large computer monitor to view and control the exposure and color of the image as you shoot. In addition, you can monitor the histogram to ensure that pixels aren't being clipped, or discarded, as you change the lighting. The Live View shooting function is also useful when shooting tethered or wirelessly in the studio.

About Live View Shooting

While Live View shooting is a staple feature on point-and-shoot digital cameras, it is a relatively new feature for digital SLR cameras such as the 7D. In fact, the concept of a digital SLR being able to hold the shutter open to give you a real-time view of the scene and yet pause long enough to focus is impressive. Normally, the camera can't see the live scene because the shutter and reflex mirror block the view to the image sensor. The 7D overcomes this blind spot with a mechanical shutter that stays completely open during Live View shooting.

Live View offers some advantages that you don't get with non-Live View shooting. For example, because the first-curtain shutter is electronic, the shutter cocking noise can be reduced. Live View also offers face detection that automatically identifies faces in the scene and focuses on one of the faces. If it focuses on the wrong face, you can shift the selection by using the Multi-controller to choose the correct subject. And you can use the supplied or an accessory cable to connect the 7D to a TV and see Live View on the TV screen.

Although Live View shooting has high coolness factor, it comes at a price with a few side effects:

- Temperature affects the number of shots you can get using Live View. With a fully charged LP-E6 battery, you can expect 230 shots without flash use and approximately 220 shots with 50 percent flash use in 73-degree temperatures. In freezing temperatures, expect 220 shots without flash use and 210 shots with 50 percent flash use per charge. With a fully charged battery, you get approximately one-and-a-half hours of continuous Live View shooting before the battery is exhausted.
- High ambient temperatures, high ISO speeds, and long exposures can cause digital noise or irregular color in images taken using Live View. Before you start a long exposure, stop shooting in Live View and wait several minutes before shooting. With continual use of Live View, the sensor heats up quickly. Both high

internal and external temperatures can degrade image quality and cause Live View to automatically shut down until the internal temperature is reduced.

An icon that resembles a thermometer is displayed on the LCD when internal and/or external temperatures are high enough to degrade image quality. If the icon appears, it's best to stop shooting until the temperature cools down. Otherwise, the camera will automatically stop shooting if the internal temperature gets too high. Additionally, high ISO settings combined with high temperatures can result in digital noise and inaccurate image colors.

The Live View may not accurately reflect the captured image in several different conditions. Image brightness may not be accurately reflected in low- and bright-light conditions. If you move from low to a bright light and if the LCD brightness level is high, the Live View may display *chrominance* (color) *noise*, but the noise will not appear in the captured image. Suddenly moving the camera in a different direction can also throw off accurate rendering of the image brightness. If you capture an image in magnified view, the exposure may not be correct. And if you focus and then magnify the view, the focus may not be sharp.

Live View features and functions

While some key aspects of Live View shooting differ significantly from standard shooting, other aspects carry over to Live View shooting. For example, you can use the LCD panel functions during Live View shooting to change White Balance settings, Drive modes, ISO sensitivity settings, and so on. Likewise, you can press the INFO. button one or more times to change the display to include more or less shooting information along with a Brightness histogram or RGB histograms. The following sections give you a high-level view of setting up for and using Live View shooting.

Live View focus

With the 7D's large and bright LCD monitor, you can use Live View shooting to get tack-sharp focus. Here is an overview of the Live View focusing options so that you can decide in advance which is best for the scene or subject that you are shooting:

AF mode	Live mode
	C Live mode
	Quick mode

6.1 These are the focusing mode options that are available on the Shooting 4 menu.

- Live mode. With this focusing option, the camera's image sensor detects subject contrast to establish focus. This focusing mode keeps the reflex mirror locked up so that the Live View on the LCD is not interrupted during focusing. However, focusing takes longer with Live mode. To focus in this mode, tilt the Multi-controller to move the focusing point over the subject, and then press the Shutter button halfway to focus. The AF point turns green when focus is achieved.
- Face Detection Live mode. This is the same as Live mode except that the camera automatically looks for and focuses on a human face in the scene. If the camera does not choose the face of the subject you want, you can tilt the Multi-controller to move the focusing frame to the correct face. If the camera cannot detect a face, then the AF point reverts to the center AF point, and you can manually move the AF point to a face.

If the person is a long way from the camera, you may need to manually focus enough to get the subject in reasonable focus range, and then focus by halfpressing the Shutter button. Face detection does not work with extreme closeups of a face, if the subject is too far away, too bright or dark, partially obscured, or is tilted horizontally or diagonally. In Face Detection Live mode, you can't magnify the image on the LCD using the AF-point selection/Magnify button. In both Live and Face Detection Live modes, focus at the edges of the frame is not possible and the face focusing frame is grayed out.

- Quick mode. This focusing mode uses the camera's autofocus system. In this mode, the Live View on the LCD is suspended as the reflex mirror drops down long enough for the camera to establish focus. With Quick mode focusing, you can activate the 19 AF points by tilting the Multi-controller. You can use the M-Fn button to select an AF area selection mode, and then select an AF point by turning the Main or Quick Control dials or using the Multi-controller. Then half-press the Shutter button to focus and make the picture.
- Manual Focus. This focusing option is the most accurate, and you get the best results when you magnify the image. Another advantage is that Live View is also not interrupted during focusing. To focus manually, set the lens switch to MF (Manual Focus), and then move the focusing frame wherever you want by tilting the Multi-controller. Turn the focusing ring on the lens to focus.

If you use Live View with Continuous shooting, the exposure is set for the first shot and is used for all images in the burst.

Exposure simulation and metering

Live View shooting provides exposure simulation that replicates what the final image will look like at the current shutter speed, aperture, and other exposure settings on the LCD during Live View display. You can turn on Exposure Simulation on the Shooting 4 menu. Exposure simulation is nice, but the image may be easier to see at standard brightness without using Exposure Simulation.

For Live View, the camera uses Evaluative metering. Unlike standard shooting, the most recent meter reading is maintained for a minimum of 4 seconds even if the lighting changes. You can set how long the camera maintains the current exposure by setting the Live View Metering timer from 4 seconds to 30 minutes. If the light or your shooting position changes frequently, set a shorter meter time. Longer meter times speeds up Live View shooting operation, and longer times are effective in scenes where the lighting remains constant.

Auto Lighting Optimizer automatically corrects underexposed and low-contrast images. If you want to see the effect of exposure modifications, then turn off Auto Lighting Optimizer on the Shooting 2 menu.

Silent shooting modes

Live View shooting offers two Silent shooting modes. In either Silent mode 1 or 2, the shutter noise is noticeably reduced. Following is a summary of the two Silent shooting modes and the Disable option:

- Mode 1. In this mode, the shutter cocking noise is reduced significantly when using the Live focus mode. This mode enables high-speed continuous shooting at 7 fps by holding down the Shutter button completely.
- Mode 2. This mode delays shutter noise as long as you keep the Shutter button pressed, thus delaying the re-cocking sound of the shutter. If the camera is in Continuous drive mode, only one image is made because the shutter does not re-cock until you release the Shutter button.
- Disable. This is the setting to choose if you use a *tilt-and-shift* (TS-E) lens and make vertical shift movement, or if you use an extension tube on the lens. Pressing the Shutter button sounds like two images are being taken, but only one image is made. Choose this option if you are using a non-Canon flash, otherwise the flash will not fire.

Using a flash

When shooting in Live View with the built-in flash, the shooting sequence (after fully pressing the Shutter button) is for the reflex mirror to drop to allow the camera to gather the preflash data. The mirror then moves up out of the optical path for the actual exposure. As a result, you hear a series of clicks, but only one image is taken. Here are some things you should know about using Live View shooting with a flash unit:

- With an EX-series Speedlite, FE Lock, modeling flash, and test firing cannot be used except for wireless flash shooting.
- Flash Exposure Lock cannot be used with the built-in or an accessory Speedlite.
- If you are using a Canon Speedlite and have the camera set to Silent mode 1 or 2, the camera automatically switches to the Disable option. Non-Canon flash units do not automatically switch to Disable, so you must manually set the camera to Disable.

Setting up for Live View Shooting

The settings on the Shooting 4 menu not only activate Live View shooting, but they also enable you to set your preferences for shooting in this mode, including enabling Live View shooting, displaying a grid in the LCD, setting up Silent modes, and setting the Exposure metering timer.

To set up the 7D for Live View shooting and to set your preferences, follow these steps:

지 때 때 <mark>이 키 키 키 키 키 이</mark> 때 때		
Live View shoot.	Enable	
AF mode	Quick mode	
Grid display	Grid 1 🗰	
Expo. simulation	Enable	
Silent shooting	Mode 1	
Metering timer	16 sec.	

6.2 These are the options that you can set for Live View shooting on the Shooting 4 menu.

- 1. With the Mode dial set to P, Tv, Av, M, or B, press the Menu button, and then turn the Main dial to select the Shooting 4 tab.
- 2. Turn the Quick Control dial to highlight Live View shoot., and then press the Set button. The Live View shooting options appear.

- **3.** Turn the Quick Control dial to select Enable, and then press the Set button. The Shooting 4 menu is displayed.
- 4. On the Shooting 4 menu, turn the Quick Control dial to highlight any of the following options, and then press the Set button to display the settings you can select.
 - **AF mode:** Select Live mode, Face Detection Live mode, or Quick mode, and then press the Set button.
 - **Grid display:** Select a 3 × 3 or 4 × 6 grid to help you align horizontal and vertical lines in the scene. Or select Off if you do not want to use a grid, and then press the Set button.
 - **Exposure simulation:** Choose Enable to see an approximation of the final exposure on the screen. Otherwise, choose Disable, and then press the Set button.
 - **Silent shooting:** Choose Mode 1 to reduce the sound of the shutter. Choose Mode 2 to delay the sound of the shutter until you release the Shutter button. Choose Disable if you are using a non-Canon flash unit, a tilt-and-shift lens, or a lens extender. Then press the Set button.
 - **Metering timer:** Choose 4, 16, or 30 seconds, or 1, 10, or 30 minutes to determine how long the camera retains the exposure. If the light changes often, choose a shorter time. Then press the Set button.

Working with Live View

Now that you've chosen the focusing mode and selected the shooting options, you're ready to begin shooting. Here are a few tips to get you started:

- ► For still life and macro shooting, manual focusing with the image enlarged to 5 or 10x helps ensure tack-sharp focus.
- For a really large view, tether the camera to your laptop using the supplied USB cable, or use the Wireless File Transmitter WFT-ED/WFT-E3A/B/C/D. Or you can hook up the camera to the TV and use the TV screen as a monitor.

See Chapter 2 for details on connecting the 7D to a TV.

Just a few minutes of watching the real-time view will convince you that a tripod is necessary for Live View shooting. With any focal length approaching telephoto, Live View provides a real-time gauge of just how steady or unsteady your hands are.

Shooting in Live View

The operation of the camera during Live View shooting differs from traditional still shooting, but the following steps guide you through the controls and operation of the camera.

To shoot in Live View using autofocus, follow these steps:

- With the camera set to any shooting mode, turn the START-STOP switch to the camera icon (Live View setting), and then press the START-STOP button. A current view of the scene appears on the LCD.
- 2. Press the Q button to display the Information display. You can press the Q button a second time to display options to change the image quality and to change the Auto Lighting Optimizer setting by using the Multi-controller. Press the Q button again to return to the Live View with the information display.
- 3. Press the INFO. button one or more times to display to show more or less informa-

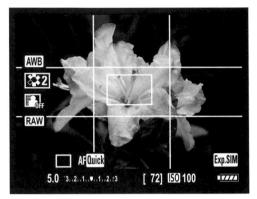

6.3 The Live View screen displays whether exposure simulation is active, as well as the focus mode, white balance, current Picture Style, the Auto Lighting Optimizer setting, and the image-recording quality. Exposure information is along the bottom of the frame. Here the large 3×3 grid is displayed.

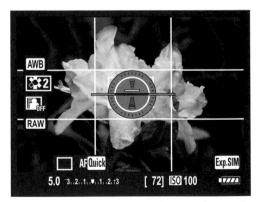

6.4 The Live View screen with the electronic level displayed

tion, and to display the electronic level, the histogram, or the grid.

- 4. Press any of the buttons above the LCD panel to display the screen to display screens where you can change the white balance, drive mode, AF mode, and ISO. However, Evaluative metering is automatically set for Live View shooting, and you can't change it. The camera controls and buttons that you use in still shooting can be used during Live View shooting. For example, to set Exposure Compensation, press the Shutter button halfway, and then turn the Quick Control dial to set the amount of compensation. If you access the camera menus, then lightly press the Shutter button to restore the Live View on the LCD.
- Compose the image by moving the camera or the subject. As you move the camera, the exposure changes and is displayed in the bottom bar under the Live View display.
- 6. If you are using Quick mode to focus, turn the Main or Quick Control dial to select the AF point that you want. You can also press the M-Fn button to change the AF area selection mode.
- 7. Press the AF-point Selection/ Magnify button on the top far-right corner of the camera to magnify the view. The first press of the button enlarges the view to 5x, and a second press enlarges the view to 10x.

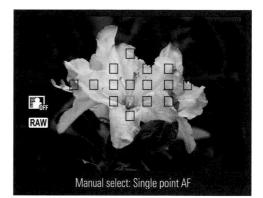

6.5 The Live View screen with the AF points displayed

The magnifications are shown on the LCD as X5 and X10. You cannot magnify the image if you're using Face Detection Live mode focusing.

- 8. Press the AF-ON button to focus. If you are using Quick mode to focus, when you press the AF-ON button, you hear the sound of the reflex mirror dropping down to focus and Live View is suspended. If you are using Live focusing mode, focus takes longer, and it is a good idea to magnify the image to verify sharp focus. In all focus modes, when the camera achieves sharp focus, the AF focus rectangle turns red.
- **9.** Press the Shutter button completely to make the picture. The shutter fires to make the picture, the image preview is displayed, and then Live View resumes.
- **10.** Press the Start-Stop button to go back to standard shooting mode. If you do not do this step, the camera automatically closes the shutter when the camera Auto Power Off (Set-up 1 menu) delay elapses.

Shooting Tethered or with a Wireless Connection

One of the most useful ways to use Live View shooting is for studio work, particularly when you shoot still-life subjects such as products, food, stock shots, and portraits. You can set up with the 7D connected to a computer using the USB cable supplied with the camera. The extra-long cord allows a good range of movement, particularly if the computer is on a wheeled or swivel table.

You can also shoot with the accessory Wireless File Transmitter WFT-E3/ WFT-E3A/B/C/D. For the following illustration, I use the supplied USB cable.

Before you begin, install the EOS Digital Solution Disk on the computer to which you are connecting the camera. To shoot in Live View with the 7D tethered to the computer, follow these steps:

 Turn off the camera and attach the USB cord to the Digital terminal located under the terminal cover on the side of the camera. Be sure that the icon on the cable connector faces the front side of the camera.

EOS 7D			
CONE SH			
Pictures	1 T		
Participation and the second second	and a star section of the section		
Av	F5.0		
AWB	¹⁰⁰ 100		
	. +0		
321 O	*1*2*3.		
▲ \$ \$\$	0 4		
Shooting me	enu		
Picture Style	User Def. 2		
Detail set.	3,0,0,0		
Register User Defined			
WB SHIFT	0,0		
Peripheral illumin. correct.			
Remote Live View	shooting		
Other Functions			
Preferences	Main Window		

6.6 The EOS Utility Remote Shooting control panel

- 2. Connect the other end of the USB cable to a USB terminal on the computer.
- Turn on the power switch on the camera. If this is the first time you've connected the camera to the computer, then the computer installs the device driver software and identifies the camera.

4. Click Camera settings/Remote shooting in the EOS Utility window. The EOS 7D control panel appears. You can use the panel to control exposure settings, set the white balance, set the Picture Style, and set White Balance Shift.

6.7 I set the white balance by clicking the White Balance eyedropper and clicking on the white background.

- 5. Click Preferences to set the options you want, such as choosing the destination folder in which to save captured images and whether to save the images both on the computer and on the CF card.
- 6. Click Remote Live View Shooting toward the bottom of the Remote Shooting control panel. The Remote Live View window appears and the camera reflex mirror flips up to preview the scene on the computer screen. In this window, you can set the white point by clicking a white area or neutral gray area in the scene, use the controls to set the focus, preview the depth of field by clicking the On button, and switch between the Brightness and RGB histograms as well as monitor the histogram as the camera moves or as lighting changes.

6.8 You can set the exposure settings such as the aperture pictured here.

6.9 You can set flash controls during tethered shooting.

- **7. Press the Shutter button completely to take the picture.** The Digital Photo Professional main window opens with the image selected.
- 8. When you finish, turn off the camera and disconnect the USB cable from the camera.

6.10 This is the final image taken in Live View shooting with Remote shooting using the EOS Utility with the camera tethered to a laptop. Exposure: ISO 100, f/11, 1/125 sec.

CHAPTER

Using Movie Mode

Movie mode on the EOS 7D opens a new avenue of creative expression. Now the visual stories that you capture with the 7D can be enriched with high-definition movies.

It is also to your advantage that the 7D's movie quality is among the best available. And it is packaged for you in a lightweight camera that accepts more than 60 lenses to enhance your videos in ways that traditional video cameras cannot.

This chapter is by no means exhaustive, but it is written to be a starting point for you as you explore the world of digital video with the 7D.

About Video

For still photographers, videography is like learning a new visual language. The language is different, but video shares with traditional still photography the aspect of creative communication. So with the 7D, you can spend time envisioning ways in which you can use still images with video to create multimedia stories.

If you are new to videography, then it is good to have a basic understanding of digital video and how it relates to the 7D.

Video standards

In the world of video, there are several industry standards, including the following resolutions: 720p, 1080i, and 1080p.

The numbers 720 and 1080 represent vertical resolution. The 720 standard has a resolution of 921,600 pixels, or 720 (vertical pixels) \times 1280 (horizontal pixels). The 1080 standard has a resolution of 2,073,600 pixels, or 1080 \times 1920. It seems obvious that the 1080 standard provides the highest resolution, and so you would think that it would be preferable. But that is not the entire story.

The rest of the story is contained in the *i* and *p* designations. The *i* stands for *interlaced*. Interlaced is a method of displaying video where each frame is displayed on the screen in two passes — first, a pass that displays odd-numbered lines, and then a second pass that displays even-numbered lines. Each pass is referred to as a *field*, and two fields comprise a single video frame. This double-pass approach was engineered to keep the transmission bandwidth for televisions manageable. And the interlaced transmission works only because our minds automatically merge the two fields, so that the motion seems smooth with no flickering. Interlacing, however, is the old way of transmitting moving pictures.

The newer way of transmitting video is referred to as *progressive scan*, hence, the *p* designation. Progressive scan quickly displays a line at a time until the entire frame is displayed. And the scan happens so quickly that you see it as if it were being displayed all at once. The advantage of progressive scanning is most apparent in scenes where either the camera or the subject is moving fast. With interlaced transmission, fast camera action or moving subjects tend to blur between fields. That is not the case with 720p, which provides a smoother appearance. So while 1080i offers higher resolution, 720p provides a better video experience, particularly when there are fast-action scenes.

Another piece of the digital video story is the frame rate. In the world of film, a frame rate of 24 frames per second (fps) provided the classic cinematic look of old movies. In the world of digital video, the standard frame rate is 30 fps. Anything less than 24 fps, however, provides a jerky look to the video. The TV and movie industries use standard frame rates, including 60i that produces 29.97 fps and is used for NTSC; 50i that produces 25 fps and is standard for PAL, which is used in some parts of the world; and 30p that produces 30 fps, which produces smooth rendition for fast-moving subjects.

Videographers who want a cinematic look prefer cameras that convert or *pull down* 30 fps to 24 fps.

With this very brief background on video, it is time to look at the digital video options on the 7D.

Video on the 7D

By now, you probably have questions, like how does the 7D compare to industry standards, how long you can record on your CF card, and how big the files are. Following is a rundown of the digital video recording options that you can choose on the 7D.

- Full HD (Full High-Definition) at 1920 × 1080p at 30 (actual 29.97), 25 (when set to PAL), or 24 (actual 23.976) fps. You get about 12 minutes of recording time with a 4GB card and about 49 minutes with a 16GB card. The file size is 330MB per minute. Full HD enables you to use HDMI output for HD viewing of stills and video.
- HD (High-Definition) at 1280 × 720p at 60 (actual 59.94) and 50 (when set to PAL) fps. You get about 12 minutes of recording time with a 4GB card, and 49 minutes with a 16GB card. The file size is 330MB per minute.
- SD (Standard recording) at 640 × 480 at 60 (actual 59.94) or actual 50 fps when set to PAL. You get 24 minutes of recording time with a 4GB card, and 1 hour and 39 minutes with a 16GB card. The file size is 165MB per minute.
- There is a 4GB limit to single movie clips, and the clips are H.264-comperessed movie files with a .mov file extension. At 1080p and 720p, clips run approximately 12 minutes depending on ISO and movie content and movement. You can also trim the beginning and end of a clip in the camera. Videos can be viewed in the Apple's QuickTime Player.

NTSC is the standard for North America, Japan, Korea, Mexico and other countries. PAL is the standard for Europe, Russia, China, Australia, and other countries.

So you have two high-quality video options, albeit at different frame rates. The 30 fps option is the traditional recording speed for online use whereas the actual 29.97 speed is the TV standard in North America. As a result, the 30 fps option is suitable for materials destined for DVD or display on a standard definition or HDTV. Although 24 fps may be more film like, it can produce jerky motion for subjects that are moving, and it requires slower shutter speeds of around 1/50 second. In addition, the actual 29.97 frame rate makes it easier to sync audio when it is recorded separately using a video-editing program.

Here are other aspects to consider when shooting video:

- Audio. You can use the 7D's built-in monaural microphone, which is adequate if you do not want to invest in a separate audio recorder and microphone. The audio is 16-bit at a sampling rate of 48 kHz and is output in mono. If you use the built-in microphone, be aware that all of the mechanical camera functions are recorded, including the sound of the Image Stabilization function on the lens, and the focusing motor. The microphone features a wind-cut filter that is on at all times when using the internal microphone. You cannot control the recording volume.
- Exposure and camera settings. Video exposure offers full manual exposure control with the slowest shutter speed being linked to the frame rate. For example, the slowest frame rate at 60 or 50 fps is 1/60 second. And at all resolutions, the maximum shutter speed is 1/4000 second. ISO can be set automatically or manually. Manual settings range from 100 to 6400. To use manual exposure, set the Mode dial to M.

You can use fully automatic exposure with the 7D setting the aperture, shutter speed, and ISO automatically. You can, as well, use AE Lock and set Exposure Compensation of +/-3 stops. To enable auto exposure, set the Mode dial to any mode except M. You can change the focus mode, Picture Style, white balance, recording quality, and still image quality before you begin shooting in Movie mode.

Battery life. At normal temperatures, you can expect to shoot for 1 hour 20 minutes, with the time diminishing in colder temperatures.

- ▶ Video capacities and cards. The upper limit is 4GB of video per movie. When the movie reaches the 4GB point, the recording automatically stops. You can start recording again, provided that you have space on the card, but the camera creates a new file. As the card reaches capacity, the 7D warns you by displaying the movie size and time remaining in red. Also, Canon recommends a UDMA card with an 8 MB/sec. or faster write speed. Slower cards may not provide the best video recording and playback.
- Focusing. You have the same options for focusing as you have in Live View shooting. In Quick mode, the reflex mirror has to flip down to establish focus, and this blackout is not the best video experience. However Quick mode focus-ing can be suitable for an interview or other still subject where you can set the focus before you begin recording.

For more details on Live View focusing options, see Chapter 6.

- Still-image shots during recording. You can capture, or grab, a still image at any time during video recording by pressing the Shutter button completely. This results in a 1-second pause in the video and a full-resolution still image. The still image is recorded to the card as a file separate from the video. The still image is captured at the image-quality setting that was previously set for still-image shooting, and the camera automatically sets the aperture and shutter speed or manually if you're shooting in M mode, and the built-in flash is not used. The white balance, Picture Style, and quality settings that it is set for shooting in P, Tv, Av, M, and B shooting modes are used for still images.
- ▶ Frame grabs. You can opt to pull a still image from the video footage rather than shooting a still image during movie recording. If you shoot at 1920 x 1080, frame grabs are limited to approximately 2 million pixels. Also because the shutter speeds during automatic exposure tend to be slow to enhance video movement, frame grabs can appear blurry.

Recording and Playing Back Videos

Some of the setup options for Movie shooting are the same as or similar to those offered in Live View shooting. In particular, the focusing modes are the same in both cases.

Before you begin shooting, set up the options you want. When the video is recorded, you have several options for playback, as described in the following sections.

Setting up for movie recording

To set up for movie shooting, you can choose the movie recording size, the focusing mode, and whether to record audio using the built-in speaker. As with Live View shooting, you can also display a grid to line up vertical and horizontal lines, set the amount of time the camera retains the last metering for exposure, and whether to use a remote control.

AF mode	Live mode
Grid display	Grid 1 #
Movie rec. size	1920x1080 T30
Sound recording	On
Silent shooting	Mode 1
Metering timer	16 sec.

7.1 The Movie shooting mode menu

Be sure to review Chapter 6 for details on the focusing modes, grid display, Silent shooting modes, and Metering timer because the same options are used in Movie mode shooting.

To set up options for shooting movies, follow these steps:

- 1. With the Mode dial set to P, Tv, Av, M, or B, press the Menu button, set the switch for the START-STOP button to the movie (icon) setting. The reflex mirror flips up and a current view of the scene appears on the LCD.
- 2. Press the Menu button, and then turn the Main dial to select the Shooting 4 menu.
- 3. On the Shooting 4 menu, turn the Quick Control dial to highlight any of the following options, and then press the Set button to display the settings you can select.
 - **AF mode:** Select Live mode, Face Detection Live mode, or Quick mode, and then press the Set button.
 - **Grid display:** Select a 3 × 3 or 4 × 6 grid to help you align horizontal and vertical lines in the scene. Or select Off if you do not want to use a grid, and then press the Set button.
 - Movie rec. size: Choose 1920 x 1080 at 30 fps, 1920 x 1080 at 24 fps, 1280 x 720 at 60 fps, or 640 x 480 at 60 fps. Then press the Set button.

- Sound recording: Choose On or Off, and then press the Set button.
- **Silent shooting:** Choose Mode 1, Mode 2, or Disable, and then press the Set button.
- **Metering timer:** Choose 4, 16, or 30 seconds, or 1, 10, or 30 minutes to determine how long the camera retains the exposure. If the light changes often, choose a shorter time. Then press the Set button.

Recording movies

To get a feel for shooting, you may want to record your first movies using automatic exposure, and then move into manual exposure shooting. Preparation is also important. Here are a few things to do before you begin shooting a movie.

- Focus on the subject first. While you can reset focus during shooting, it creates a visual disconnect that isn't optimal. This is especially important if you use Quick focusing mode where the reflex mirror flips down to establish focus.
- Plan the depth of field. One advantage of movie mode on any digital SLR is that you can create a shallow depth of field that isn't possible with video camera if you are recording with manual exposure. Thus, you can blur the foreground and background for creative effect. Plan ahead for the look you want.
- Make camera adjustments before recording. If you're using the built-in microphone, think through camera adjustments that you can make before you begin shooting to keep the camera sounds they produce to a minimum during recording. Be sure to set the Picture Style, white balance, recording quality, and so on before you begin shooting.
- Attach and test the accessory microphone. Stereo sound recording with an accessory microphone is possible by connecting the microphone with a 3.5mm-diameter mini plug that can be connected to the camera's external microphone IN terminal.
- Stabilize the camera. Use a tripod or specialized holding device for video shooting to ensure smooth movement. And if you stabilize the camera, turn off Image Stabilization (IS) on the lens if the lens has IS.

It's best to use a high-capacity CF card with a write speed of at least 8/MB per second.

Once the camera is set up, you can begin recording by following these steps.

- 1. Set the Mode dial to M if you want to manually control the exposure. If you want automatic exposure, set the Mode dial to any setting except M.
- **2.** Set the switch above the START-STOP button to the movie (icon) setting. The reflex mirror flips up and a current view of the scene appears on the LCD.
 - Turn the Main dial to set the shutter speed. At 50 or 60 fps, you can choose 1/4000 to 1/60 second. At 24, 25, and 30 fps, you can choose 1/4000 to 1/30 second. For smooth motion of moving subject, shutter speeds 1/30 to 1/125 second are recommended.
 - With the Quick Control dial switch set to the far left, turn the Quick Control dial to set the aperture. Shooting with the same aperture is best to avoid variations in exposure during the movie.
 - Press the ISO button above the LCD panel and turn the Main dial to set the ISO between 100 and 6400. If you have Highlight tone priority (C.Fn II-3) enabled, the ISO range is 200 to 6400.

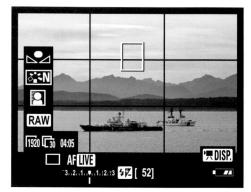

7.2 The Movie shooting display

- 3. Focus on the subject. Here is how to use the focusing options.
 - Live mode. Tilt the Multi-controller to move the white magnifying rectangle so that it is over the part of the subject that you want in focus, and then press the AF-ON button or half-press the Shutter button. When focus is achieved, the AF-point rectangle turns green. If focus is not achieved, the AF-point rectangle turns orange. In Live mode, focus takes slightly longer than you are accustomed to.
 - Face Detection Live mode. The camera looks for a face or faces in the scene, and displays corner marks or corner marks with left and right arrows, respectively, over the face or faces it selects. You can press the left or right cross key to move the focusing frame to another face. To focus, press the AF-ON button or half-press the Shutter button. When focus is obtained, the

corner marks appear in green. If the camera cannot find a face in the scene, it displays a solid rectangle and the camera uses the center AF point for focusing.

- **Quick mode.** Press the Q button to display the 19 AF points. Tilt the Multicontroller to activate the AF points, and then select the AF point by turning the Main and Quick Control dials.
- Manual focusing. Set the switch on the side of the lens to MF (Manual Focus). Then turn the focusing ring on the lens to focus on the subject. If you have to change focus during shooting, manual focusing avoids the noise of the AF motor being recorded, but the focusing adjustment can be intrusive to the video.
- Press the START-STOP button to begin recording the movie. The Movie mode (red) dot appears at the top right of the screen.
- 5. Press the Q button one or two times to cycle through the two shooting displays, and press the INFO. button to display more or less shooting and camera setting information.
- 6. To stop record, press the START-STOP button.

Playing back videos

For a quick preview of your movies, you can play them back on the camera's LCD. Of course, with the high-definition quality, you will enjoy the movies much more by playing them back on a television or computer.

To play back a movie on the camera LCD, follow these steps:

- 1. Press the Playback button, and then turn the Quick Control dial until you get to a movie file. Movies are denoted with a movie icon and the word *Set* in the upper-left corner of the LCD display.
- **2. Press the Set button.** A progress bar appears at the top of the screen, and a ribbon of controls appears at the bottom of the display.
- **3.** Press the Set button to begin playing back the movie, or turn the Quick Control dial to select a playback function, and then press the Set button. You can choose from the following:
 - Exit. Select this control to return to single-image playback.
 - Play. Press the Set button to start or pause the movie playback.

- Slow motion. Turn the Quick Control dial to change the slow-motion speed.
- First frame. Select this control to move to the first frame of the movie.
- **Previous frame.** Press the Set button once to move to the previous frame, or press and hold the Set button to rewind the movie.
- **Next frame.** Press the Set button once to move to the next frame, or press and hold the Set button to fast forward through the movie.
- Last frame. Select this control to move to the last frame or the end of the movie.
- **Edit.** Select this control to display the editing screen where you can edit out one-second increments of the first and last scenes of a movie.
- **Volume.** This is denoted as ascending gray or green bars; just turn the Main dial to adjust the audio volume.
- 4. Turn the Quick Control dial to select Exit. The playback screen appears.
- 5. Press the Set button to stop playing the movie.
- 6. Press Exit to exit out of the movie.

CHAPTER

Working with Flash and Studio Lights

Whith the EOS 7D, the flash becomes not only a handy built-in accessory, but it serves for the first time as a wireless E-TTL (Evaluative Through the Lens) flash control. With this, the 7D opens the door to creative multiple and wireless flash photography.

You can use the 7D's Integrated Speedlite Transmitter as a master control unit to fire up to three groups of wireless slave units with or without having the built-in flash fire. The built-in flash can also be used as a separate flash group with reduced power output.

From the camera menu, you can control flash ratios or manually control the output of each group, and con-

trol the settings and custom functions for accessory Speedlites including the 580EX II, 430EX II, and the 270X from the 7D's Flash Control menu.

Flash Technology and the 7D

Canon flash units, whether it's the built-in or an accessory EX-series Speedlite, use *E-TTL II technology*. To make a flash exposure, the flash unit receives information

from the camera including the focal length of the lens, distance from the subject, and exposure settings including aperture.

The camera gathers this information from a preflash beam that's fired after the Shutter button is fully pressed Information from this preflash is combined with data from the Evaluative metering system and the lens to analyze and compare existing light exposure values with the amount of light needed to make a good exposure.

The flash also automatically figures in the angle of view for the 7D given its cropped image sensor size. Thus, the built-in and EX-series Speedlites automatically adjust the flash zoom mechanism for the best flash angle and to illuminate only key areas of the scene, which conserves power.

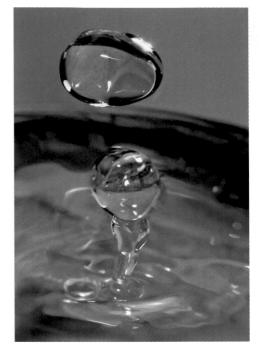

8.1 This image of water drop action in a glass dish was made with the built-in flash. Exposure: ISO 100, f/8, 1/250 sec.

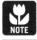

The built-in flash offers coverage for lenses as wide as 15mm and a recycle time of 3 seconds.

E-TTL II technology also enables high-speed sync flash with accessory Speedlites. High-speed sync flash enables flash synchronization at a shutter speed faster than the camera's flash sync speed of 1/250 second. The advantage is that you can open up the lens to a wide aperture when shooting a backlit subject to create a shallow depth of field to blur to the background while shooting at faster than 1/250 second shutter speeds.

Why Flash Sync Speed Matters

If flash sync speed isn't set correctly, only part of the image sensor has enough time to receive light while the shutter curtain is open. The result is an unevenly exposed image. The 7D doesn't allow you to set a shutter speed faster than 1/250 second, but you can set a slower flash sync speed. Using Custom Function C.Fn I-7, you can set whether the 7D sets the flash sync speed automatically (option 0), sets the sync speed to 1/250 to 1/60 second (option 1), or always sets the sync speed at 1/250 second (option 2) when you shoot in Av mode.

Shooting with the Built-in Flash

The built-in flash is handy when you need a pop of fill flash for a portrait, or when you are in low light scenes where you might not otherwise be able to get a shot without a flash. The built-in flash offers coverage for lenses as wide as 15mm, sync speeds between 1/250 and 30 seconds, and the flash recycles in approximately 3 seconds. Depending on the shooting mode you choose, Tables 8.1 and 8.2 show what you can expect when you use the built-in flash and the flash range estimates.

Shooting mode	Shutter Speed	Aperture	
Τv	30 sec to 1/250 sec	You set the shutter speed, and the camera automatically sets the appropriate aperture. If you set a shutter speed faster than 1/250 sec, the camera automatically readjusts it to 1/250 with flash use.	
Av	30 sec to 1/250 sec	You set the aperture, and the camera automatically sets the shutter speed. The 7D uses slow-speed flash sync in low light so that the flash provides the subject exposure and the existing light registers with the slow shutter speed. You can determine the flash sync speed by setting C.Fn I-7 to either Option 1, 1/250 to 1/60 second, or to Option 2, 1/250 sec- ond fixed. If you use slow-speed flash sync, you may need a tripod depending on the shutter speed and whether you're using an IS lens.	
M (Manual)	30 sec to 1/250 sec	You set both the aperture and the shutter speed. Flas exposure is set automatically based on the aperture.	
Ρ	1/60 sec to 1/250 sec	Both the aperture and the shutter speed are set automatically by the camera. With flash use, you cannot shift the exposure in P mode.	
В	Exposure continues until you release the Shutter button		

Table 8.1 7D Exposure Settings Using the Built-in Flash

ISO sensitivity setting	f/3.5	f/4	f/5.6
100	12 (3.5)	10 (3.)	7 (2)
200	16 (5)	13 (4)	10 (3)
400	23 (7)	20 (6)	15 (4.5)
800	31 (9.5)	28 (8.5)	20 (6)
1600	46 (14)	39 (12)	28 (8.5)
3200	62 (19)	56 (17)	39 (12)
6400	89 (27)	79 (24)	56 (17)
H (12800)	128 (39)	112 (34)	79 (24)

Table 8.2 7D Built-in Flash Range

Information in this table provided by Canon

Gauging the power of the built-in flash

Understanding the power of the built-in flash is important because it helps you evaluate whether the flash will provide the coverage you need for the scene you're photographing. The classic way to gauge the relative power of the flash is the flash unit's guide number. While the guide number is not something that you deal with each time you use the built-in flash, understanding guide numbers helps you use the flash more effectively.

A guide number indicates the amount of light that the flash emits. From that number, you or the camera can determine what aperture to set given the subject distance and the ISO. The guide number for the 7D's built-in flash is 39 feet (12 meters) at ISO 100. Divide the guide number by the flash-to-subject distance to determine the appropriate aperture to set.

The relationship between the aperture and the flash-to-subject distance is Guide Number ÷ Aperture = Distance for optimal exposure and Guide Number ÷ Distance = Aperture for optimal exposure.

Thus, if the subject is 15 feet from the camera, you divide 39 (the guide number) by 15 feet (camera-to-subject distance) to get f/2.6, or round up to 2.8, at ISO 100 (because the guide number is given at ISO 100).

If you want a different aperture, you can change the camera-to-subject distance, or you can increase the ISO sensitivity setting on the camera. By increasing the ISO, the camera needs less light to make the exposure, and it simultaneously increases the range of the flash. When you increase the ISO from 100 to 200, the guide number increases by a factor of 1.4x, while increasing from 100 to 400 doubles the guide number.

Working with the built-in flash

The built-in flash features many of the same overrides that you find in EX-series Speedlites including Flash Exposure Compensation (FEC) and Flash Exposure Lock (FE Lock). In addition, flash functions can be set using the Flash Control menu (Shooting 1 menu) when you shoot in P, Tv, Av, M, and B modes.

Flash control options include setting the flash mode, shutter synchronization with either first or second curtain, setting Flash Exposure Compensation, selecting Evaluative or Average metering, and using the Wireless function. You can also turn on Red-eye Reduction on the Shooting 1 menu.

To use the flash in P, Tv, Av, M, and B shooing modes, you have to press the flash popup button.

When you use the built-in flash, be sure to remove the lens hood to prevent obstruction of the flash coverage. And if you use a large telephoto lens, the built-in flash coverage may also be obstructed.

Red-eye Reduction

The red appearance in a person's eye is caused when the bright flash reflects off the retina, revealing the blood vessels in the reflection. The Red-eye Reduction function fires a preflash causing the pupils of the subject's eye to contract when the subject looks at the preflash.

You can turn on Red-eye Reduction on the Shooting 1 menu. Just highlight Red-eye On/Off, press the Set button, and then choose On. Then press the Set button to confirm the change.

Modifying Flash Exposure

There are times when the flash output won't produce the image that you envisioned, and there are times when you want a slightly increased or decreased flash exposure, or to avoid a hot spot on the subject. In these situations, you can modify the flash output using either Flash Exposure Compensation or Flash Exposure Lock. Both of these options can be set for both the built-in flash and an accessory Speedlite.

Flash Exposure Compensation

Flash Exposure Compensation enables you to manually adjust the flash output without changing the aperture or the shutter speed. This is a good modification to use when your subject is lighter or darker than middle (18 percent) gray and when the

Canon EOS 7D Digital Field Guide

background is very bright or very dark. Flash Exposure Compensation is also useful to balance lighting in unevenly lit scenes and to reduce the dark background shadows that are characteristic with flash exposures.

With Flash Exposure Compensation, you can increase the flash output up to plus/minus 3 stops in 1/3-stop increments. As a result, you can maintain the camera's original E-TTL readings while manually increasing or decreasing the flash output. You can change the increment level to 1/2 stop using C.Fn I-1, Exposure level increments.

If you use an accessory Speedlite, you can set Flash Exposure Compensation either on the camera or on the Speedlite. However, the compensation that you set on the Speedlite overrides any compensation that you set using the 7D's ISO-Flash exposure

8.2 For this image, I used window light to the left and one Speedlite shooting into an umbrella to the right to brighten the subject's face. Exposure: ISO 200, f/2.8, 1/15 sec. using a -1/2 stop compensation.

compensation button above the LCD panel. The take-away is to set compensation either on the Speedlite or on the camera, but not both.

Flash Exposure Compensation can also be combined with Exposure Compensation. If you shoot a scene where one part of the scene is brightly lit and another part of the scene is much darker — for example, an interior room with a view to the outdoors — then you can set Exposure Compensation to -1 and set the Flash Exposure Compensation to -1 to make the transition between the two differently lit areas more natural.

Auto Lighting Optimizer can mask the effect of Flash Exposure Compensation. If you want to see the effect of the Compensation, turn off Auto Lighting Optimizer by setting it to Disable on the Shooting 2 menu. To set Flash Exposure Compensation for either the built-in flash or an accessory Speedlite, follow these steps:

- 1. Set the camera to P, Tv, Av, M, or B, and then press the ISO-Flash Compensation button above the LCD panel. The Exposure Level indicator meter is activated on the LCD panel.
- 2. Turn the Quick Control dial to the left to set negative compensation (lower flash output) or to the right to set positive flash output (increased flash output) in 1/3-stop increments. As you turn the Quick Control dial, a tick mark under the Exposure Level meter moves to indicate the amount of Flash Exposure Compensation. The Flash Exposure Compensation is displayed in the viewfinder and on the LCD panel when you press the Shutter button halfway. The Flash Exposure Compensation you set on the camera remains in effect until you change it.

To remove Flash Exposure Compensation, repeat these steps, but in Step 2, move the tick mark on the Exposure Level meter back to the center point.

Flash Exposure Lock

Flash Exposure Lock (FE Lock) is a great way to set flash output for any part of the scene or subject—typically an area of critical exposure in the scene. You can also use FE Lock to help compensate for the exposure error that can be caused by reflective surfaces such as mirrors or windows or other highly reflective subjects. Regardless of the approach, FE Lock is a technique that you want to add to your arsenal for flash images. Once you take a preflash reading off a small area of the subject or scene using the Spot meter, the 7D locks the reading long enough for you to recompose the shot and make the image.

If you are shooting a series of images under unchanging existing light, Flash Exposure Compensation is more efficient and practical than FE Lock.

To set FE Lock, follow these steps:

 Set the camera to P, Tv, Av, M, or B mode, and then press the Flash button to raise the built-in flash or mount the accessory Speedlite. The flash icon appears in the viewfinder.

- 2. Point the center of the viewfinder over an area that is middle (18 percent) gray or on the area of the subject where you want to lock the flash exposure, and then press the M-Fn button. The camera fires a preflash. FEL is displayed momentarily in the viewfinder, and the flash icon in the viewfinder displays an asterisk beside it to indicate that flash exposure is locked. If the flash icon in the viewfinder blinks, you're beyond the flash range, so move closer and repeat the process.
- 3. Move the camera to compose the image, press the Shutter button halfway to focus on the subject, and then completely press the Shutter button to make the image. Ensure that the asterisk is still displayed to the right of the flash icon in the viewfinder before you make the picture. As long as the asterisk is displayed, you can take other images at the same compensation amount.

Setting Flash Control Options

Many of the onboard and accessory flash settings can be set using the Shooting 1 menu on the 7D. This menu offers an impressive array of adjustments for the built-in flash including the first or second curtain shutter sync and the choice of Evaluative or Average exposure metering.

If you're using an accessory Speedlite, you can use the Shooting 1 menu to set Flash Exposure Compensation and choose between Evaluative or Average metering. This menu also enables you to change the Custom Function (C.Fn) settings for compatible Speedlites such as the 580 EX II.

To change settings for the built-in or compatible accessory EX-series Speedlites, follow these steps:

- Set the camera to P, Tv, Av, M, or B mode, press the Menu button, and then turn the Main dial until the Shooting 1 tab is highlighted. If you are using an accessory Speedlite, mount it on the camera and turn it on.
- Turn the Quick Control dial to highlight Flash Control, and then press the Set button. The Flash Control screen appears.
- 3. Turn the Quick Control dial to highlight the setting that you want, and then press the Set button. Table 8.3 details the Flash Control menu and the options you can choose for both the built-in and/or an accessory Speedlite flash.

Table 8.3 Flash Control Menu Options

Built-in	Enable, Disable Flash mode Shutter sync	Turns the flash firing on and off for shooting in P, Tv, Av, M, and B modes. E-TTL II, Manual flash, MULTI flash. 1st curtain: Flash fires at the beginning of the exposure.		
flash func.				
	Shutter sync	1st curtain: Flash fires at the beginning of the exposure.		
		Can be used with a slow-sync speed to create light trails in front of the subject.		
		2nd curtain: Flash fires just before the exposure ends. Can be used with a slow-sync speed to create light trails behind the subject.		
	Flash exp. comp.	Press the Set button to activate the Exposure Level meter, and then turn the Quick Control dial to set up to 3 stops of Flash Exposure Compensation.		
	E-TTL II	Evaluative. This default setting sets the exposure based on an evaluation of the entire scene. Average: Flash exposure is metered and averaged for the entire scene. Results in brighter output on the subject and less balanc- ing of existing background light.		
	Wireless func.	Disable, Speedlite or built-in flash, Speedlite only, or both a Speedlite and the built-in flash.		
External flash func. setting	Flash mode	E-TTL II, Manual flash, MULTI flash, and depending on the Speedlite, TTL AutoExtFlash, and Man.ExtFlash. Note that the settings may depend on Speedlite setting		
	Shutter sync	1st curtain: Flash fires immediately after the exposure begins.		
		2nd curtain: Flash fires just before the exposure ends. Can be used with slow-sync speed to create light trails behind the subject.		
		Hi-speed: enables flash at speeds faster than 1/250 sec- ond. However, the flash range is shorter.		
	Zoom	Auto, or turn the Quick Control dial to set the zoom set- ting from 24mm to 105mm.		
	Wireless func.	Disable or Enable. See the flash manual for details on additional settings.		
	Master flash	Enable to have the external flash control slave flash units. Disable.		
	Channel	Select and turn the Quick Control dial to select the nuber of channels for multiple wireless flashes.		
	Firing group	A+B+C, A:B, or A:B C		
	Group A output*	1/4, 1/2, or 1/1		
	A:B fire ratio	2:1, 1:1, 1:2. Sets the lighting ratio of external flashes.		
	Grp. C exp. compensation	Press the Set button to activate the Exposure Level meter to set +/- 3 stops of compensation for the C group of flas units.		

continued

Setting	Option(s)	Suboptions/Notes
External flash C.Fn setting	Custom Functions depend on the Speedlite in use	Press the Set button to display the C.Fn screen for the external Speedlite.
Clear ext. flash C.Fn set	Turn the Quick Control dial to select OK, and then press the Set button to clear all Custom Functions for the Speedlite	Press the Set button to display the Clear ext. flash C.Fn set screen where you can clear all Custom Function set- tings on the Speedlite.

Table 8.3 Flash Control Menu Options (continued)

* Additional Group output options are available depending on the number of flash units you are using

Using the flash autofocus assist beam without firing the flash

In some lowlight scenes, you may not want the built-in or an accessory flash, but the light is too low for the camera to establish focus. This is when you can use the flash unit's autofocus assist beam to help the camera establish focus without actually firing the flash.

To disable flash firing but still allow the camera to use the flash's autofocus assist beam for focusing, follow these steps:

- 1. Press the Menu button, and then turn the Main dial to display the Shooting 1 menu.
- 2. Turn the Quick Control dial to highlight Flash control, and then press the Set button. The Flash control screen appears.
- **3.** Turn the Quick Control dial to highlight Flash firing, and then press the Set **button.** Two options appear.
- **4.** Turn the Quick Control dial to highlight Disable, and then press the Set **button.** Neither the built-in flash nor an accessory Speedlite will fire.
- 5. Press the flash pop-up button, or mount an accessory EX-series Speedlite.
- 6. Half-press the Shutter button to have the flash autofocus assist beam fire to help the camera establish focus.

If these steps do not work, check the settings for C.Fn III-11, AF-assist beam firing. If this function is set to Option 1: Disable, then change it to Option 0: Enable. Also if the Speedlite's Custom Function is set to Disabled, the Speedlite AF-assist beam will not fire until you change the Custom Function on the Speedlite.

For details on Custom Functions, see Chapter 5.

8.3 For this image, I used wireless flash with the 580EXII and the 580EX Speedlites. One Speedlite was on a stand shooting into a silver umbrella and placed at camera left and at eye level with the mother. The other flash was held at camera right. Exposure: ISO 100, f/4, 1/100 sec. using an EF 24-70mm, f/2.8L USM lens.

The advantage of the built-in flash is that it is available anytime you need a pop of additional light. The scenarios for using the flash in P, Tv, Av, M, and B modes vary from filling shadows in portraits to providing the primary subject illumination in lowlight scenes.

On the 7D, the E-TTL II setting automatically detects when the flash pops up and when the exposure for the existing light in the scene is properly set. In those cases, the camera automatically provides reduced output to fill shadows in a natural-looking way as opposed to a blasted-with-flash rendering.

In lower light indoor or night outdoor scenes, the flash often illuminates the subject properly, but the background is too dark. In these scenes, switch to Av or Tv shooting mode and use a wide aperture or slow shutter speed respectively to allow more of the existing light to contribute to the exposure.

Wireless Flash and Studio Lighting

If one flash is good, it follows that more flash units would be better. While that logic doesn't hold true for everything, in the case of flash units it does. Multiple Speedlites enable you to set up lighting patterns and ratios that are similar to a studio lighting setup. You also have the option of using one or more flash units as either the main or an auxiliary light source to balance existing light with flash to provide even and natural illumination and balance among light sources. Plus, unlike some studio lighting systems, a multiple Speedlite system is lightweight and portable.

For detailed information on using Canon Speedlites, be sure to check out the *Canon Speedlite System Digital Field Guide* by J. Dennis Thomas (Wiley).

Using multiple Speedlites wirelessly

The 7D is compatible with all EX-series Speedlites. With EX-series Speedlites, you get FP (focal-plane) Flash Sync, Flash Exposure Bracketing, and *flash modeling* (to preview the flash pattern before the image is made). And you can use the 7D's built-in flash as the Speedlite transmitter to fire multiple Speedlites. You can set up the flash units in groups and control the lighting ratio directly from the Flash Control on the Shooting 1 camera menu.

When I shoot portraits on location, I take three Speedlites with stands, silver umbrellas, a softbox, and multiple reflectors. This setup is a lightweight mobile studio that can either provide the primary lighting for subjects or supplement existing light. And with the 7D, I can leave the Speedlite Transmitter ST-E2 at home because I have the same functionality on the 7D's Flash Control menu.

The 7D enables you to control up to three groups of slave flash units with the built-in flash serving as the fourth group. And if you're working near other photographers using flash units, you can set your flash units to any of four channels and not worry about triggering another photographer's flash units.

Add the WFT-E5 Wireless File Transmitter and Bluetooth-enabled GPS

The 7D combined with the WFT-E5 Wireless File Transmitter and the Bluetooth dongles make file transmission to either an FTP server or to your computer easy. And the full-size USB port on the WFT-E5 is compatible with a Bluetooth dongle, so that you can connect with a GPS device to geotag images taken with the 7D. The WFT-E5 offers high-speed wireless file transfer with enhanced remote capture, media server functionality, and linked shooting. The EOS Utility enables communication between the camera and computer, and the WFT Server feature enables the 7D to be controlled over an HTTP connection using a Web browser to display images on the CF card and control the camera.

The WFT-E5 enables linked shooting of up to 10 slave 7D cameras as long as all cameras are using the WFT-E5 unit. Cameras can be triggered from up to 100m away. For those with deep pockets, this is doubtless the way to cover something like an Olympic event from multiple viewpoints.

Setting up wireless flashes

While this book cannot provide exhaustive instructions for wireless flash techniques, the following tips will help get you started with multiple wireless flash setups using the 7D as the master transmitter for the flash units. I use the 580EX II as the slave unit(s) for the following example (the 7D settings mentioned are set on the Shooting 1/Flash Control/External flash func. setting screen on the camera):

- Set the Speedlite(s) as slave units. On the 580EX II's, hold the Zoom button until the display "on" blinks on the LCD. Turn the Select dial until "SLAVE" blinks, and then press the Set button on the Speedlite.
- Set the communication channels. Press the Zoom button until Channel blinks, turn the Select dial to set the channel number, and then press the Set button. Set the 7D and any other flash units to the same channel.
- Set the slave unit "group" or ID. If you're using two or more Speedlites, then identify each unit as A, B, C, etc., so that you can set the lighting ratio or flash output for the groups. On the 580EX II, press the Zoom button until "A" blinks. Press the Set button to set the unit to A. Repeat these steps but turn the Select dial to set the next unit to B.

- Set the firing group for multiple units. On the 7D, set the Firing group to the setting icon that shows the number of Speedlites you're using, for example, the setting that shows the icon depicting a Speedlite (A:B). You can also press the Picture Styles button to test the flash firing at this point.
- Set the lighting ratio for multiple flash units. On the 7D, set the A:B fire ratio or the setting appropriate for the group you are setting up. You can also set Flash Exposure Compensation of you want. You can choose a 2:1, 1:1, or 1:2 ratio. The flash ratio range of 8:1 is equivalent to 3:1 1:1 -1:3 f-stops by 1/2-stop increments.
- Position the camera and Speedlites. Set up the camera and the Speedlites to get the lighting effect that you want, keeping each unit within its range of coverage. The Speedlite wireless sensors must be set facing the 7D.

Whether you're using one or multiple Speedlites, you'll get pleasing results by using modifiers. I routinely use silver, gold, and shoot-through umbrellas, a small Photoflex LiteDome for strobes, and I also mount the Speedlites on affordable Photoflex LiteStand LS-B2211.

If there is quality existing light, then my approach is to use wireless Speedlights as fill light, but keep the existing light as the main light. For example, if there is nice window

light for a portrait, then I may set up a Speedlite on the shadow side of the subject, and one or two flash units to light the background.

If you have a studio lighting system, the 7D performs exceptionally well with studio lighting. The PC terminal on the side of the 7D allows you to use wired strobes or wireless systems. I use a four-strobe Photogenic system with umbrellas, softboxes, and a large silver reflector for studio work. Canon suggests that with studio systems, you use 1/60 or 1/30 second

8.4 The 7D is a pleasure to use with studio lighting systems. This image was lit by four Photogenic strobes: two on the background, two to camera left, and a large silver reflector to camera right. Exposure: ISO 100, f/16, 1/80 sec.

sync speeds with large studio flash units because the flash duration is longer. I have found that for my strobes, a 1/125 second sync speed works well.

Do not connect a flash unit that requires 250 V or more to the 7D. If you are unsure about the voltage of the flash unit, use a Wein Safe Sync hot shoe PC adapter to protect the camera.

Exploring flash techniques

While it is beyond the scope of this book to detail all the lighting options that you can use with one or multiple Speedlites, I will cover some common flash techniques that provide better flash images than using straight-on flash.

Bounce flash

One frequently used flash technique is bounce flash, which softens hard flash shadows by diffusing the light from the flash. To bounce the light, turn the flash head so that it points diagonally toward the ceiling or a nearby wall so that the light hits the ceiling or wall and then bounces back to the subject. This technique spreads and softens the flash illumination.

If the ceiling is high, then it may underexpose the image. As an alternative, I often hold a silver or white reflector above the flash to act as a "ceiling." This technique offers the advantage of providing a clean light with no colorcast.

Adding catchlights to the eyes

Another frequently used technique is to create a catchlight in the subject's eyes by using the panel that is tucked into the flash head of some Speedlites. Just pull out the translucent flash panel on the Speedlite. At the same

8.5 The Canon Speedlite 580EX II accessory flash. The 7D includes a waterproof jacket around the hot shoe that matches up to the 580EX II seal to keep water from getting into the electrical connection in wet weather. time, a white panel comes out; that is what you can use to create catchlights. The translucent panel is called the *wide* panel and it is used with wide-angle lenses to spread the light. Push the wide panel back in while leaving the white panel out. Point the flash head up, and then take the image. The panel throws light into the eyes, creating catchlights that add a sense of vitality to the eyes. For best results be within 5 feet of the subject.

If your Speedlite doesn't have a panel, you can tape an index card to the top of the flash to create catchlights as described previously.

CHAPTER

Lenses and Accessories

While the EOS 7D delivers fine images with all of the Canon lenses, it delivers the best images with high-quality lenses. Ultimately, your investment in lenses will far exceed your investment in the camera body.

Most photographers know that "the camera is as good as the lens," and this is no less true for the 7D. With its high resolution and cropped sensor, the 7D demands a lot from lenses. Keep this in mind as you add lenses to your gear bag.

As you consider a new lens, remember that you are building a system of lenses that will last for years to come. So it is a good investment to buy lenses that serve your needs now and in the future.

Evaluating Lens Choices for the 7D

The 7D is compatible with more than 60 Canon EF and EF-S lenses and accessories. That's a wide range of lenses, and your options are even more extensive when you factor in compatible lenses from third-party companies.

Building a lens system

One of the first considerations photographers face is building a lens system. A few basic tips can help you create a solid strategy for adding new lenses to your system. For photographers buying their first and second lenses, a rule of thumb is to buy two lenses that cover the focal range from wide-angle to telephoto. With those two lenses as the foundation of your system, you can shoot 80 to 95 percent of the scenes and subjects that you'll encounter.

Because you'll use these lenses so often, they should be high-quality lenses that produce images with snappy contrast and excellent sharpness, and they should be fast enough to allow shooting in low light scenes. A *fast lens* is generally considered to be a lens with a maximum aperture of f/2.8 or faster. With a fast lens, you can often shoot in low light without a tripod and get sharp images. And if the lens has Image Stabilization, detailed later in this chapter, you gain even more flexibility.

When I switched to Canon cameras about seven years ago, I bought the Canon EF 24-70mm f/2.8L USM lens and the EF 70-200mm f/2.8L IS USM lens — two highquality lenses that covered the focal range of 24mm to 200mm. Today these two lenses are still the ones I use most often for everyday shooting. And because I shoot

with a variety of Canon EOS cameras, I know that I can mount these lenses on the 7D, the T1i, the 5D Mark II, or the 1Ds Mark III and get beautiful images.

If you bought the 7D as a kit with the EF 28-135mm f/3.5-5.6 IS USM, then you may already have learned that while this lens seems to provide a good focal range, in practice, it falls short of giving a true wide-angle view. The 28-135mm lens falls short on the wide-angle side of the focal range because of the focal length multiplier, which is discussed in the next section.

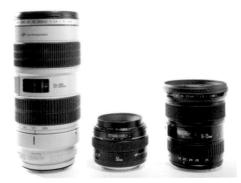

9.1 The EF 70-200mm f/2.8L IS USM, the EF 50mm f/1.4 USM, and the 16-35mm f/2.8L USM lenses cover most everyday shooting situations, and they are a good starting point for building a lens system.

Getting a wide-angle view is, of course, important for landscape, cityscape, interior, and architectural shooting as well as for photographing groups of people. On the other hand, if you bought the 7D as a kit with the EF-S 18-135mm f/3.5-5.6 IS lens, you paid more, but you also got a lens that is truly wide-angle.

Understanding the focal-length multiplier

One of the most important lens considerations for the 7D is its smaller APS-C-size image sensor. *APS-C* is simply a designation that indicates that the image sensor is 1.6 times smaller than a traditional full 35mm frame. As a result, the lenses you use on the 7D have a smaller angle of view than a full-frame camera. A lens' angle of view is how much of the scene, side-to-side and top-to-bottom that the lens encompasses in the image.

In short, the angle of view for Canon EF lenses that you use on the 7D is reduced by a factor of 1.6x at any given focal length. That means that a 100mm lens is equivalent to a 160mm when used on the 7D. Likewise, a 50mm normal lens is the equivalent to using an 80mm lens — a short telephoto lens.

This focal-length multiplication factor works to your advantage with a telephoto lens because it effectively increases the lens' focal length (although technically the focal length doesn't change). And because telephoto lenses tend to be more expensive than other lenses, you can buy a shorter and less expensive telephoto lens and get 1.6x more magnification at no extra cost.

The focal-length multiplication factor works to your disadvantage with a wide-angle lens; the sensor sees less of the scene because the focal length is magnified by 1.6. However, because wide-angle lenses tend to be less expensive than telephoto lenses, you can buy an ultrawide 14mm lens to get the equivalent of an angle of view of 22mm.

As you think about the focal-length multiplier effect on telephoto lenses, it seems reasonable to assume that the multiplier also produces the same depth of field that a longer lens — the equivalent focal length — gives. That isn't the case, however. Although an 85mm lens on a full 35mm-frame camera is equivalent to a 136mm lens on the 7D, the depth of field on the 7D matches the 85mm lens, not a 136mm lens. This depth of field principle holds true for enlargements. The depth of field in the print is shallower for the longer lens on a full-frame camera than it is for the 7D.

And that brings us to another important lens distinction for the 7D. The 7D is compatible with all EF-mount lenses and with all EF-S-mount lenses. The EF lens mount is compatible across all Canon EOS cameras regardless of image sensor size, and regardless of camera type, whether digital or film. The EF-S lens mount, however, is specially designed to have a smaller image circle, or the area covered by the image on the sensor plane. EF-S lenses can be used only on cameras with a cropped frame such as the 7D, T1i, and 50D among others because of a rear element that protrudes back into the camera body.

9.2 This image shows the approximate difference in image size between a full-frame 35mm camera and the 7D. The smaller image size represents the 7D's image size.

The difference in lens mounts should also factor into your plan for building a lens system. As you consider lenses, think about whether you want lenses that are compatible with both a full-frame camera and a cropped sensor, or not. Remember that as your photography career continues, you'll most likely buy a second, backup camera body or move from the 7D to another EOS camera body. And if your next EOS camera body has a full-frame sensor, then you'll want the lenses that you've already acquired to be compatible with it.

Types of Lenses

The most common question that my photography students ask is, "What lens should I buy?" It is virtually impossible to answer that question for someone else. The best advice is to have a strategy based on the scenes and subjects that you shoot, your budget, and your plans for expanding your photography. With that said, the best starting point for considering new lenses is to gain a solid understanding of the different types of lenses and their characteristics. Only then can you evaluate which types of lenses best fit your needs. The following sections provide a foundation for evaluating lenses by category and by characteristics.

Lenses are categorized by whether they zoom to different focal lengths or have a fixed focal length — known as prime lenses. Then within those two categories, lenses are grouped by focal length (the amount of the scene included in the frame) in three main categories: wide angle, normal, and telephoto. And within those categories are macro lenses that serve double-duty as either normal or telephoto lenses with macro capability.

At the top level of lens groupings are *zoom* and *prime*, or single focal-length lenses. The primary difference between zoom and prime lenses is that zoom lenses offer a range of focal lengths in a single lens while prime lenses offer a fixed, or single, focal length. There are additional distinctions that come into play as you evaluate whether a zoom or prime lens is best for your shooting needs.

About zoom lenses

Because zoom lenses offer variable focal lengths by just zooming the lens to bring the subject closer or farther away, they are very versatile in a variety of scenes. As a result, zoom lenses allow you to carry fewer lenses. For example, carrying a Canon EF-S 17-55mm f/2.8 IS USM lens and a Canon EF 55-200mm f/4.5-5.6 II USM lens, or a similar combination of lenses, provides the focal range needed for most everyday shooting.

Zoom lenses, which are available in wide-angle and telephoto ranges, are able to maintain focus during zooming. To keep the lens size compact and to compensate for aberrations with fewer lens elements, most zoom lenses use a multi-group zoom with three or more movable lens groups.

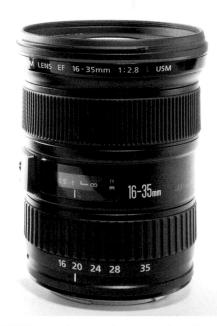

9.3 Wide-angle zoom lenses such as the Canon EF 16-35mm f/2.8L USM lens help bridge the focal-length multiplier gap by providing a wide view of the scene.

Most mid-priced and more expensive zoom lenses offer high-quality optics that produce sharp images with excellent contrast. As with many Canon lenses, full-time manual focusing is available by switching the button on the side of the lens to MF (Manual Focusing).

Some zoom lenses are slower than single focal-length lenses, and getting a fast zoom lens means paying a higher price. In addition, some zoom lenses have a variable aperture, which means that the minimum aperture changes at different zoom settings (discussed in the following sections). While zoom lenses allow you to carry around fewer lenses, they tend to be heavier than their single focal-length counterparts.

Other zoom lenses have variable apertures. An f/4.5 to f/5.6 variable-aperture lens means that at the widest focal length, the maximum aperture is f/4.5 and at the longer end of the focal range, the maximum aperture is f/5.6. In practical terms, this limits the versatility of the lens at the longest focal length for shooting in all but bright light or at a high ISO setting. And unless you use a tripod or your subject is stone still, your ability to get a crisp picture in lower light at f/5.6 will be questionable.

More expensive zoom lenses offer a fixed and fast maximum aperture, meaning that with maximum apertures of f/2.8, they allow faster shutter speeds that enhance your ability to get sharp images when handholding the camera. But the lens speed comes at a price: the faster the lens, the higher the price.

About prime lenses

While you hear much less about prime or single-focal-length lenses, they are worth careful evaluation. With a prime lens, the focal length is fixed, so you must move closer to or farther from your subject or change lenses to change image composition. Canon's venerable EF 50mm f/1.4 USM and EF 100mm f/2.8 Macro USM lenses are only two of a full lineup of Canon prime lenses.

Unlike zoom lenses, prime lenses tend to be fast with maximum apertures of f/2.8 or wider. Wide apertures allow fast shutter speeds that enable you to handhold the camera in lower

9.4 Single focal-length lenses such as the EF 50mm f/1.4 USM lens are smaller and lighter and provide excellent sharpness, contrast, and resolution when used on the 7D.

light and still get a sharp image. Compared to zoom lenses, single focal-length lenses are lighter and smaller. In addition, single focal-length lenses tend to be sharper than some zoom lenses.

Most prime lenses are lightweight, but you need more of them to cover the range of focal lengths needed for everyday photography. Prime lenses also limit the options for on-the-fly composition changes that are possible with zoom lenses.

Working with Different Types of Lenses

Within the categories of zoom and prime lenses, lenses are grouped by their focal length. While some lenses cross group lines, the groupings are still useful for talking about lenses in general. Before going into specific lenses, it is helpful to understand a few concepts.

First, the lens' *angle of view* is expressed as the angle of the range that's being photographed, and it's generally shown as the angle of the diagonal direction. The image sensor is rectangular, but the image captured by the lens is circular, and it's called the *image circle*. The image that's captured is taken from the center of the image circle.

For a 15mm fisheye lens, the angle of view is 180 degrees on a full-frame 35mm camera. For a 50mm lens, it's 46 degrees; and for a 200mm lens, the angle of view is 12 degrees. Simply stated, the shorter the focal length, the wider the scene coverage, and the longer the focal length, the narrower the coverage.

The lens' aperture range also affects the depth of field. The depth of field is affected by several factors including the lens' focal length, aperture (f-stop), focus position, camera-to-subject distance, and subject-to-background distance.

Finally, the lens you choose affects the perspective of images. *Perspective* is the visual effect that determines how close or far away the background appears to be from the main subject. The shorter (wider) the lens, the more distant background elements appear to be, and the longer (more telephoto) the lens, the more compressed the elements appear.

Using wide-angle lenses

Wide-angle lenses are aptly named because they offer a wide view of a scene. Generally, lenses shorter than 50mm are commonly considered wide angle on full-frame 35mm image sensors. Not including the 15mm fisheye lens, wide-angle and

ultra-wide lenses range from 17mm to 40mm on a full-frame camera. The wide-angle lens category provides angles of view ranging from 114 to 63 degrees.

However, on the 7D, the 1.6x focal-length multiplier works to your disadvantage. For example, with the EF 28-135mm f/3.5-5.6 IS lens, the lens translates to only 44mm on the wide end and 216mm on the telephoto end of the lens. The telephoto range is excellent, but you don't get a wide angle of view on the 7D with this lens. Thus, if you often shoot landscapes, cityscapes, architecture, and interiors, a first priority will be to get a lens that offers a true wide-angle view. Good choices include the EF 16-35mm f/2.8L II USM (approximately 26 to 56mm with the 1.6x multiplier), the EF-S 10-22mm f/3.5-4.5 USM lens (approximately 16 to 35mm with the multiplier), or the EF 17-40mm f/4L USM lens (approximately 27 to 64mm with the multiplier).

Wide-angle lenses are ideal for capturing scenes ranging from sweeping landscapes and underwater subjects to large groups of people, and for taking pictures in places where space is cramped.

9.5 To get the wide-angle view on the 7D, you need a wide or an ultra-wide-angle lens such as the EF 16-35mm f/2.8L USM or the EF 24-70mm f/2.8L lens that I used here to photography a well-known restaurant at night. The focal length was set to 32mm. Exposure: ISO 100, f/5.6, 5 sec. using -2/3 stop Exposure Compensation.

When you shoot with a wide-angle lens, keep these lens characteristics in mind:

- Extensive depth of field. Particularly at small apertures from f/11 to f/32, the entire scene, front to back, will be in acceptably sharp focus. This characteristic gives you slightly more latitude for less-than-perfectly focused pictures.
- ► **Fast apertures.** Wide-angle lenses tend to be faster (meaning they have wider apertures) than telephoto lenses. As a result, these lenses are good choices for everyday shooting when the lighting conditions are not optimal.
- Distortion. Wide-angle lenses can distort lines and objects in a scene, especially if you tilt the camera up or down when shooting. For example, if you tilt the camera up to photograph a group of skyscrapers, the lines of the buildings tend to converge and the buildings appear to fall backward (also called *keystoning*). You can use this wide-angle lens characteristic to creatively enhance a composition, or you can move back from the subject and keep the camera parallel to the main subject to help avoid the distortion.
- Perspective. Wide-angle lenses make objects close to the camera appear disproportionately large. You can use this characteristic to move the closest object farther forward in the image, or you can move back from the closest object to reduce the effect. Wide-angle lenses are popular for portraits, but if you use a wide-angle lens for close-up portraiture, keep in mind that the lens exaggerates the size of facial features closest to the lens, which is unflattering.

Using telephoto lenses

Telephoto lenses offer a narrow angle of view, enabling close-ups of distant scenes. On full 35mm-frame cameras, lenses with focal lengths longer than 50mm are considered telephoto lenses. For example, 80mm and 200mm lenses are telephoto lenses. On the 7D, however, the focal-length multiplier works to your advantage with telephoto lenses. Factoring in the 1.6x multiplier, a 50mm lens is equivalent to 80mm, or a short telephoto lens. And because telephoto lenses are more expensive overall than wide-angle lenses, you get more focal length for your money when you buy telephoto lenses for the 7D.

Telephoto lenses offer an inherently shallow depth of field that is heightened by shooting at wide apertures. Lenses such as 85mm and 100mm are ideal for portraits, while longer lenses (200mm to 800mm) allow you to photograph distant birds, wildlife, and athletes. When photographing wildlife, these lenses also allow you to keep a safe distance.

9.6 For this foggy farm scene image, I used the EF 70-200mm f/2.8L IS USM lens. I used a 155mm focal length, and Image Stabilization enabled me to handhold the camera and lens at a 1/60-second shutter speed. Exposure: ISO 200, f/4, 1/60 second.

When you shoot with a telephoto lens, keep these lens characteristics in mind:

- Shallow depth of field. Telephoto lenses magnify subjects and provide a limited range of sharp focus. At wide apertures, you can reduce the background to a soft blur. Because of the extremely shallow depth of field, it's important to get tack-sharp focus. Many Canon lenses include full-time manual focusing that you can use to fine-tune the camera's autofocus. Canon also offers an extensive lineup of Image Stabilized telephoto lenses.
- Narrow coverage of a scene. Because the angle of view is narrow with a telephoto lens, much less of the scene is included in the image. You can use this characteristic to exclude distracting scene elements from the image.
- Slow speed. Midpriced telephoto lenses tend to be slow; the widest aperture is often f/4.5 or f/5.6, which limits the ability to get sharp images without a tripod in all but the brightest light unless they also feature Image Stabilization. And because of the magnification factor, even the slightest movement is exaggerated.
- Perspective. Telephoto lenses tend to compress perspective, making objects in the scene appear close together.

Using normal lenses

Normal lenses offer an angle of view and perspective very much as your eyes see the scene. On full 35mmframe cameras, 50mm to 55mm lenses are considered normal lenses. However, on the 7D, a normal lens is 28mm to 35mm when you take into account the focal-length multiplier. And, likewise, the 50mm lens is equivalent to an 80mm lens on the 7D.

When you shoot with a normal lens, keep these lens characteristics in mind:

Natural angle of view. On the 7D, a 28 or 35mm lens closely replicates the sense of distance and perspective of the human eye. This means the final image will look much as you remember seeing it when you made the picture.

9.7 The EF 50mm f/1.4 USM lens is a normal lens on a full-frame camera. On the 7D it translates to a short telephoto. Regardless of designation, this lens offers snappy contrast as it did with this puppy that was trying to reach the toy. Exposure: ISO 100, f/18, 1/125 sec.

Little distortion. Given the natural angle of view, the 28-35mm lens retains a normal sense of distance, especially when you balance the subject distance, perspective, and aperture.

Charlotte's Favorite Lenses

My general approach to adding lenses to my system is to buy the highest-quality lens available in the focal length that I need. If I can't afford the highest-quality lens, then I wait and save money until I can buy it. For example, my last lens purchase was an EF 100-400 f/4.5-5.6L IS USM lens, and it took me a year to save enough money to buy it.

But for inquiring minds, the workhorse lenses in my gear bag are the first two Canon lenses I bought: the EF 70-200mm f/2.8L IS USM and the EF 24-70mm f/2.8L USM lens. Both lenses have outstanding optics, superb sharpness, and excellent resolution and contrast on *any* EOS camera body. I also frequently use the EF 100mm f/2.8L IS Macro USM lens, the EF 50mm f/1.2L USM, and the EF 100-400 f/4.5-5.6L IS USM.

Using macro lenses

Macro lenses are designed to provide a closer lens-to-subject focusing distance than non-macro lenses. Depending on the lens, the magnification ranges from half life-size (0.5x) to 5x magnification. Thus, objects as small as a penny or a postage stamp can fill the frame, while nature macro shots can reveal breathtaking details that are commonly overlooked. Using extension tubes can further reduce the closest focusing distance.

Normal and telephoto lenses offer macro capability. Because these lenses can be used both at their nor-

9.8 Canon offers several macro lenses including the EF 180mm f/3.5L Macro USM (left) that offers 1x (life-size) magnification and a minimum focusing distance of 0.48m/1.6 ft. Also shown here is the older Canon EF 100mm f/2.8 Macro USM lens. Canon updated the 100mm Macro, and I highly recommend the new version of this macro lens.

mal focal length as well as for macro photography, they do double duty. Macro lenses offer one-half or life-size magnification or up to 5X magnification with the MP-E 65mm f/2.8 1-5 Macro Photo lens.

9.9 The EF 180mm f/3.5L Macro USM lens captured this detail shot of sunflower petals. Exposure: ISO 100, f/16, 1/125 sec.

If you're buying a macro lens, you can choose lenses by focal length or by magnification. If you want to photograph moving subjects such as insects, choose a telephoto lens with macro capability. Moving subjects require special techniques and much practice.

Using tilt-and-shift lenses

Tilt-and-shift lenses, referred to as *TS-E lenses*, allow you to alter the angle of the plane of focus between the lens and sensor plane to provide a broad depth of field even at wide apertures and to correct or alter perspective at almost any angle. This allows you to correct perspective distortion and control focusing range.

Tilt movements allow you to bring an entire scene into focus even at maximum apertures. By tilting the lens barrel, you can adjust the lens so that the plane of focus is uniform on the focal plane, thus changing the normally perpendicular relationship between the lens's optical axis and the camera's focal plane. Alternatively, reversing the tilt has the opposite effect of greatly reducing the range of focusing.

Shift movements avoid the trapezoidal effect that results from using wide-angle lenses pointed up to take a picture of a building, for example. Keeping the camera so that the focal plane is parallel to the surface of a wall and then shifting the TS-E lens to raise the lens results in an image with the perpendicular lines of the structure being rendered perpendicular and with the structure being rendered with a rectangular appearance.

TS-E lenses revolve within a range of plus/minus 90 degrees making horizontal shift possible, which is useful in shooting a series of panoramic images. You can also use shifting to prevent having reflections of the camera or yourself in images that include reflective surfaces, such as windows, car surfaces, and other similar surfaces.

All of Canon's TS-E lenses are Manual Focus only. These lenses, depending on the focal length, are excellent for architectural, interior, merchandise, nature, and food photography.

Using Image Stabilized Ienses

For anyone who has thrown away a stack of images blurred from handholding the camera at slow shutter speeds, the idea of Image Stabilization is a welcome one. Image Stabilization (IS) counteracts some or all of the motion blur from handholding the camera and lens. If you've shopped for lenses lately, then you know that IS comes at a premium price. IS lenses are pricey because they give you from 1 to 4 f-stops of

additional stability over non-Image Stabilized lenses — and that means that you may be able to leave the tripod at home.

With an IS lens, miniature sensors and a high-speed microcomputer built into the lens analyze vibrations and apply correction via a stabilizing lens group that shifts the image parallel to the focal plane to cancel camera shake. The lens detects camera motion via two gyro sensors — one for yaw and one for pitch. The sensors detect the angle and speed of shake. Then the lens shifts the IS lens group to suit the degree of shake to steady the light rays reaching the focal plane.

Stabilization is particularly important with long lenses, where the effect of shake increases as the focal length increases. As a result, the correction needed to cancel camera shake increases proportionately.

9.10 To capture this bird at the birdbath, I used the EF 100-400mm f/4.5-5.6L IS USM lens zoomed to 400mm with Image Stabilization turned on for a handheld shot. Exposure: ISO 200, f/5.6, 1/200 sec.

To see how the increased stability pays off, consider that the rule of thumb for handholding the camera and a non-IS lens is 1/[focal length]. For example, the slowest shutter speed at which you can handhold a 200mm lens and avoid motion blur is 1/200 second. If the handholding limit is pushed, then shake from handholding the camera bends light rays coming from the subject into the lens relative to the optical axis, and the result is a blurry image. Thus, if you're shooting in low light at a music concert or a school play, the chances of getting sharp images at 200mm are low because the light is too low to allow a 1/200 second shutter speed even at the maximum aperture of the lens. You can, of course, increase the ISO sensitivity setting and risk introducing digital noise into the images. But if you're using an IS lens, the extra stops of stability help minimize ISO increases to get better image quality, and you still have a good chance of getting sharp images by handholding the camera and lens.

9.11 This 70-200mm f/2.8L IS USM lens offers Image Stabilization in two modes: one for stationary subjects and the second for panning with subjects horizontally.

But what about when you want to pan or move the camera with the motion of a subject? Predictably, IS detects panning as camera shake and the stabilization then interferes with framing the subject. To correct this, Canon offers two modes on IS lenses. Mode 1 is designed for stationary subjects. Mode 2 shuts off image stabilization in the direction of movement when the lens detects large movements for a preset amount of time. So when panning horizontally, horizontal IS stops but vertical IS continues to correct any vertical shake during the panning movement.

Calibrating and Fine-Tuning Lenses

Two common lens problems are *vignetting* and *back* or *front focusing*. You can correct these problems yourself with two new 7D features. If you have winced more than once over images where the point of sharpest focus is slightly in front of or behind where you set it, you can now tweak the lens focus in the comfort of your own home or studio. And with the Peripheral Illumination Correction option, you can have the camera automatically correct for vignetting for up to 20 Canon lenses.

Calibrating lenses for focus accuracy

In the past, if a lens focused slightly in front of or behind a subject, you'd send the camera to Canon where technicians would carefully make microadjustments to refine the focus. Now, however, Canon puts that ability in your hands — should you decide to accept the assignment. Generally this is not for the faint of heart or for the impatient.

In practice, you should seldom need to use Canon's AF Microadjustment option. According to Canon documents on this subject, the adjustment should be made only in two instances. The first instance is if you notice a consistent tendency for the sharpest plane of focus in *all* of your images to be in front of or behind the actual plane where you focused. This is commonly referred to as *front focusing* and *back focusing*. In this case, microadjustment is applied to all lenses. The second instance is if you notice front or back focusing only with *specific* lenses. In this case, microadjustment is applied only to specific lenses.

When you make microadjustments, the camera's sharpest plane of focus is shifted forward or backward to compensate for front or back focusing. The adjustment is applied within the camera body and its internal AF system. And if you need to, you can store adjustment information for up to 20 lenses.

Canon suggests that you can use something as simple as a 12-inch ruler for making test shots. Also consider the using LensAlign products available at www.lensalign. com. If you notice front or back focusing on one or all lenses, then you can adjust the plane of focus using the new microadjustment function on the 7D. Before you begin, be aware that you cannot make the microadjustments using Live View shooting.

Michael Tapes of RawWorkflow.com offers a video tutorial on setting microadjustment on the LensAlign Web site at this shortened URL: http://bit.ly/1C0kr2

To make the adjustments, follow these steps:

- With the 7D mounted on a tripod, shoot a target at a distance similar to what you would normally shoot the subject. The subject should have discernable detail both in front of and behind where you focus. Keep the focus point at the exact same spot for all images in the test.
- 2. With the lens at the widest aperture, select the center AF point manually. Do not use Automatic AF-point selection mode. With zoom lenses, zoom the lens to its maximum telephoto focal length. Avoid using wide focal lengths for creating test photos. The adjustment is always based on the lens' maximum aperture, not on the lens' focal length. The camera cannot distinguish between two of the same lenses. In other words, it cannot distinguish between two 70-200mm f/2.8L lenses. But it can distinguish between an EF 70-200mm f/2.8L USM and an EF 70-200mm f/2.8L IS USM lens. You can also do the test with either the 1.4x or 2x tele-extender on the lens.

- 3. With the camera set to P, Tv, Av, M, or B shooting mode, press the Menu button and turn the Main dial to select the Custom Functions menu.
- 4. Turn the Quick Control dial to select C. Fn III: Autofocus/Drive, and then press the Set button. The last C.Fn that you accessed is displayed.
- 5. Turn the Quick Control dial until the number 5 appears in the control at the top right of the screen.
- Press the Set button. The options control is activated. One of three options can be selected: Option 0: Disable; Option 1: Adjust all by same amount; and Option 2: Adjust by lens. If all images are front or back focused, then choose Option 1. If only one or two lenses are front or back focused, then choose Option 2.
- Turn the Quick Control dial to select the option you want, and then press the INFO. button. The AF Microadjustment screen appears with the currently mounted lens listed on the screen and a scale with plus/minus 20 steps of correction.
- 8. Turn the Quick Control dial to the left to adjust focusing forward or to the right to adjust focusing toward the back. Single-step adjustments are very fine, so starting with a large adjustment and progressively narrowing the adjustment from there is recommended.
- 9. Take several images at various adjustment positions and view the images at 100 percent enlargement on a high-quality computer monitor. Do not use the LCD monitor to judge the correction levels. When you find the adjustment that is closest to putting the plane of focus where it should be, then shoot some real-world images at the setting, evaluate the sharpness, and adjust if necessary.

If the adjustment does not correct the focus, you can reset the adjustment scale to the zero point.

Setting lens peripheral correction

Depending on the lens that you use on the 7D, you may notice a bit of *light falloff* and darkening in the four corners of the frame. Light falloff describes the effect of less light reaching the corners of the frame as compared to the center of the frame. The darkening effect at the frame corners is known as *vignetting*. Vignetting is most likely to be evident in images when you shoot with wide-angle lenses, when you shoot at a lens' maximum aperture or when an obstruction such as the lens barrel rim or a filter reduces light reaching the frame corners.

On the 7D, you can correct vignetting for JPEG shooting. If you shoot RAW images, you can correct vignetting in Canon's Digital Photo Professional program during RAW image conversion. When you turn on Peripheral Illumination Correction, the camera detects the lens that you have mounted, and it applies the appropriate correction level. The 7D can detect 25 lenses, but you can add information for other lenses by using the EOS Utility software supplied on the EOS Solutions Disk.

In the strictest sense, vignetting is considered to be unwanted effects in images. However, vignetting is also a creative effect that photographers sometimes intentionally add to an image during editing to bring the viewer's eye inward toward the subject.

You can test your lenses for vignetting by photographing an evenly lit white subject such as a white paper background or wall at the lens' maximum aperture and at a moderate aperture such as f/8 and examine the images for dark corners. Then you can enable Peripheral Illumination Correction on the camera and repeat the images to see how much difference it makes.

If you use Peripheral Illumination Correction for JPEG images, the amount of correction applied is just shy of the maximum amount. If you shoot RAW images, you can, however, apply the maximum correction in Digital Photo Professional. Also, the amount of correction for JPEG images decreases as the ISO sensitivity setting increases. If the lens has little vignetting, the difference in using Peripheral Illumination Correction may be difficult to detect. If the lens does not communicate distance information to the camera, then less correction is applied. Canon recommends that you turn off correction if you use a non-Canon lens.

Here is how to turn on Peripheral Illumination Correction:

- 1. Set the camera to the JPEG image quality setting that you want.
- 2. Press the Menu button, and then turn the Main dial to highlight the Shooting 1 menu.
- 3. Turn the Quick Control dial to highlight Peripheral illumin. Correct., and then press the Set button. The Peripheral illumin. Correct. screen appears with the attached lens listed, and whether or not correction data is available. If correction data is unavailable, then you can register correction data using the Canon EOS Utility program.
- 4. Turn the Quick Control dial to select Enable if it is not already selected, and then press the Set button.

Doing More with Lens Accessories

There are a variety of ways to increase the focal range and decrease the focusing distance to provide flexibility for the lenses you already own. These accessories are not only economical, but they extend the range and creative options of existing and new lenses. Accessories can be as simple as a lens hood to avoid flare, a tripod mount to quickly change between vertical and horizontal positions without changing the optical axis or the geometrical center of the lens, or a drop-in or adapter-type gelatin filter holder. Other options include using extension tubes, extenders, and close-up lenses.

Lens extenders

For relatively little cost, you can increase the focal length of any lens by using an extender. An *extender* is a lens set in a small ring mounted between the camera body and a regular lens. Canon offers two extenders, a 1.4x and 2x, that are compatible only with L-series Canon lenses. Extenders can also be combined for even greater magnification.

For example, using the Canon EF 2x II extender with a 600mm lens doubles the lens's focal length to 1200mm before applying 1.6x. Using the Canon EF 1.4x II extender increases a 600mm lens to 840mm.

However, extenders reduce the light reaching the sensor. The EF 1.4x II extender decreases the light by 1 f-stop, and the EF 2x II extender decreases the light by 2 f-stops. In addition to being fairly lightweight, the obvious advantage of extenders is that they can reduce the number of telephoto lenses you carry.

The 1.4x extender can be used with fixed focal-length lenses 135mm and

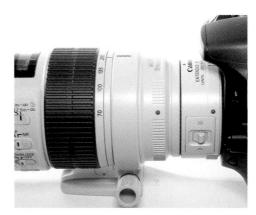

9.12 Extenders, such as this Canon EF 1.4x Il mounted between the camera body and the lens, extend the range of L-series lenses. They increase the focal length by a factor of 1.4x, in addition to the 1.6x focallength conversion factor inherent in the camera.

longer (except the 135mm f/2.8 Softfocus lens) and the 70-200mm f/2.8L, 70-200mm f/2.8L IS, 70-200mm f/4.0L, 70-200mm f/4.0L IS USM, and 100-400mm f/4.5-5.6L IS zoom lenses. With the EF 2x II, autofocus is possible if the lens has an f/2.8 or faster maximum aperture and compatible IS lenses continue to provide stabilization for two shutter speeds less than 1/focal length in seconds.

Extension tubes and close-up lenses

Extension tubes are close-up accessories that provide magnification increases from approximately 0.3 to 0.7, and they can be used on many EF lenses, though there are exceptions. Extension tubes are placed between the camera body and lens and connect to the camera via eight electronic contact points. Extension tubes can be combined for greater magnification.

Canon offers two extension tubes, the E 12 II and the EF 25 II. Magnification differs by lens, but with the EF12 II and standard zoom lenses, it is approximately 0.3 to 0.5. With the EF25 II, magnification is 0.7. When combining tubes, you may need to focus manually. Extension tubes are compatible with specific lenses. Be sure to check the Canon Web site for lenses that are compatible with extension tubes.

Additionally, you can use screw-in close-up lenses. Canon offers three lenses that provide enhanced close-up photography. The 27D/500D series uses a double-element design for enhanced optical performance. The 27D/500D series features double-element achromatic design to maximize optical performance. The 500 series has a single-element construction for economy. The working distance from the end of the lens is 25cm for the 27D and 50cm for the 500D.

Learning Lens Lingo and Technology

As you think about the lenses that you want to add to your system, it helps to also understand the language and technologies that apply to lenses. Canon uses several designations and lens construction technologies that are summarized here.

- EF lens mount. The designation EF identifies the type of mount that the lens has. The EF lens mount provides not only quick mounting and removal of lenses, but it also provides the communication channel between the lens and the camera body. The EF mount is fully electronic and resists abrasion, play, and shock. The EF system does a self-test using a built-in microcomputer that alerts you to possible malfunctions of the lens via the camera's LCD screen. In addition, if you use lens extenders, the exposure compensation is automatically calculated.
- ▶ USM. When you see USM it indicates the lens features an ultrasonic motor. A USM lens has an ultrasonic and very quiet focusing mechanism (motor) that is built in. The motor is powered by the camera; however, because the lens has its own focusing motor you get exceptionally fast focus. USM lenses use electronic vibrations created by piezoelectric ceramic elements to provide quick and quiet focusing action with near instantaneous starts and stops.

In addition, lenses with a ring-type ultrasonic motor offer full-time manual focusing without the need to first switch the lens to Manual Focus. This design is offered in the large-aperture and super-telephoto lenses. A second design, the micro ultrasonic motor, provides the advantages of this technology in the less expensive EF lenses.

- L-series lenses. Canon's L-series lenses feature a distinctive red ring on the outer barrel, or in the case of telephoto and super-telephoto lenses, are distinguished by Canon's well-known white barrel. The distinguishing characteristics of L-series lenses, in addition to their sobering price tags, are a combination of technologies that provide outstanding optical performance. L-series lenses include one or more of the following technologies and features:
 - UD/Fluorite elements. Ultralow Dispersion (UD) glass elements help minimize color fringing or chromatic aberration. This glass also provides improved contrast and sharpness. UD elements are used, for example, in the EF 70-200mm f/2.8L IS USM and EF 300mm f/4L IS USM lenses. Fluorite elements, which are used in super-telephoto L-series lenses, reduce chromatic aberration. Lenses with UD or fluorite elements are designated as CaF2, UD, and/or S-UD.
 - Aspherical elements. This technology is designed to help counteract spherical aberration that happens when wide-angle and fast normal lenses cannot resolve light rays coming into the lens from the center with light rays coming into the lens from the edge into a sharp point of focus. The result is a blurred image. An aspherical element uses a varying curved surface to ensure that the entire image plane appears focused. These types of optics help correct curvilinear distortion in ultrawide-angle lenses as well. Lenses with aspherical elements are designated as AL.
 - Dust, water-resistant construction. For any photographer who shoots in inclement weather, whether it's an editorial assignment or sports event, having a lens with adequate weather sealing is critical. The L-series EF lenses have rubber seals at the switch panels, exterior seams, drop-in filter compartments, and lens mounts to make them both dust and water resistant. Moving parts including the focusing ring and switches are also designed to keep out environmental contaminants.
- Image Stabilization. Lenses labeled as IS lenses offer image stabilization. IS lenses allow you to handhold the camera at light levels that normally require a tripod. The amount of handholding latitude varies by lens and the photographer's ability to hold the lens steady, but you can generally count on 1 to 4 additional f-stops of stability with an IS lens than with a non-IS lens.

- Macro. Macro lenses enable close-up focusing with subject magnification of one-half to life size and up to 5X with the MP-E 65mm f/2.8 Macro Photo lens.
- ▶ Full-time manual focusing. An advantage of many Canon lenses is the ability to use autofocus, and then tweak focus manually using the lens's focusing ring without switching out of autofocus mode or changing the switch on the lens from the AF to MF setting. Full-time Manual Focusing comes in very handy, for example, with macro shots and when using extension tubes.
- Inner and rear focusing. Lens's focusing groups can be located in front or behind the diaphragm, both of which allow for compact optical systems with fast AF. Lenses with rear optical focusing, such as the EF 85mm f/1.8 USM, focus faster than lenses that move their entire optical system, such as the EF 85mm f/1.2L II USM.
- Floating System. Canon lenses use a floating system that dynamically varies the gap between key lens elements based on the focusing distance. As a result, optical aberrations are reduced or suppressed through the entire focusing range. In comparison, optical aberrations in non-floating-system lenses are corrected only at commonly used focusing distances. At other focusing distances, particularly at close focusing distances, the aberrations appear and reduce image quality.
- AF Stop. The AF Stop button allows you to temporarily suspend autofocusing of the lens. For example, you can press the AF Stop button to stop focusing when an obstruction comes between the lens and the subject to prevent the focusing from being thrown off. When the obstruction passes by the subject, the focus remains on the subject provided that the subject hasn't moved so that you can resume shooting. The AF Stop button is available on several EF IS supertelephoto lenses.
- Focus preset. This feature lets you program a focusing distance into the camera's memory. For example, if you shoot a bicycle race near the finish line, you can preset focus on the finish line and then shoot normally as riders approach. When the racers near the finish line, you can turn a ring on the lens to instantly return to the preset focusing distance, which is on the finish line.
- Diffractive optics. Diffractive optics (DO) are made by bonding diffractive coatings to the surfaces of two or more lens elements. The elements are then combined to form a single multilayer DO element designed to cancel chromatic aberrations at various wavelengths when combined with conventional glass optics. Diffractive optics result in smaller and shorter telephoto lenses without compromising image quality. For example, the EF 70-300mm f/4.5-5.6 DO IS USM lens is 28 percent shorter than the EF 70-300mm f/4.5-5.6 IS USM lens.

CHAPTER

Event and Action Photography

With a burst rate of 126 shots with a UDMA card and the allnew autofocus system that's fast and accurate, the EOS 7D helps you keep up with event and action subjects without a hiccup.

The category of event and action photography covers everything from festivals, corporate gatherings, and weddings to sports and other competitive events such as car and motocross racing. Opportunities abound for one-of-a-kind images that capture the emotion and thrill of the event.

Central to capturing the decisive moments is having a camera that not only responds with quick focusing and a snappy

shutter but also that can record a succession of images during critical moments in the event or peak moments of competitive action.

Event and Action Photography

With a generous burst rate and reasonable performance at higher ISO settings, the 7D is especially well-suited for shooting events and action whether that means sports events and races, or concerts, carnivals, festivals, receptions, and parties. And whether you're a seasoned professional, or you're just starting with event photography, the opportunities for both earning income and making great images make these areas of photography attractive.

10.1 Twilight is an excellent time to capture a sapphire blue in the sky. In this image, the twilight sky contrasts beautifully with the glow of the hot-air balloons as they set up for a show. Exposure: ISO 800, f/2.8, 1/80 second using an EF 24-70mm f/2.8L USM lens.

Regardless of the subject, the objective is to show the energy and emotion of the event as well as capturing the decisive moments, and at 8 fps with up to 126 Large/ JPEG shots per burst with an Ultra DMA card, the 7D will keep up with the action.

Packing the gear bag

One of the characteristics of event and action shooting is that you have only one opportunity to capture the images. Whether the event is a wedding or athletic competition, if you don't get the shot, there are no do-overs. With that in mind, it is important to have what you need in the gear bag, including backup gear should you need it.

The gear that you pack in the camera bag is directly related to the scene and subjects that you're going to shoot as well as other factors including your distance from the action, the lighting, weather, length of the event, how much you're willing to carry, and other factors.

As you look at these suggestions, consider them a starting point for your planning:

The 7D and a backup camera body. Many events are once in a lifetime situations, so if anything goes wrong with the 7D, you need a backup 7D or other EOS camera body so that you can continue shooting without a hiccup.

With two 7D bodies, you can also have a camera mounted

10.2 I like to get clean backgrounds for action shots, but in this scene, it wasn't possible. The boys watching the skater are distracting, but, on the other hand, they add the element of an audience. Exposure: ISO 200, f/5, 1/3200 second using an EF 70-200m f/2.8L IS USM lens.

with a wide-angle lens and the other camera mounted with a telephoto lens — or whatever lenses make sense for the subject you're shooting.

One or more wide-angle and telephoto zoom lenses. I've found the 24-70mm f/2.8L USM lens and the 70-200mm f/2.8L IS USM lens to be a versatile combination depending, of course, on the shooting proximity to the players or participants. In good light, you can make good use of the Extender EF 1.4x II or Extender EF 2x II to get more reach with compatible telephoto lenses. (See Chapter 9 for details on which lenses work with extenders.)

Other good telephoto lens choices are the EF 28-135mm f/3.5-5.6 IS USM, the EF 100-400mm f/4.5-5.6L IS USM, or the EF 70-300mm f/4.5-5.6 IS USM lens. For low-light events such as concerts, fast lenses including the EF 50mm f/1.2L

USM and the EF 85mm f/1.2L II USM will practically shoot in the dark. For outdoor events such as motocross or events where dirt and wind collide, be sure to have lens-cleaning cloths handy as well.

- Monopod or tripod. If the event continues through sunset and evening hours, then you'll be glad to have the solid support of a tripod. To almost all events, I carry the TrekPodGO that includes fold-out legs.
- Laptop computer or portable storage device, spare CF cards, and charged batteries. Any event that features action means that you'll take a lot of images. If you have multiple CF cards, be sure that you have a system for keeping used cards separate from empty cards. And depending on how many cards you have, consider offloading images to a laptop or handheld storage unit during lulls in the action. Certainly you want a minimum of one spare charged battery and maybe two, depending on the duration of the event.
- Weatherproof sleeves and camera cover. If it rains or if you're shooting in fog or mist, having a weatherproof camera jacket and lens sleeve is good insurance against camera damage and malfunctions.

Setting up the 7D for event and action shooting

I'm a big fan of the 7D's C shooting mode customization. If you routinely shoot events in a specific venue such as an arena, then you can set up and register settings for one of the C modes specifically for that venue. Then you have little if any camera adjustments to make before you begin shooting.

Here are some suggestions for camera and Custom Function settings for action and event photography. Modify them as appropriate for your needs.

- RAW+JPEG image quality. Many photographers shoot events and sell the images to players and family. They post the event images to a Web site where players can order prints. If you do this or are considering doing it, then the RAW+JPEG or Medium or Small RAW+JPEG image quality options come in handy. The JPEG images enable you to immediately post images to the Web site while the RAW or Medium and Small RAW images give you the option to process exceptional shots for maximum potential or tweak shots that need more attention.
- Tv shooting mode. This mode gives you control over the shutter speed so that you can freeze action of the players or participants and get tack-sharp focus given the lens that you're using. Just remember that for non-IS lenses, the handholding guideline is 1/[focal length]. So for a 300mm lens, you need at least a

1/300 second shutter speed to be able to handhold the camera and lens and get a sharp image.

Al Servo AF mode and manual or automatic AF-point selection. Al Servo AF mode is designed for action shooting by tracking subject motion. This is where zone focusing can come in handy. If you set up the AF area zones detailed in Chapter 3, switching to the zone that the subject is in is as easy as pressing the AF point selection and M-Fn buttons. Then you can choose the starting AF point for subject focus tracking or let the camera choose it.

The 7D offers an array of Custom Functions to refine AI Servo AF performance. You can use Al Focus AF that starts out in Oneshot AF and automatically switches to AI Servo AF if the subject starts moving, or Oneshot AF where you choose the

10.3 Bright mid-day sun made this exposure problematic. To prevent the bright facial highlights from blowing out, I set Exposure Compensation to -1. Exposure: ISO 100, f/4, 1/1600 second with -1 Exposure Compensation using an EF 70-200m f/2.8L IS USM lens.

focus with no focus tracking from the camera. If you use One-shot AF mode, then consider using AF point expansion mode to allow the 7D to use adjacent AF points to help achieve focus.

▶ **High-speed Continuous drive mode.** High-speed continuous shooting (8 fps) allows a succession of shots up to 126 Large Fine JPEGs if you are using an Ultra DMA card or 94 with a non-UDMA card per burst. When the internal camera buffer is full, you will be able to continue shooting as images are offloaded to the CF card. Also, if you see FuLL CF in the viewfinder, wait until the red access lamp goes out to replace the card. The camera displays a warning if you open the CF card door while images are being recorded.

If the 7D is not shooting the burst rate that you expect, check to see if you have enabled C.Fn II-2, High ISO speed noise reduction, which can reduce the burst rate depending on the option chosen.

- Evaluative metering mode. With the 7D's improved metering linked to the AF points, Evaluative metering performs well in a variety of different lighting situations.
- Picture Style. The Standard Picture Style is a good choice, particularly if you've previously tested it and examined the prints.
- Custom Functions. For action and events, consider using C.Fn I-2, ISO speed setting increments, and choosing Option 1: 1 stop. This enables larger ISO changes instead of the default 1/3 stop increment. You can consider enabling ISO expansion, C.Fn I-3, but you should test the H (12800) setting for digital noise level before using it.

Exposure Safety Shift, C.Fn I-7, automatically adjusts the exposure if the light suddenly changes enough to make the current exposure settings inaccurate. This can be helpful for outdoor events as well as indoor events where the lighting varies across the venue. Consider also using C.Fn IV-1 reassign the functions of camera buttons to suit your shooting needs.

Shooting Events and Actions

The 7D offers versatility in shooting a broad range of events and games with a seriously fast shutter action and excellent burst depth. Couple that with shutter speeds ranging from 1/8000 to 30 seconds and Bulb, and you have ample opportunity to freeze or show motion, and to create interesting panned images. Action photography and the techniques used for it are by no means limited to sports. Any event — from a football game to a carnival or concert — is an opportunity to use action-shooting techniques.

Exposure approaches and shooting techniques

A classic action approach is to show the motion of the athlete or participant in midwhatever — midjump, midrun, middrop — with tack-sharp focus and no motion blur. Stopping action requires fast shutter speeds and fast shutter speeds require ample light, or an increased ISO sensitivity setting. The shutter speed that you need to stop motion depends on the subject's direction in relation to the camera. Table 10.1 provides some common action situations and the shutter speeds needed to stop motion and to pan with the motion of the subject.

Subject direction in relation to camera	Shutter speeds in seconds
Subject is moving toward camera	1/250
Subject is moving side-to-side or up-and-down	1/500 to 1/2000
Panning with the motion of the subject	1/25 to 1/8

Table. 10.1 Recommended Shutter Speeds for Action Shooting

Depending on the light and the speed of the lens that you're using, getting a fast shutter speed often means increasing the ISO sensitivity setting. In previous chapters, I recommended shooting test shots at the higher ISO settings, and then evaluating the images for digital noise at 100 percent enlargement on the computer.

You also should print the images and view them at a standard 1-foot viewing distance to evaluate digital noise and at what ISO setting it becomes objectionable. I shoot at the lowest ISO possible to get the shutter speed that I need to stop subject motion. I do not shoot at sensitivity settings higher than ISO 1600, and I use ISO 1600 when the light is too low to allow shooting at ISO 800 or 400.

Getting accurate and visually pleasing color is important as well. For outdoor events and games, the preset White Balance settings such as Daylight, Cloudy, and so on are excellent, and

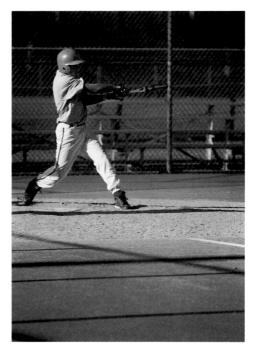

10.4 For action shooting, timing the shutter release is everything. Here I shot a tad too slow to capture the ball coming off the bat. Exposure: ISO 200, f/2.8, 1/4000 second with -2/3's stop Exposure Compensation using an EF 70-200mm f/2.8L IS USM lens.

you will always get better color by using one of these settings versus setting Auto White Balance.

Add a Sense of Motion with Panning

If you've wondered how photographers capture images where the subject is in focus but the background details appear as colorful streaks, wonder no more. The technique they use is called panning, and it involves focusing on the subject, and then moving the camera with the motion of the subject while using a slow shutter speed. Here is how the technique works:

- 1. Find a shooting location where the background will be attractive when it is rendered as long streaks of color.
- 2. Set the 7D to Tv mode, and set a shutter speed that is slow enough to allow you to record movement with the camera. I typically use shutter speeds slower than 1/30 sec. I've found that 1/30 sec. is not long enough to get good follow through motion with the camera while the shutter is open. I usually set 1/25 to 1/8 sec. In addition, it is great if you can also get a fairly narrow aperture to give better acceptable sharpness throughout the subject.

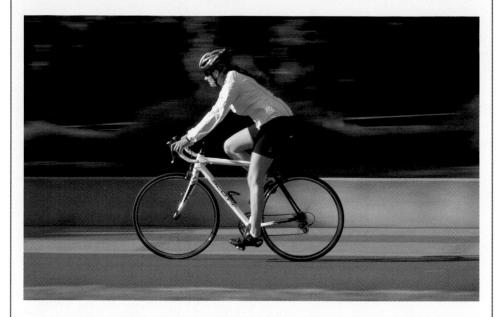

3. Prefocus on a spot where the subject will eventually be in the scene and keep the Shutter button half-pressed. In this example, I focused on a spot in the bike trail. Then I watch for the subject to come into the scene.

4. When the subject enters the frame, move the camera to start following the subject's motion and when the subject hits the spot where you prefocused, press the Shutter button completely to make the picture and continue moving the camera with the subject as the subject leaves the scene.

This technique is much easier to accomplish if you are using a tripod. The tripod keeps the scene level and frees you to concentrate on a smooth panning motion. But it's also possible to pan while you are handholding the camera.

Since I shoot RAW, I carry a small gray card and take a picture of it in the event light. If the light changes, I shoot a new picture of the gray card. Then I open the images taken under the same light as a group with the picture of the gray card in a RAW conversion program. I can select all the images, click the gray card, and color balance the entire image series. Other photographers prefer using the ExpoDisc, a calibrated 18 percent gray lens filter.

Find your own gray card attached in the back of this book.

While stopping subject motion is what we often most see in event and action images, there are also countless scenes where a slow shutter speed creates a rich display of motion whether it's the blurred lights of a Ferris wheel or the crash of a waterfall where the water is transformed to a silky blur. And the range of subjects is almost limitless. Even everyday occurrences such as a dog coming out of a lake after a swim present opportunities to explore the effect of motion against motion or motion against a still backdrop. The same is true for music concerts, athletic events, and some events during weddings.

Combine a flash with a slow shutter, and you open new doors for creative renderings that add the dynamic aspect of motion to event and action images. One technique that is popular with wedding photography is called *dragging the shutter*, and while it can be used with or without a flash, it's very often used in combination with flash. This technique has several components. First, the flash suspends subject motion for a sharply focused subject; second, a slow shutter speed allows the existing light to fully register during the exposure; and, third, panning the camera creates blur that adds the dynamic sense of motion to the image.

Canon EOS 7D Digital Field Guide

10.5 This image of a Ferris wheel in motion was shot with a monopod that I stabilized by wedging it between the back and seat sections of a bench, and then pushing the monopod forward with one hand to stabilize it. Exposure: ISO 400, f/18, 2.5 seconds using an EF 24-70mm f/2.8L USM lens.

You can set the Speedlite to secondcurtain sync so that the flash fires at the end of the exposure rather than at the beginning so that the motion is recorded and the subject motion is frozen at the end of the exposure with the pop of flash. During the long exposure, you can pan the camera with or against the direction of the subject

10.6 A slow 1/25-second shutter speed captures the circular motion of the dog's coat as he shakes off water after a swim in Lake Washington. Exposure: ISO 100, f/8, 1/25 second using an EF 24-70mm f/2.8L USM lens.

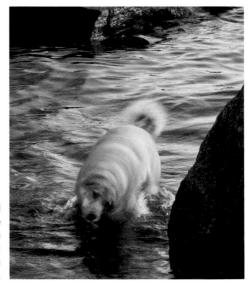

motion. Or you can turn the camera to create a circular background blur, or you can zoom the lens during the exposure.

Of course, the subject should be sharply focused, so the usual lens handholding guidelines apply.

Tips for capturing the moment

Beyond the point of selecting the correct shutter speed to capture the action, the biggest challenges of action shooting are timing shots and composing images. The first challenge is to anticipate the moments of high emotion and the decisive moment. And when the mirror flips up, you hold your breath during the blackout hoping that you captured the critical moment. Because the subject is in constant motion, there is limited time to compose the image as you react to the subject's motion.

In many scenarios, action shooting often means getting a handful of keepers from 50 to 100 exposures. You can use a few approaches to increase your ability to get good action images.

- In a venue with spotty lighting, find an area with good light. Prefocus on the area, and then wait for the action to come to that spot. If your lens allows prefocusing, then you can prefocus on an important area such as the goal line. Then continue shooting other areas until the action moves to the goal line, and press the preset button to have the lens automatically return focus to that area.
- Keep exposure changes to a minimum for as long as the light allows so that you can concentrate on capturing the important moments and composing images.
- Anticipate the action. Whether the event is a football game or a wedding recessional, knowing what is likely to happen next means that you can set up for the next action sequence before the subject gets to the area.

You can switch between using a telephoto lens to photograph action, and a wideangle lens to capture establishing shots of the overall venue, the audience, and crowd reactions. These are the shots that help create the full story and spirit of the event.

10.7 Whether you're shooting iconic image of American pastimes and events or sports, event and action shooting gives you an opportunity to challenge your photographic skills and creative vision. Exposure: ISO 400, f/14, 1/ 8 second using an EF 24-70mm f/2.8L USM lens.

CHAPTER

Nature and Landscape Photography

When you combine the rich features of the EOS 7D with your creative vision, you have all you need to make stunning nature and landscape images.

Making pictures is the unconscious blending of the technical and creative aspects of photography so they become a synergistic and fluid process — each complimenting the other. In this chapter, both the technical and creative aspects of shooting with the 7D come into play with different approaches to making exposures.

Nature and Landscape Photography

It is a rare photographer who is not lured to places near and far and in all kinds of weather, simply by the call to capture the stunning beauty of creation. And this area of photography encompasses travel, fine-art landscape, seascapes, flora, fauna, wildlife, and birds, as well as close-ups of the smallest structures in the natural world.

All of these areas share commonality in the wide diversity of light, in the goal of capturing the singular beauty, structure, and rhythm of the scenes and subjects, and in the need to creatively interpret what you see and perceive in new and exciting ways.

Many of the techniques used for nature and landscape photography can also be applied to shooting skyscapes, cityscapes, and, in part, outdoor architectural photography.

11.1 Stormy weather offers an excellent opportunity to capture dramatic cloud formations and unique lighting on a landscape scene. Exposure: ISO 100, f/4.5, at 1/30 second using an EF 100-400mm f/4.5-5.6L IS USM lens.

In the camera bag

The adventure of outdoor photography begins by having a good selection of lenses and filters, as well as other accessories. The lenses and filters that you choose for landscape and nature photography depend on the scenes and subjects that you're shooting or that you're likely to encounter on a hike or trip. Because nature offers such an amazing variety of subjects and because the light can change in minutes, my approach is to be prepared to capture everything, from sweeping landscapes to closeups of flora and fauna, and to be prepared for any light and weather.

At the top of the packing list are lenses. Here are some lenses to consider packing in addition to other gear that will come in handy.

Wide-angle lenses. To capture truly sweeping landscapes with the 7D, you need a wide-angle and ultra-wide-angle lens such as the EF 16-35mm f/2.8L II USM, EF-S 10-22mm f/3.5-4.5 USM, or the EF 17-40mm f/4L USM lens. If you don't have a wide-angle lens, consider using the lens you have, and shoot a panorama of images that you can later stitch together using the PhotoStitch program that Canon provides on the EOS Digital Solution Disk.

If you shoot panoramas, it's also a good idea to have a monopod or a tripod to keep the image series level. Keeping the images level makes stitching images together easier and more precise.

Telephoto lenses. Your choice of telephoto lenses depends to some extent on what shooting opportunities you'll most likely encounter. For example, if the area has wildlife, then pack the longest telephoto lens that you own, along with the Canon Extender EF 2x II or the Extender EF 1.4x II, to double the focal length or to multiply the focal length by 1.4x, respectively.

In general, a lens in the 70-200mm or 100-400mm range is a good choice for birds and wildlife, and to bring distant landscapes closer.

Lens extenders can be used with all prime (single-focal-length) lenses of 135mm and longer, except the 135mm f/2.8 Softfocus lens. Extenders can also be used with the EF 70-200mm f/2.8L, 70-200mm f/2.8L IS, 70-200mm f/4.0L, 70-200mm f/4.0L IS USM, and 100-400mm f/4.5-5.6L IS zoom lenses. When you use an extender, it reduces the maximum effective aperture. The 1.4x extender reduces the effective aperture by 1 f-stop, and the 2x extender reduces it by 2 f-stops.

Optional Filters

The most useful filters in outdoor photography include the circular polarizer, neutral density and variable neutral density filters, and warm-up filters. Here is a brief overview of each type of filter.

- Polarizer. Polarizers deepen blue skies, reduce glare on surfaces to increase color saturation, and help remove spectral reflections from water and other reflective surfaces. A circular polarizer attaches to the lens, and you rotate it to reduce glare and increase saturation. Maximum polarization occurs when the lens is at a right angle to the sun. With wide-angle lenses, uneven polarization can occur, causing part of the sky to be darker than the sky closest to the sun. You can use a 1- to 2-stop neutral density (ND) graduation filter to tone down the lighter area of the sky by carefully positioning the grad-ND filter. If you use an ultrawide-angle lens, be sure to get the thin polarizing filter to help avoid vignetting that can happen when thicker filters are used at small apertures. Both B+W and Heliopan offer thin polarizing filters.
- Variable neutral density filters. Singh-Ray's Vari-ND variable neutral density filter (www.singh-ray.com/varind.html) allows you to continuously control the amount of light passing through your lens up to 8 stops, making it possible to use narrow apertures and slow shutter speeds, even in brightly lit scenes. Thus you can show the motion of a waterfall, clouds, or flying birds. The filter is pricey, but it is a good addition to your gear bag.
- Graduated neutral density filters. These filters allow you to hold back the brightness in the sky from 1 to 3 f-stops to balance a darker foreground with a brighter sky. Filters are available in hard or soft-stop types and in different densities: 0.3 (1 stop), 0.45 (1.5 stops), 0.6 (2 stops), and 0.9 (3 stops). With this filter, you can darken the sky without changing its color; its brightness is similar to that of the landscape, and it appears in the image as it appears to your eye.
- Warm-up filters. Originally designed to correct blue deficiencies in light or certain brands of film, warm-up filters correct the cool bias of the light. You can use them to enhance the naturally warm light of early morning and late afternoon. Warm-up filters come in different strengths, including 81 (weak-est); 81A, B, C, and D; and 81EF (strongest). For the greatest effect, combine a warm-up filter with a polarizer.

- Macro lenses. I seldom go anywhere without a macro lens. If I know that I'll be doing a lot of macro shooting, I take both a long and short macro lens. For macro work where you can't or don't want to get close to the subject, the EF 180mm f/3.5L Macro USM lens is ideal. For flowers and plants, either the EF-S 60mm f/2.8 Macro USM or the EF 100mm f/2.8L Macro IS USM les is an excellent choice.
- Filters. Standard filters for outdoor shooting include a high-quality circular polarizer, and graduated neutral density filters. Filters are described in the Optional Filters sidebar in this chapter.
- Weatherproof camera and lens sleeves. The EOS 7D has more weather sealing than some EOS cameras, but it's not as extensive as the 1Ds Mark III or 1D Mark III. And non-L-series lenses also lack extensive weather sealing. As a result, carrying along a water-repellant bag is good insurance against moisture, as well as dust and sand that can quickly put a camera out of commission. You can buy a wide variety of weatherproof camera protectors from Storm Jacket, Pelican, Aquatec, and Op-Tech. If your lenses are not well sealed, then a good lens sleeve is also in order. I always also have several quart-size plastic bags in my camera bag that I can use to protect accessories during an unexpected shower. Most newer camera bags are water repellent and have overlapping protectors around zippers to keep moisture and dust out of the bag. But if you've left the camera bag in the car and venture out with a spare lens and some filters, the separate camera covers and lens sleeves come in handy.
- Additional gear. Because conditions can change quickly, and depending on the time of day and the focal length of your telephoto lenses, you may need a sturdy tripod or a monopod. You also need spare CF cards, charged camera batteries, cell phone, plastic bags, florist's wire (to steady plants), silver reflectors, GPS locator, and water and snacks as necessary. If you're on an extended shooting trip, you'll want to carry a laptop or handheld drive to offload photos at the end of each day's shooting.

While the 7D is a great camera and Canon lenses are among the best on the market, the camera and lens capture only what you see. So keep your photographic eye practiced and sharp and bring along your curiosity and passion.

Setting up the 7D for outdoor shooting

Different photography subjects require different camera setups. And, if you've read through the book to this point, now is the time to get the most you can from the 7D's rich features and options. After all, why have a full-featured camera and use only a fraction of its power?

So when I get ready to go out shooting, I always think through all of the camera settings that I want to use and set as many options as possible before I leave. Not only does this planning save time when I'm ready to begin shooting, but it also helps avoid oversights that can make a big difference in the quality of the images. By the time I get to the location where I'm shooting, I can get in position and concentrate on evaluating the scene, the light, and the composition.

11.2 For this shot of the Cascade mountains, I was handholding the camera with the lens zoomed to 200mm. I used Av mode, and the shutter speed at 1/100 second normally would not be fast enough to ensure sharp focus, but with Image Stabilization, I was able to get tack-sharp focus. Exposure: ISO 100, f/13, at 1/100 second using the EF 70-200mm f/2.8L IS USM lens.

Speaking of handy 7D features, you can use a C mode to register your preferred settings for the shooting, metering, drive, and autofocus mode, the Custom Functions that you prefer, and the Picture Style you want to use.

Here is a checklist of camera settings that you can set in advance, or register as a C mode.

Av shooting mode. In most outdoor and nature scenes, a primary goal is to control the depth of field. For that reason, many photographers use Av shooting mode because with one adjustment, they can set the aperture while the camera automatically adjusts the shutter speed. If you use Av shooting mode and you're

handholding the camera, be sure to continually check the shutter speed. If the shutter speed is too slow, you run the risk of getting an out-of-focus image.

As a rule of thumb, the minimum shutter speed at which you can handhold a non-IS lens is the reciprocal of the focal length. Thus, for a 200mm lens or zoom setting, the minimum shutter speed at which you can handhold the camera and get a sharp image is 1/200 second. For a 300mm lens, the fastest shutter speed is 1/300 second, and so on. If the shutter speed is too slow and you're handhold-ing the camera, then increase the ISO, stabilize the camera on a tripod or monopod, switch to an IS lens if possible. But if you're shooting in lower light such as at dusk, you may want to switch to Tv mode to lock in a fast enough shutter speed to handhold the camera.

One-shot AF mode with manual AF-point selection. I use One-shot AF mode with manual AF-point selection because I always want to control where the point/ plane of sharpest focus is in the image. But if you're shooting birds or wildlife, then you may prefer using AF Focus AF, which automatically switches to automatic focus tracking (AI Servo AF mode) if the subject begins to move. And for birds and wildlife, the AF AF-area selection modes discussed in Chapter 3 can work to your advantage. I also like to use the Orientation linked AF point C.Fn III-12. As I change from horizontal to vertical shooting, the AF selection mode.

11.3 In average scenes such as this, the 7D produces very good exposures. However, to keep good detail in the brightest water highlights, I used a -1/3 stop Exposure Compensation setting. Exposure: ISO 100, f/22, at 1/200 second, -1/3 Exposure Compensation using an EF 16-35mm f/2.8L USM lens.

- Single or a Continuous Drive mode. The drive mode you choose depends on the scene or subject you're shooting. If I'm shooting in areas where birds and wildlife are common, then I use high-speed continuous shooting. But if I'm shooting only landscapes or other non-moving subjects, then I use Single Drive mode.
- Evaluative or Spot Metering mode. Evaluative metering gives good results in a majority of scenes. I also often use AE Lock to meter on midtone areas and lock that exposure. To review how to use AE Lock, go to Chapter 3. You can also switch to Spot metering mode and Manual shooting mode and meter on a middle gray area of the scene.
- Picture Style. Because I always edit my images on the computer before displaying them on the Web or printing them, I use my modified Neutral Picture Style for shooting outdoors. This style offers ample room for interpreting the color and contrast during image editing, and the colors are very true to the scene. You can also use Landscape Picture Style with its more vivid greens and blues. If you don't edit images on the computer before printing them, then the Standard Picture Style also produces good prints from the camera.

For more information on modifying Picture Styles, see Chapter 5.

Custom Functions. My choices depend on the scene and subject, but in general, here are some Custom Functions that you may want to consider. If you want to make larger or smaller changes in aperture and shutter speed, then you can set exposure level increments, C.Fn I-1, to 1/2 stop instead of the default 1/3 stop increment. Safety shift (C.Fn I-6) offers some insurance to automatically change the exposure setting if the light suddenly changes. Long exposure and High ISO noise reduction (C.Fn II: 1 and 2) are good choices if you are shooting low light at a high ISO setting and/or using long exposures. If you are using a super-telephoto lens, the C.Fn III-4 will minimize defocusing when the lens is having trouble achieving focus. Finally, you can set C.Fn III-13 to lock up the reflex mirror to prevent blur when you are making long exposures or macro shots, or using a long lens.

Shooting Mode Considerations

There are different opinions about which shooting mode is best for outdoor and nature scenes. Here is a synopsis of when and why photographers use Av, Tv, and M shooting modes for landscape and nature shooting.

- Av mode seems like the logical choice since it enables control over the depth of field with a minimum of adjustments. And this mode works well as long as you keep an eye on the shutter speed to ensure it is fast enough to get a sharp image if you are handholding the camera.
- Some photographers prefer to use Tv shooting mode. This school of thought argues that the ability to control depth of field is useful only so long as the image has sharp focus. And to get sharp focus when you're handholding the camera, controlling the shutter speed is a more important than controlling the aperture. Using Tv mode, you can lock in the shutter speed fast for handholding the camera and lens (depending on the light, of course). And if there is potential subject movement, Tv mode enables you to quickly set a fast enough shutter speed to freeze subject motion.
- For photographers who determine exposure settings by metering from a gray card or from a midtone in the scene, M (Manual) mode is best because it is necessary to manually set the aperture and the shutter speed based on the mid-tone meter reading. You can meter a middle tone in Tv or Av mode using AE lock as well, but it is a temporary setting.

Approaches to Exposure

Technically, good exposure is one that retains detail in the highlights and shadows, and that has a full range of tones between the brightest highlight and the deepest shadow. In addition to this, the late, great photographer Monte Zucker added this caveat: "A properly exposed digital file is one in which the [tonal range] fits within the range that can be printed on photographic paper and still show the same detail."

Good exposure should happen in the camera rather than in the image-editing phase. Too often, photographers see an exposure problem and think, "I'll fix it in Photoshop." Doubtless, many image problems can be improved with skillful editing in both a RAW conversion program and in Photoshop. But your goal should be to get the best incamera exposure that the 7D is capable of delivering. The exposure sections that follow assume that you want the best exposures from the 7D that you can get. At first glance, the advanced exposure approach may seem too complex or too much trouble. In that case, use the basic exposure technique knowing that the 7D will give you consistently good exposures. But the advanced technique is a classic for ensuring good exposure.

You can expect the 7D's onboard reflective light meter, along with Canon's new and improved Evaluative metering, to provide excellent exposures for most scenes. However, in some scenes, you'll want to override the camera's suggested exposure by using Exposure Compensation, Auto Exposure Lock, or Exposure Bracketing.

The camera assumes that all scenes contain a variety of tonal values from the highlights to the shadows. And if all of those values are averaged, they produce a middle-gray tonal value. As a result, if the middle-gray tones are properly exposed, then the tonal values will also be properly exposed in the final image in most scenes. Knowing this, you can correctly expose most nature and landscape scenes.

This basic exposure method, described next, is a popular exposure technique that is bolstered by the 7D's new metering sensor and metering algorithms. The camera takes into account focus, luminance, and color from the 63 zones throughout the viewfinder, and each layer of the duallayer sensor is sensitive to different wavelengths of light. The combination of the new sensor and algorithms provide very accurate meter readings.

11.4 This is another average scene where the onboard light meter produces an excellent exposure. Exposure: ISO 100, f/5.6, at 1/100 second using an EF 70-200mm f/2.8L IS USM lens.

Basic exposure technique

For the majority of nature and landscape images, the primary consideration is controlling the depth of field — whether you visualize a final image with extensive depth of field for a stunning sweep of flower-covered hills, or with a shallow depth of field for a selective focus in a macro shot. In any case, the shortest route to controlling the depth of field via aperture changes is Av shooting mode. And for metering, the Evaluative metering mode is a dependable and accurate metering mode, even for backlit subjects.

The usual sequence for the basic exposure approach is to set the aperture or shutter speed, and then make the first exposure using the camera's recommended settings. Then you evaluate the image and histogram to see if exposure modifications are needed. In some scenes, the camera's recommended exposure will need to be modified to preserve highlight detail or to open blocked shadows.

A spike on the right side of the histogram indicates blown highlights, and a spike on the left side indicates blocked shadows — shadows that transition too quickly to black. For more details, see Chapter 3.

Dealing with High-Dynamic Range Scenes

Many photographers use high-dynamic range imaging that involves shooting five to eight images bracketed by shutter speed, and then combining them in a high-dynamic range-imaging program. To aid in this type of imaging, the 7D enables you to set the bracketing range up to +/- 3 stops. However, you can increase this range by combining AEB with Exposure Compensation. Exposure Compensation offers 5 stops of compensation, so combining them gives a range of 8 stops from the metered exposure. It's beyond the scope of this book to detail the high-dynamic range processing steps, but many new books are available that describe both the steps and the specialty programs for this imaging approach.

Alternately, you can shoot a single RAW image, and then convert the image multiple times in a RAW conversion program, saving the different versions. For example, one version of the image is processed with an eye toward recovering or retaining highlight detail, another is converted to maximize midtone rendering, and another is to provide good shadow detail. These three different files are composited in Photoshop and manipulated to reveal the best details in each processed version.

Canon EOS 7D Digital Field Guide

Most often, photographers have to deal with high-dynamic range scenes. In practical terms, a high-dynamic range scene is one where the range from highlights to shadows as measured in f-stops is greater than the camera's imaging sensor can handle. In most high-dynamic range scenes, the camera sacrifices the highlights, resulting in blown highlights, although the shadows may also be blocked. If you're not sure whether the scene falls into the high dynamic range category, you can quickly assess the scene brightness range. Just switch to Spot metering mode and take a meter reading on a highlight and another on a shadow area. Then calculate the difference between the two readings.

If the range is greater than the camera can handle, you have several choices: to properly expose the subject and let the rest of the scene go overexposed or underexposed; to use high-dynamic range imaging; or, if you're shooting RAW images, to process a single

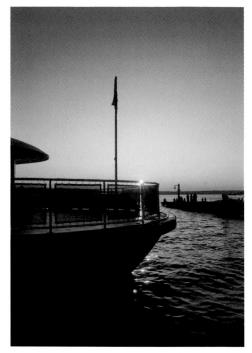

11.5 To capture the sun as a starburst, I used a narrow f/22 aperture, and I waited for the sun to just drop past the boat's deck railing to illuminate the bow of the boat. Exposure: ISO 200, f/22, at 1/200 second with -1/3 stop Exposure Compensation. I used an EF 16-35mm f/2.8L USM lens for this image.

RAW file multiple times to make the best of highlights, midtones, and shadows, and then composite the files into an image.

In some scenes, however, you can get better overall exposure by using exposure modification techniques. One of the goals of exposure is to retain highlight detail within the subject, and if possible, to maintain detail in most, if not all, highlight areas. This is especially important if you are shooting JPEG capture because if you don't capture the highlight detail, it cannot be added later. If you're shooting RAW capture, you can recover some highlight detail when you convert the image in a RAW conversion program.

The amount of highlight detail that you can recover depends on different variables, as well as the conversion program you use. If the highlights are blown when using the camera's suggested exposure, the easiest modification you can use is negative Exposure Compensation to give the image less exposure. The amount of compensation that you set depends on the scene. Every scene is different, but I usually start with 1/2 stop of compensation. Then check the histogram to see if more or less compensation is needed. Experiment with the Exposure Compensation amount until you get an exposure that retains highlight detail in the critical highlight areas. In some scenes, you may have to live with some blown highlights in non-subject-critical areas.

When you set Exposure Compensation in Av shooting mode, the camera changes the shutter speed to achieve the compensation. So always monitor the shutter speed, and use a tripod if the shutter speed is too slow for handholding the camera and lens.

Another exposure modification option is Auto Exposure Bracketing (AEB). Normally, you use AEB to shoot three exposures: one at the camera's recommended exposure, one with more exposure, and one with less exposure. But if the challenge you're trying to solve is overexposed highlights, then shooting the frame with more exposure is pointless. Fortunately, the 7D enables you to shift AEB so that all frames are in the negative exposure range.

Here is how to shift AEB so that all three frames are at negative exposure. If you are in another scene where you want increased exposure, these steps work for that situation as well, with slight modification required to move toward the increased exposure side of the scale.

- 1. Set the Mode dial to P, Tv, or Av, press the Menu button, and then turn the Main dial to select the Shooting 2 menu.
- 2. Turn the Quick Control dial to highlight Expo. comp./AEB, and then press the Set button. The Exposure comp./AEB screen appears.
- 3. Turn the Main dial to the right to display the AEB scale.
- 4. Turn the Quick Control dial to shift the bracketing tick marks below or above the zero mark.
- 5. Turn the Main dial to the right to set the amount of bracketing difference, and then press the Set button. As you turn the Main dial, the tick marks separate, showing the exposure difference in 1/3 stop increments for the exposures.
- 6. To make all three bracketed shots, press the Shutter button three times if you're in One-shot drive mode.

11.6 I used AE Lock for this shot of a backlit fern frond. I locked the exposure on a midtoned area and used M (Manual) shooting mode to set the exposure based on the light meter reading. Exposure: ISO 400, f/8, at 1/80 second using an EF 100mm f/2.8 Macro USM lens.

You can also use AE Lock. With AE Lock and Evaluative metering, you point the lens so that the currently selected AF point is over a midtone area in the scene. (Midtones are detailed later in this chapter.) Then you press and hold the AE Lock button on the back-right top of the camera to lock in the exposure settings. Move the camera to recompose the image, focus, and shoot.

However, if you use Partial, Spot, or Center-weighted Average metering modes, AE lock is set only at the cen-

ter AF point, and this is also true if you turn the switch on the lens to MF (Manual Focus). So point the lens so the center AF point is over the midtone area when you use this technique.

With any exposure approach, you may not see any difference in images where you make exposure changes if you have Auto Lighting Optimizer on the Shooting 2 menu set to any setting except Disable. Auto Lighting Optimizer automatically brightens pictures that it detects as being too dark and corrects low contrast. If you are using exposure modification, then turn off Auto Lighting Optimizer so that you can see the effect that the modifications make.

Advanced exposure approach

The classic exposure approach for landscape and nature scenes is to set the exposure based on taking a meter reading on a gray card or on a midtone area in the scene. This approach is based on the calibration of the camera's built-in reflective light meter to 18 percent reflectance. Knowing that the meter is calibrated for the middle tonal value,

when the midtone values in the image are correctly exposed, the other tonal values are also properly exposed. The caveat is that if you meter from a gray card, the card must be in the same light as the subject.

To use this exposure technique, switch to M (Manual) shooting mode, and then identify an area in the scene that has the same brightness value as middle gray, or 18 percent reflectance. The color may not be gray, but the tonal value should be the same as middle gray.

First set the aperture for the depth of field you want. Then set the 7D to Spot metering mode and select the center AF point. Point the lens so that the center AF point is on top of the middle gray area. Press the Shutter button halfway, and then set the shutter speed from the meter reading; select the AF point you want, compose the image, focus, and make the picture. And if you're handholding the camera, be sure that the shutter speed is fast enough to get a sharp image. If shutter speed is a critical factor, then set it before setting the aperture. Photographic gray card

If you are unaccustomed to finding middle gray, it can take some visual training to learn to spot middle gray in a scene that you are viewing in color. Figure 11.7 can be used to help you identify the tonal value to look for and its comparative brightness. Then your task is to be able to translate the middle gray tonal value in a scene that

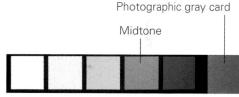

11.7 In this abbreviated tonal scale, middle gray is the fourth gray square from the left. At the far right is a section of a photographic gray card, a copy of which you can find in the back of this book.

you're viewing in color. With practice, you'll be able to spot middle-tone areas in scenes.

You can meter off of a gray card that is placed in the same light as the scene or subject. Or if you have a middle-gray color camera bag, you can meter off it as long as it's in the same light as the subject. If you use a gray card, and a gray card is included in the back of this book, ensure that there are no shadows, glare, or hotspots on the card, and then hold the camera about 6 inches from the card. Press the Shutter button halfway to get the meter reading, and then set the aperture and shutter speed from the meter reading.

An advantage of using a gray card is that you can use it not only to take a meter reading but also to correct color during RAW image conversion.

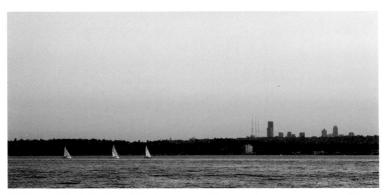

11.8 For this Lake Washington sunset image, I metered on a middle tonal value in the water to determine the exposure. Exposure: ISO 100, f/8, at 1/160 second using an EF 70-200mm f/2.8L IS USM lens.

Exposing nonaverage scenes

Because the camera is calibrated to properly expose scenes with an average distribution of tonal values, it follows that scenes with a predominance of light or dark tones will throw off the camera's suggested exposures. Thus it's important to be able to recognize non-average scenes and adjust the exposure appropriately. Non-average scenes include backlit scenes, white-on-white and black-on-black subjects, snow, white sand, large expanses of dark water, and large, black subjects.

When you're presented with a breathtaking snowy landscape or an expanse of white sandy beach, you know by now that if you don't make an exposure modification, the camera will average all of the tones in the scene to middle gray. As a result, you'll get gray snow and gray water if you use the basic exposure approach.

To compensate for the camera's calibration, you can set positive exposure compensation for bright-toned scenes and negative exposure compensation for dark-toned scenes.

Generally, a +1 or +2 exposure compensation for scenes with a predominance of light tones, or -1 to -2 compensation for scenes with a predominance of dark tones produces true whites and blacks. Then check the histogram to ensure that highlights are not blown or the shadows are not blocked. This method is less precise because you have to experiment to find the amount of compensation needed. You can meter on a midtone value in the scene — a tree trunk in a snow scene, a middle-gray cloud, and so on — and then use those exposure settings to make the picture. If the midtones are properly exposed, the rest of the tones will be rendered accurately as well.

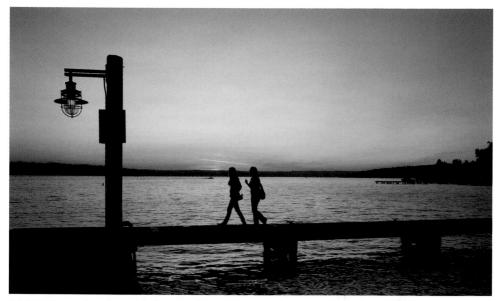

11.9 To keep the pier and the people walking in silhouette, I used a -1/3 stop Exposure Compensation, which also helped retain detail in the bright areas of the sunset. Exposure: ISO 200, f/11, at 1/100 second, -1/3 stop Exposure Compensation, using an EF 16-35mm f/2.8L USM lens.

With a variety of different light sources and light colors in night scenes that include natural and artificial light, I've found the best color using Automatic White Balance when shooting JPEG images. AWB is also a good choice when shooting fair rides, floodlit buildings, and street scenes at dusk and in low light.

> 11.10 For this image of a robin, I used the basic exposure technique with AE Lock set on the bright area of the birdbath. Exposure: ISO 200, f/5.6, at 1/800 second using an EF 100-400mm f/4.5-5.6L IS USM lens.

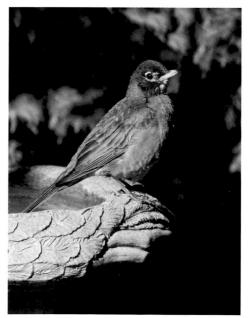

Canon EOS 7D Digital Field Guide

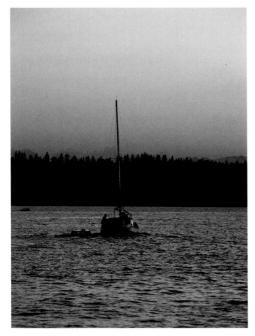

11.11 For this shot of a sailboat on Lake Washington, I metered off a midtone in the lake. Exposure: ISO 100, f/8, at 1/200 second with -1.33 Exposure Compensation using the EF 70-200mm f/2.8L IS USM lens.

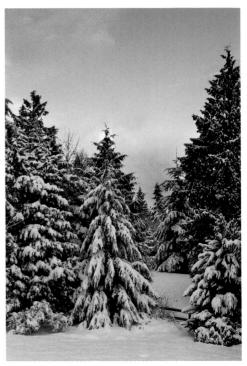

11.12 Exposure Compensation of +1.33 stops helped render the snow in this scene as white instead of middle gray. Exposure: ISO 100, f/8, 1/50 second, using an EF 24-70mm f/2.8L USM lens.

If you are shooting into the bright sun, the camera meter tries to bring the foreground elements to middle-gray tonal values, and, in the process, it often overexposes the brighter sky. In these scenes, take a meter reading on a part of the sky that you want to be rendered as middle gray, to keep the sky from being too bright. Or if you want a partial silhouette that retains some detail in the foreground objects, then meter on a cloud that is slightly brighter than middle gray.

In low light and night scenes that include buildings or structures, you can meter bricks, stones, or concrete in the scene. And if you're photographing buildings or structures lit by artificial light, then meter on an area that is lit by the light, but not the light source itself. In scenes lit by both artificial and ambient (natural) light, you can take a meter reading from the sky just after sunset.

11.13 A sturdy tripod with a ball head is essential for capturing macro images such as this spider. Exposure: ISO 100, f/11, 1/4 second using an EF 100mm f/2.8 Macro USM lens.

Shooting Landscape and Nature Images

As with each area of photography in this chapter, countless other books have been written specifically on these topics. In my experience, however, all the tips in the world cannot make great images if the photographer doesn't constantly practice seeing and appreciating everything in nature. I've irritated more people on the highway than I can count because I routinely slow down to appreciate a stunning mountain lit by that rare and incomparable light that happens only occasionally. Slowing down is something that will help you get great landscape and nature shots.

Keep your eye in practice. Photography is like any other skill: The more you practice it, the more finely tuned your eye becomes and the more you will look for unique and unusual scenes and approaches. For example, when I spend long stretches writing at the computer, and then go out shooting, it takes a while to see with a practiced eye again.

- Look for the light. Light, especially beautiful light, is transitory and fleeting, but this is the light you desire. Maybe the light illuminates a mountainside forest with gold and purple hues, or maybe a small shaft of light pierces through the forest trees to spotlight a tiny frog or wild mushroom, but whatever the light, look with an acute eye for the stunning light. And be ready to shoot, regardless of whether or not the right lens is on the camera. Don't let stunning light opportunities pass you by.
- Image composition is very important. Many books have been written on composition, but you'll do well to study nature itself. For me, nature is the ultimate field guide to good composition.

11.14 Some of the best images are found in your own yard, as was the case with this rose. Exposure: ISO 100, f/8, at 1/250 second using an EF 100mm f/2.8 Macro USM lens.

11.15 In this image, I wanted to bring the flower visually forward in the frame, so I chose a wide aperture of f/2.8. The resulting shallow depth of field retains the context of the surrounding flowers and foliage without having them distract from the main blossom. Exposure: ISO 100, f/2.8, at 1/1000 second using an EF 24-70mm f/2.8L USM lens.

Maximizing Depth of Field

Maximizing depth of field is especially important in landscape photography. Certainly a narrow aperture is part of maximizing depth of field, but you can also use hyperfocal focusing to maximize the acceptably sharp focus from near to far in the frame. With hyperfocal focusing, the depth of field extends from half the hyperfocal distance to infinity at any given aperture.

The easy way to set hyperfocal distance focusing is if you have a lens that has both a distance scale and a depth of field scale. If you have this type of lens, first focus the lens on infinity, and then check the depth of field scale to see what the nearest point of sharp focus is at the aperture you've set. Then focus the lens on the hyperfocal distance. For example, with the aperture set to f/11 and using the EF 28mm lens, the hyperfocal distance is just over 2 meters. That means you would refocus the lens at a point in the scene just over 2 meters from the camera to get acceptable sharpness from half the hyperfocal distance, or approximately 5 feet, to infinity.

If your lens does not have a depth of field scale, and most newer lenses do not, then you can buy a hyperfocal focusing calculator. Or you can calculate the distance using a formula. The formula takes into account the circle of confusion, or the maximum size of points on an image that are well defined, that is, to 3 feet. For the 7D with a cropped sensor, that circle size is approximately 0.018mm.

To calculate the hyperfocal distance, use this equation:

 $H = (F \times F)/(f \times c)$

Where H is the hyperfocal distance, F is the lens focal length, f is the aperture, and c is the circle of confusion.

So a 28mm lens set to f/16 produces:

H = $(28 \times 28)/(16 \times 0.018)$, or H = 2,722mm or 2.72m. To ensure maximum depth of field, you focus the lens on a point in the scene that is 2.7 meters from the camera.

CHAPTER

People Photography

One of the most rewarding and challenging areas of photography is people photography.

There is a never-ending source of great subjects, and you can unleash your creative ideas for locations, sets, lighting, clothing, and subject action and position.

But even better than the creative opportunities is the opportunity to work with people — to get to know them, to coax out the best in them, and to make images that both they and you will enjoy for years to come.

People Photography

In almost all people-shooting situations, your primary work is to establish and maintain rapport with the person or people you're photographing. Establishing rapport takes time — sometimes a lot of time. Unlike nature and landscape shooting, where you can set the pace and face snafus with equanimity, people photography, whether it's a structured portrait session or street shooting, demands more of your time and attention.

12.1 Regardless of where I'm shooting, I take advantage of making people pictures with almost anyone who agrees to let me photograph them. This biker agreed to let me make a few quick images just before he left the area. Exposure: ISO 100, f/3.5, at 1/1000 second with -2 Exposure Compensation using an EF 24-70mm, f/2.8L USM lens.

When you photograph people, you have to maintain an ongoing conversation, provide direction, change lenses, and, in a portrait session, you have to coordinate clothing, lighting, and background changes. Given these demands, the last thing that you have time to worry about is the camera's performance, and with the 7D, you can depend on the camera to perform when you need it to. And if you plan carefully for session, your odds of having a smooth and fluid session are greatly increased.

Planning includes having the camera, lenses, and accessories that you want within easy reach, knowing in advance the range of setups or locations you want, and knowing the lighting you'll use, whether it's studio strobes, flash units, reflectors, or supplementing outdoor light.

Selecting gear

The type and amount of gear that you use for photographing people depends on whether you shoot in your studio or home where your gear is conveniently close by, or if you shoot at a different location. Another aspect that influences gear selection is whether you're photographing a single person or a group, and, if a group, how large the group is.

Consider the following additions and accessories, and make adjustments according to your specific portrait session.

- Two 7Ds or a 7D and a backup EOS camera body. In almost all shooting situations, having a backup camera is important for all the reasons mentioned in previous chapters.
- One or more fast wide-angle and short telephoto lenses. For portraits, I most often use the EF 24-70mm f/2.8L USM, the EF 70-200mm f/2.8 IS USM, and the EF 85mm f/1.2L II USM lens. In particular, the 24-70mm is very versatile you can shoot individual subjects at the 70mm focal length or at a wider focal length for groups of up to five or six people.

The EF 70-200mm f/2.8L IS USM, or the lighter-weight but slower EF 70-200mm f/4L IS USM is also a good choice to increase background softness, particularly at wide apertures. As well, a short telephoto between 85 and 50mm minimizes the characteristic telephoto lens compression, while still providing a shallow depth of field that's characteristic of telephoto lenses.

Reflectors. I can't imagine shooting a portrait session indoors or outdoors without using one, two, or more silver, white, or gold reflectors. Reflectors are small, lightweight, collapsible, and indispensable for everything, from redirecting the main light or filling shadow areas to adding catchlights to the subject's eyes.

Reflectors are easier to manipulate than flash (and much less expensive), and silver and white reflectors retain the natural color of the ambient light. A gold reflector adds appealing warmth to skin tones.

- EX-series flashes, light stands, umbrellas or softboxes. You can create a nice portrait with a single flash unit mounted off-camera on a flash bracket. But you'll have a lot more creative control if you use two to three Speedlites mounted on stands with either umbrellas or softboxes, and fired wirelessly from the 7D that has a built-in wireless Speedlite transmitter. The light ratios can be easily controlled, while the Speedlites can be placed around the set to replicate almost any classic lighting pattern. Best of all, this system is portable and lightweight.
- Tripod, monopod, CF cards, and spare batteries. These are obvious items to have on hand, but they bear mentioning.
- Brushes, combs, cosmetic blotters, lip gloss, concealer, safety pins, and anything else you can think of. The subject will likely forget to bring one of these items, a garment will tear, or a button will pop off. Have a small emergency kit at the ready. The kit will often contain just what you need to keep the session going with minimal stress and interruption.

Setting up the 7D for portrait shooting

If you primarily shoot portraits, then devoting one of the C modes to your portrait settings saves you time setting up for the session. And if you shoot both outdoor and studio portraits, then you can set up a C mode for each location. The choice is yours, but having the camera set up and ready to shoot saves making adjustments for different locations.

Here are suggestions for setting up the 7D for portrait shooting.

Av shooting mode. Av shooting mode is a natural choice for people shooting because it offers quick control over the depth of field by changing the aperture and/or the lens. If you use Av shooting mode, always keep an eye on the shutter speed to ensure it's fast enough to handhold the camera.

I don't recommend riding the edge of handholding shutter speeds. With people photography, you have to consider the potential that the people or person you're photographing may also move. So if you err, err on the side of getting a faster rather than a slower shutter speed. If you shoot with studio strobes, then Manual shooting mode is the best option to sync the camera to the strobes while adjusting the aperture as necessary.

As a rule of thumb, the minimum shutter speed at which you can handhold a non-IS lens is the reciprocal of the focal length. Thus, if your lens is set to 100mm, the minimum shutter speed at which you can handhold the camera and get a sharp image is 1/100 second. That's the *minimum* shutter speed. But I also factor in the potential that the subject may move, so a safer shutter speed is 1/200 second or faster.

12.2 Late afternoon light provides soft illumination for this mother and baby. I added a soft focus effect using Nik Software's Color Efex Pro filter. Exposure: ISO 100, f/7, at 1/50 second using an EF 24-70mm, f/2.8L USM lens.

One-shot AF mode, and Spot AF with manual selection. Unless the portrait subject is a young child who moves unexpectedly, One-shot AF mode is a good choice. If you are photographing a young child, then you can use AI Focus AF. In AI Focus AF mode, you can focus on the child and if the child begins to move, the 7D switches automatically and tracks the child to maintain focus. In addition, I also always use manual AF-point selection with the AF area mode set to Spot AF. Spot AF area selection mode provides pinpoint focusing so that I can focus precisely on the subject's eye. In Single-point AF selection mode, the focus can drift to the eyelashes or even the eyebrows. A portrait isn't successful if the point of sharpest focus is anywhere except on the subject's eyes, and the best way to ensure sharp focus on the eyes is to manually set the AF point with the critical focusing that Spot AF provides.

- Low-speed Continuous drive mode. This mode allows a succession of shots at a reasonably fast 3 fps shooting speed. If you are photographing children in ambient light, then switching to High-speed Continuous mode enables you to keep shooting fast-moving youngsters.
- Evaluative metering mode. Evaluative metering is both fast and accurate for portraits. However, you may want to switch to Spot metering mode to take an area-specific meter reading. If you're shooting in the studio, you can use a handheld flash meter if you have one, or simply make test shots, examine the images and histograms, and then set the exposure for the best test shot exposure.
- Picture Style. The Portrait Picture Style produces lovely skin tones and renders colors faithfully and with subdued saturation, which is appropriate for portraits. I

also use a modified Neutral Picture Style. If you are shooting where the lighting is flat, then Standard produces a more vibrant rendering. Be sure to test these Picture Styles well before the session and evaluate the prints so that you know which style works best for the lighting and the printer that you'll use.

Custom Functions. For flash portraits, consider whether you want to use a fixed 1/250-second sync speed to make flash the primary illumination, or to sync at shutter speeds slower than 1/250 second to allow more of the ambient light to figure into the exposure. If you're shooting scenes with bright tones, such as a bride in a white dress, you can enable C.Fn II-3, Highlight tone priority, to expand the top

12.3 This environmental portrait of a building contractor was made in overcast light. Exposure: ISO 160, f/2.8, at 1/125 second using the EF 24-70mm f/2.8L USM lens.

half of the tonal dynamic range. Also, if you want to use Spot AF area selection mode, you can enable it using C.Fn III-6. I also use Orientation linked AF points that you can set in C.Fn III-12. And if you opt to use AI Servo AF mode, then be sure to set up the tracking sensitivity image priorities, and tracking method using C.Fn III-13.

Making Naturallight Portraits

The goal of any portrait is to capture the spirit of the subject. When you capture the spirit of the person, the subject's eyes are engaged with you, and they are vibrant and compelling, drawing the viewer into the image. No amount of skillful lighting, posing, or post-capture editing can substitute for this. And that's why establishing rapport is so important.

Other factors including lighting, exposure, and color are also important in getting stunning portraits. With the plethora of options that the 7D offers, you can get excellent results whether you are making outdoor or indoor natural-light portraits.

Outdoor portraits

There are many times during the day, and many types of outdoor light, that is lovely portrait light. With that said, I can think of no one who is flattered in bright, overhead, unmodified midday sunlight. Nor can I think of any subject

12.4 This was a mid-afternoon street portrait. With bright sunlight all around, I decided to move the man to shade on a nearby sidewalk. The bright background burned out, but I softened it in Photoshop using a Gaussian blur to tone down the brightness. After comparing the color and black-and-white renderings, I felt that the black-and-white rendering best reflected the man's character. Exposure: ISO 160, f/2.8, at 1/200 second using an EF 24-70mm f/2.8L USM lens.

who is comfortable looking into the sun. So if you have a portrait session outside on a sunny afternoon and you can't reschedule, then move the subject to an area that is shaded from the top, such as by a roof, an awning, or a tree. Or in an open area with overhead sunlight, use a *scrim* — fabric or other material stretched over a frame — and hold it over the subject to diffuse the strong sunlight. If the subject is in the shade, use a reflector to direct light onto the frontal plane of the face. Then you can move the subject and use reflectors to create and control shadow areas.

The most desired outdoor portrait light is during and just after sunrise, just before and during sunset, and, if you use reflectors or fill flash skillfully, the light of an overcast day.

Canon EOS 7D Digital Field Guide

In any type of outdoor light, watch how the shadows fall on the face. If unflattering shadows form under the eyes, nose, and chin, then you can bounce fill light into those areas using a silver or gold reflector. I prefer a silver reflector for the neutral light that it reflects. If I want to diminish the light that's reflecting onto the subject, I use a white reflector because it scatters light and decreases the intensity.

If you're shooting a head-andshoulders portrait, you can ask the subject to hold a reflector at waist level, and then watch as the subject tilts the reflector to find the best position to fill in facial and chin shadow areas. Also ensure that catchlights appear in the subject's eyes. In overcast light, in particular, you may need to use a reflector to create the catchlights. The ideal positions for catchlights are at the 10 and 2 o'clock positions. The size and shape of the

12.5 Late afternoon light, in addition to a Speedlite shooting into a silver umbrella, lit this couple. Exposure: ISO 100, f/3.5, at 1/80 second using an EF 24-70mm f/2.8L USM lens.

catchlight reflects the light source. If you use the built-in flash for fill light and to create catchlights, the catchlights will be unattractive pinpoints of white. I prefer the larger size and shape of catchlights created by the skillful use of a reflector.

To get the best color in overcast or cloudy light, use a Custom White Balance. At sunrise or sunset, you can use either the Daylight or Cloudy White Balance setting. Or if you're shooting RAW, you can shoot a gray card in one frame and use that image to color-correct images as a batch during RAW image conversion, as described in Chapter 4. If you don't want a completely neutral color — and generally you don't want perfectly neutral color — then adjust the temperature and tint controls during RAW image conversion to warm up or cool down the color.

Window light portraits

Without question, window light is one of the most beautiful of all natural light options for portraits, and it offers exceptional versatility. If the light is too bright, you can simply move the subject farther from the window or put a fabric over the window. Window light provides ample light to bounce into the shadow side of the subject using a reflector. For window-light portraits, try to shoot when the sun is at a mid to low angle above the horizon. However, strong midday sunlight can also be quite usable if you cover the window with a lightweight fabric, such as a sheer curtain.

A good starting point for window light portraits is to place the subject so that one side of their face is lit and the other side is in shadow. Then position a silver or white reflector so that it bounces light into the shadow side of the face and creates a catchlight in the eye on the shadow side.

To meter window light, it's important to meter for the skin midtones. Evaluative metering and Spot metering both produce excellent metering results. Just move in close or zoom in on the subject's face and meter a middle tone skin-tone area, or vou can meter a gray card that is in the same light as the subject's face. Then you use Manual shooting mode to shoot with the resulting exposure settings. In Manual shooting mode, you can maintain the metered exposure, even if you change the image composition slightly. In other modes, such as Av, Tv, or P, the shutter speed will change

12.6 This portrait of an artist was taken in a white street-fair tent that was lit by bright sunlight. The tent diffused the light beautifully. Exposure: ISO 100, f/4, at 1/250 second using an EF 24-70mm, f/2.8L USM lens.

as you vary the image composition slightly. Of course, the metered skin-tone exposure is good to shoot with as long as the light level and the subject position does not change.

Exposure approaches

For portrait shooting, you can often get excellent exposures out of the camera with no exposure modifications. However, if there are hot spots on the subject's skin that you can't eliminate with lighting modifications, or if there are blocked shadows, you can use any of the exposure techniques described in Chapter 11.

Some portraits can fall into the nonaverage categories. For example, if you're photographing a man in dark clothing against a dark background, then the camera will tend to render the dark tones as middle gray. The same exposure error can happen with a subject such as a bride in a white dress against a light background. You can use two approaches to correct the exposure error: You can set Exposure Compensation, or you can meter from

12.7 There are so many reasons not to shoot in bright sunlight, but once in awhile you have no choice. This 90-yearold man had won a best display trophy for his immaculate Model T pickup in a vintage car show. Because he was about to leave, I grabbed the shot despite the harsh light. Exposure: ISO 100, f/5, at 1/400 second using an EF 24-70mm, f/2.8L USM lens.

a gray card and set the metered exposure in Manual shooting mode.

On the topic of exposure, my preference for portraits is to ensure very fine detail and the lowest level of digital noise possible in the images. For me, that means shooting between ISO 100 and 400, 99 percent of the time.

If you're shooting in low light scenes, increasing the ISO to 800 provides good prints; however, you need to examine the shadow areas carefully for noise. If the noise is obvious, apply noise reduction during either RAW image conversion or JPEG image editing, particularly on facial shadow areas. There is nothing that spoils an otherwise beautiful portrait more quickly than seeing a colorful scattering of digital noise in facial shadows and in skin areas.

To control depth of field, many photographers rely solely on f-stop changes. Certainly, aperture changes render the background differently, and wide apertures from f/5.6 to f/1.4 are common in portraiture. However, don't overlook the other factors that affect depth of field:

- ► Lens. A telephoto lens has an inherently shallow depth of field, and a wide-angle lens has an inherently extensive depth of field.
- Camera-to-subject distance. The closer you are to the subject, the shallower the depth of field, and vice versa.
- Subject-to-background distance. The farther the subject is from the background, the softer the background details appear, and vice versa.

Making Studio Portraits

Whether you have one or multiple studio lights such as strobes, continuous lights, or even Speedlites, you have the opportunity to make portraits using classic lighting patterns. And if you combine the lighting with modifiers such as umbrellas, softboxes, barn doors, beauty dishes, reflectors, and other accessories, you can control the light to get just about any type of lighting that you envision.

It's beyond the scope of this book to provide a guide to portrait lighting in the studio or to provide setup instructions for a studio lighting system. But whether you have one, two, three, or more lights, you can count on excellent studio portraits from the 7D. With multiple-light studio systems, you can use the PC sync terminal and set the sync speed on the camera at 1/60 to 1/30 second, which is what Canon recommends. However, I use the 7D with my four Photogenic strobes, and

[©]Sandy Rippel

12.8 When I needed a promotional portrait, I set up the studio lighting, and my daughter took this portrait of me. The 7D performs like a champ in the studio. This set was lit with four Photogenic studio strobes; with two strobes lighting the white seamless background, two to camera left, and a large silver reflector to camera right. Exposure: ISO 100, f/20, at 1/125 second, using an EF 24-70mm, f/2.8L USM lens. 12.9 While this image obviously doesn't fit within the people category, I include it to illustrate that the same techniques that you use for people can be applied to pets and other animals. Exposure: ISO 100, f/16, at 1/125 second using an EF 24-70mm, f/2.8L USM lens.

I sync at 1/125 second with no problem and with excellent exposures.

It takes only one or two studio sessions to determine the correct light temperature, if you don't already know it. For my studio system, I use the K White Balance setting, and set it to 5300. This setting gives me a clean, neutral white with no further adjustments during shooting or in image conversion or editing. In addition, if I'm shooting JPEG, which is seldom, I

use the Portrait Picture Style. This style produces the subdued color and pleasing skin tones of classic portraiture. If you think that the color rendition and contrast are too subdued, you can modify the style parameters by bumping both settings to a higher level.

Portraits with a One-Light Setup

If you're just starting to build a studio lighting system, it is important to know that you can make great portraits with a single light and an umbrella or softbox, combined with silver reflectors. For example, set up the single light on a stand shooting into an umbrella or fitted with a softbox. Then place the light at a 45-degree angle to the right of the camera with the light pointed slightly down onto the subject. This creates a shadow under the subject's nose and lip. Now place a silver reflector to the left of the camera and adjust its position to soften the shadow created by the light.

For classic loop lighting, the nose shadow should follow the lower curve of the cheek on the opposite side of the light. The shadow from the light should cover the unlit side of the nose without the shadow extending onto the subject's cheek. Also ensure that the eyebrows and the top of the eyelids are well lit. You can also adjust the height of the key light to change the curve under the cheekbone.

Keep It Simple

A library of books has been written on portrait and people photography. If you want to specialize in people photography, read the books, practice the classic techniques, and keep practicing until they become second nature.

But when the time comes to start shooting, relax and keep it simple. At a minimum, here are the basic guidelines that I keep in mind for every portrait session.

- Connect with the person, couple, or group. Engage them in conversation about themselves. When you find a topic that lights up their eyes, start shooting and keep talking with them.
- Focus on the eye that is closest to the camera. If the eyes are not in tacksharp focus, reshoot.
- Keep the subject's eyes in the top third of the frame.
- The best pose is the pose in which the subject feels comfortable and relaxed.
- Be prepared. Be unflappable. Back up everything. And check the histograms as you shoot.

APPENDIX

Exploring RAW Capture

If you want to get the highest quality images from the EOS 7D, then choosing to capture RAW images is the way to get them. In addition, you have the opportunity to determine how the image data from the camera is interpreted as you convert, or process, the RAW images. While RAW capture offers significant advantages, it isn't for everyone. If you prefer images that are ready to print straight out of the camera, then JPEG capture is the best option. However, if you enjoy working with images on the computer and having creative control over the quality and appearance of the image, then RAW is the best option.

This appendix provides an overview of RAW capture, as well as a brief walk-through on converting RAW image data into a final image.

Learning about RAW Capture

One way to understand RAW capture is by comparing it to JPEG capture, which most photographers are familiar with already. When you shoot JPEG images, the camera edits or processes the images before storing them on the CF card. This processing includes converting images from 14-bit files to 8-bit files, setting the color, saturation, and contrast, and generally giving you a file that is finished. Very often, JPEG images can be printed with no editing. But in other cases, you may encounter images where you want more control over how the image is rendered —for example, you may want to recover blown highlights, to tone down high-contrast images, or to correct the color of an image.

Of course, you can edit JPEG images in an editing program and make some corrections, but the amount of latitude for editing is limited. With JPEG images, large amounts of image data are discarded when the images are converted to 8-bit mode in the camera, and then the image data is further reduced when JPEG algorithms compress image files to reduce the size. As a result, the image leaves little, if any, wiggle room to correct the tonal range, white balance, contrast, and saturation during image editing. Ultimately, this means that if the highlights in an image are overexposed, or blown, then they're blown for good. If the shadows are blocked up (meaning they lack detail), then they will likely stay blocked up. It is possible to make improvements in Photoshop, but the edits make the final image susceptible to posterization or banding that occurs when the tonal range is stretched and gaps appear between tonal levels. This stretching makes the tonal range on the histogram look like a comb.

By contrast, RAW capture allows you to work with the data that comes off the image sensor with virtually no internal camera processing. The only camera settings that the camera applies to a RAW image are ISO, shutter speed, and aperture. And because many of the key camera settings have been noted but not applied in the camera, you have the opportunity to make changes to settings, including image brightness, white balance, contrast, and saturation, when you convert the RAW image data into a final image using a conversion program such as Canon's Digital Photo Professional, Adobe Camera Raw, Adobe Lightroom, or Apple Aperture.

In addition to the RAW image data, the RAW file also includes information, called metadata, about how the image was shot, the camera and lens used, and other description fields.

An important characteristic of RAW capture is that it offers more latitude and stability in editing converted RAW files than JPEG files offer. RAW images have rich data depth and provide significantly more image data to work with during conversion and subsequent image editing. In addition, RAW files are more forgiving if you need to recover overexposed highlight detail during conversion of the RAW file. These differences in data richness translate directly to editing leeway. And maximum editing leeway is important because after the image is converted, all the edits you make in an editing program are destructive. Another advantage of RAW conversion is that as conversion programs improve, you can go back to older RAW image files and convert them again using the improved features and capabilities of the conversion program.

Proper exposure is important with any image, and it is no less so with RAW images. With RAW images, proper exposure provides a file that captures rich tonal data that withstands conversion and editing well. For example, during conversion, image brightness levels must be mapped so that the levels look more like what we see with our eyes — a process called *gamma encoding*. In addition, you will also likely adjust the contrast and midtones and move the endpoints on the histogram. For an image to withstand these conversions and changes, a correctly exposed and data-rich file is critical.

Proper exposure is also critical, considering that digital capture devotes the lion's share of tonal levels to highlights while devoting far fewer levels to shadows. In fact, half of all the tonal levels in the image are assigned to the first f-stop of brightness.

Half of the rest of the tonal levels account for the second f-stop, and half into the next f-stop, and so on.

With digital cameras, dynamic range depends on the sensor. The brightest f-stop is a function of the brightest highlight in the scene that the sensor can capture, or the point at which the sensor element is saturated with photons. The darkest tone is determined by the point at which the noise in the system is greater than the comparatively weak signal generated by the photons hitting the sensor element.

Clearly, capturing the first f-stop of image data is critical because fully half of the image data is devoted to that f-stop. If an image is underexposed, not only is important image data sacrificed, but the file is also more likely to have digital noise in the shadow areas.

Underexposure also means that during image conversion, the fewer captured levels must be stretched across the entire tonal range. Stretching tonal levels creates gaps between levels that reduce the continuous gradation between levels.

The general guideline when shooting RAW capture is to expose with a bias to the right so that the highlight pixels just touch the right side of the histogram. Thus, when tonal mapping is applied during conversion, the file has significantly more bits that can be redistributed to the midtones and darker tones where the human eye is most sensitive to changes.

If you've always shot JPEG capture, the exposing-to-the-right approach may seem just wrong. When shooting JPEG images, the guideline is to expose so that the highlights are not blown out because if detail is not captured in the highlights, it's gone for good. This guideline is good for JPEG images where the tonal levels are encoded and the image is essentially pre-edited inside the camera. However, with RAW capture, gamma encoding and other contrast adjustments are made during conversion with a good bit of latitude. And if highlights are overexposed, conversion programs such as Adobe Camera Raw or Digital Photo Professional can recover varying amounts of highlight detail.

In summary, RAW capture produces files with the most image data that the camera can deliver, and you get a great deal of creative control over how the RAW data is converted into a final image. Most important, you get strong, data and color-rich files that withstand image editing and can be used to create lovely prints.

However, if you decide to shoot RAW images, you also sign on for another step in the process from capturing images to getting finished images, and that step is RAW conversion. With RAW capture, the overall workflow is to capture the images, convert the

RAW data in a RAW-conversion program, edit images in an image-editing program, and then print them. You may decide that you want to shoot in RAW+JPEG so that you have JPEGs that require no conversion, but you have the option to convert exceptional or problem images from the RAW files with more creative control and latitude.

Canon's RAW Conversion Program

Unlike JPEG images, RAW images are stored in proprietary format, and they cannot be viewed on some computers or opened in some image-editing programs without first converting the files to a more universal file format such as TIFF, PSD, or JPEG. Canon includes a free program, Digital Photo Professional, on the EOS Digital Solution Disk that you can use to convert 7D RAW files, and then save them as TIFF or JPEG files.

Images captured in RAW mode have a .CR2 filename extension.

Digital Photo Professional (DPP) is noticeably different from traditional image-editing programs. It focuses on image conversion tasks, including correcting, tweaking, or adjusting white balance, brightness, shadow areas, contrast, saturation, sharpness, noise reduction, and so on. It doesn't include some familiar image-editing tools, nor does it offer the ability to work with layers.

Sample RAW Image Conversion

Although RAW image conversion adds a step to image processing, this important step is well worth the time. To illustrate the overall process, here is a high-level workflow for converting an EOS 7D RAW image using Canon's DPP.

Be sure to install the Digital Photo Professional application provided on the EOS Digital Solution Disk before following this task sequence.

- **1. Start Digital Photo Professional (DPP).** The program opens. If no images are displayed, you can select a directory and folder from the Folder panel.
- Double-click the image you want to process. The image preview opens with the RAW image tool palette displayed with the RAW tab selected. If the Tool palette isn't displayed, click View → Tool palette. In the editing mode, you can:

- Drag the Brightness adjustment slider to the left to darken the image or to the right to lighten it. To quickly return to the original brightness setting, click the curved arrow above and to the right of the slider.
- Use the White Balance adjustment control to adjust color. You can click the Eyedropper tool, and then click an area that is white or gray in the image to quickly set white balance, choose one of the preset White Balance settings from the Shot Settings drop-down menu, or click Tune to adjust the white balance using a color wheel. After you correct the color you can click Register to save the setting and then use it to correct other images.
- Change the Picture Style by clicking the down arrow next to the currently listed Picture Style and selecting a different Picture Style from the list. The Picture Styles offered in DPP are the same as those offered on the menu on the 7D. When you change the Picture Style in DPP, the image preview updates to show the change. If you don't like the results, you can click the curved arrow to the right of Picture Style to switch back to the original Picture Style.
- Adjust the tonal curve. Sliders enable you to target the image contrast, highlights, and shadows for adjustments. You can also adjust the black and white points on the image histogram by dragging the bars at the far left and right of the histogram toward the center. Then you can also adjust the color, saturation, and sharpness.
- Adjust the Color tone, Color saturation, and Sharpness by dragging the sliders. Dragging the Color tone slider to the right increases the green tone, and dragging it to the left increases the magenta tone. Dragging the Color saturation slider to the right increases the saturation, and vice versa. Dragging the Sharpness slider to the right increases the sharpness, and vice versa.
- 3. Click the RGB tab. Here you can apply an RGB curve and also apply separate curves in each of the three color channels: Red, Green, and Blue. You can also adjust the following:
 - Click one of the tonal curve options to the right of Tone curve assist to set a classic S-curve without changing the black and white points. If you want to increase the curve, click the Tone curve assist button marked with a plus (+) sign one or more times to increase the curve. Or you can click the linear line on the histogram, and then drag the line to set a custom tonal adjustment curve. If you want to undo the curve changes, click the curved arrow to the right of Tone curve adjustment, or the curved arrow to the right of Tone curve assist.

- Click the R, G, or B buttons next to RGB to make changes to a single color channel. Working with an individual color channel is helpful when you need to reduce an overall colorcast in an image.
- Drag the Brightness slider to the left to darken the image or to the right to brighten the image. The changes you make are shown on the RGB histogram as you make them.
- Drag the Contrast slider to the left to decrease contrast or to the right to increase contrast.
- 4. Click the NR/Lens/ALO tab. Control on this tab enables you to:
 - Set Auto Lighting Optimizer. Auto Lighting Optimizer automatically corrects overexposed images and images with flat contrast. This option can be applied automatically to JPEG images in the camera, but the only way to apply it to RAW images is in Digital Photo Professional. You can choose Low, Standard, or Strong settings, or turn off Auto Lighting Optimizer by clicking the checkbox.
 - Control digital noise if it is problematic in the image. There are controls for both RAW and TIFF/JPEG images. Be sure to enlarge the preview image to 100 percent and scroll to a shadow area to set noise reduction for Luminance and/or Chrominance.
 - **Correct Lens aberration.** Click the Tune button to display another dialog box where you can view and adjust the Shooting distance information, correct vignetting using Peripheral illumination, Distortion, chromatic aberration, and Color blur.
- 5. In the image preview window, choose File → Convert and save. The Convert and save dialog box appears. In the dialog box, you can specify the file type and bit depth at which you want to save the image. Just click the down arrow next to Kind of file and choose one of the options, such as TIFF 16-bit. Then you can set the Image Quality setting if you are saving in JPEG or TIFF plus JPEG format, set the Output resolution, choose to embed the color profile, or resize the image.

The Edit menu also enables you to save or copy the current image's conversion settings as a recipe. Then you can apply the recipe to other images in the .

6. Click Save. DPP displays the Digital Photo Professional dialog box until the file is converted. DPP saves the image in the location and format that you choose.

How to Use the Gray Card and Color Checker

Have you ever wondered how some photographers are able to consistently produce photos with such accurate color and exposure? It's often because they use gray cards and color checkers. Knowing how to use these tools helps you take some of the guesswork out of capturing photos with great color and correct exposures every time.

The Gray Card

Because the color of light changes depending on the light source, what you might decide is neutral in your photograph, isn't neutral at all. This is where a gray card comes in very handy. A gray card is designed to reflect the color spectrum neutrally in all sorts of lighting conditions, providing a standard from which to measure for later color corrections or to set a custom white balance.

By taking a test shot that includes the gray card, you guarantee that you have a neutral item to adjust colors against later if you need to. Make sure that the card is placed in the same light that the subject is for the first photo, and then remove the gray card and continue shooting.

-	
TIP	
LIF	

When taking a photo of a gray card, de-focus your lens a little; this ensures that you capture a more even color.

Because many software programs enable you to address color correction issues by choosing something that should be white or neutral in an image, having the gray card in the first of a series of photos allows you to select the gray card as the neutral point. Your software resets red, green, and blue to be the same value, creating a neutral midtone. Depending on the capabilities of your software, you might be able to save the adjustment you've made and apply it to all other photos shot in the same series.

If you'd prefer to made adjustments on the spot, for example, and if the lighting conditions will remain mostly consistent while you shoot a large number of images, it is advisable to use the gray card to set a custom white balance in your camera. You can do this by taking a photo of the gray card filling as much of the frame as possible. Then, use that photo to set the custom white balance.

The Color Checker

A color checker contains 24 swatches which represent colors found in everyday scenes, including skin tones, sky, foliage, etc. It also contains red, green, blue, cyan, magenta, and yellow, which are used in all printing devices. Finally, and perhaps most importantly, it has six shades of gray.

Using a color checker is a very similar process to using a gray card. You place it in the scene so that it is illuminated in the same way as the subject. Photograph the scene once with the reference in place, then remove it and continue shooting. You should create a reference photo each time you shoot in a new lighting environment.

Later on in software, open the image containing the color checker. Measure the values of the gray, black, and white swatches. The red, green, and blue values in the gray swatch should each measure around 128, in the black swatch around 10, and in the white swatch around 245. If your camera's white balance was set correctly for the scene, your measurements should fall into the range (and deviate by no more than 7 either way) and you can rest easy knowing your colors are true.

If your readings are more than 7 points out of range either way, use software to correct it. But now you also have black and white reference points to help. Use the levels adjustment tool to bring the known values back to where they should be measuring (gray around 128, black around 10 and white around 245).

If your camera offers any kind of custom styles, you can also use the color checker to set or adjust any of the custom styles by taking a sample photo and evaluating it using the on-screen histogram, preferably the RGB histogram if your camera offers one. You can then choose that custom style for your shoot, perhaps even adjusting that custom style to better match your expectations for color.

GLOSSARY

Glossary

720p/1080i/1080p High-definition video recording standards that refer to the vertical resolution, or the number of horizontal lines on the screen — either 720 or 1080 lines. Seven hundred twenty horizontal lines translate to a width of 1280 pixels, and 1080 lines translate to 1920 pixels of horizontal resolution. The p stands for progressive scan, which displays the video frame all at once. The i stands for interlaced, an analog compression scheme that allows 60 frames per second (fps) to be transmitted in the same bandwidth as 30 fps by displaying 50 percent of the video frame at a time.

Adobe RGB A color space that encompasses most of the gamut of colors achievable on commercial printers, or approximately 50 percent of the visible colors specified by the CIE.

AE Automatic exposure.

AE Lock (Automatic Exposure Lock) A camera control that enables the photographer to decouple exposure from autofocusing by locking the exposure at a

point in the scene other than where the focus is set. AE Lock enables the photographer to set the exposure for a critical area in the scene.

angle of view The amount or area seen by a lens or viewfinder, measured in degrees. Shorter or wide-angle lenses and zoom settings have a wider angle of view. Longer or telephoto lenses and zoom settings have a narrower angle of view.

aperture The lens opening through which light passes. Aperture size is adjusted by opening or closing the lens diaphragm. Aperture is expressed in f-numbers such as f/8, f/5.6, and so on.

artifact An unintentional or unwanted element in an image caused by an imaging device, or as a byproduct of image processing such as compression.

artificial light The light from an electric light or flash unit.

autofocus A function where the camera focuses on the subject using the selected autofocus point or points. Pressing the Shutter button halfway down activates autofocus.

automatic exposure (AE) A function where the camera sets all or some of the exposure elements automatically. In automatic shooting modes, the camera sets all exposure settings. In semiautomatic modes, the photographer sets the ISO and either the aperture (Av mode) or the shutter speed (Tv mode), and the camera automatically sets the shutter speed or aperture, respectively.

available light The natural or artificial light within a scene. This is also called existing light.

axial chromatic aberration A lens phenomenon that bends different-colored light rays at different angles, thereby focusing them on different planes, which results in color blur or flare.

barrel distortion A lens aberration resulting in a bowing of straight lines outward from the center.

bit depth The number of bits used to represent each pixel in an image.

blocked up A description of shadow areas that lack detail.

blooming Bright edges or halos in digital images around light sources, and bright reflections caused by an oversaturation of image sensor photosites. **bokeh** The shape and illumination characteristics of the out-of-focus area in an image.

bounce light Light that is directed toward an object, such as a wall or ceiling, so that it reflects (or bounces) light back onto the subject.

brightness The perception of the light reflected or emitted by a source; the lightness of an object or image. See also *luminance*.

buffer Temporary storage for data in a camera or computer.

bulb A shutter speed setting that keeps the shutter open as long as the Shutter button is fully depressed.

cable release An accessory that connects to the camera and allows you to trip the shutter using the cable instead of by pressing the Shutter button.

chroma noise Extraneous, unwanted color artifacts in an image.

chromatic aberration A lens phenomenon that bends different-colored light rays at different angles, thereby focusing them on different planes. Two types of chromatic aberration exist: axial and chromatic difference of magnification. The effect of chromatic aberration increases at longer focal lengths. See also axial chromatic aberration and chromatic difference of magnification. chromatic difference of magnification

A lens phenomenon that bends differentcolored light rays at different angles, thereby focusing them on different planes; this appears as color fringing where high-contrast edges show a line of color along their borders.

CMOS (complementary metal-oxide semiconductor) The type of imaging sensor used in the 7D to record images. CMOS sensors are chips that use power more efficiently than other types of recording media.

color balance The color reproduction fidelity of a digital camera's image sensor and of the lens. In a digital camera, color balance is achieved by setting the white balance to match the scene's primary light source or by setting a Custom White Balance. You can adjust color balance in image-editing programs.

color/light temperature A numerical description of the color of light measured in Kelvin. Warm, late-day light has a lower color temperature. Cool, early-day light has a higher temperature. Midday light is often considered to be white light (5000K). Flash units are often calibrated to 5000K.

color space In the spectrum of colors, a subset of colors that is encompassed by a particular space. Different color spaces include more or fewer colors. See also *RGB* and *sRGB*.

compression A means of reducing file size. Lossy compression permanently discards information from the original file. Lossless compression does not discard information from the original file and allows you to re-create an exact copy of the original file without any data loss. See also *lossless* and *lossy*.

contrast The range of tones from light to dark in an image or scene.

contrasty A term used to describe a scene or image with great differences in brightness between light and dark areas.

crop To trim or discard one or more edges of an image. You can crop when taking a picture by moving closer to the subject to exclude parts of a scene, by zooming in with a zoom lens, or via an image-editing program.

daylight balance A general term used to describe the color of light at approximately 5500K, such as midday sunlight or an electronic flash. A white balance setting on the camera calibrated to give accurate colors in daylight.

depth of field The zone of acceptable sharpness in a photo that extends in front of and behind the plane of sharp focus.

diaphragm Adjustable blades inside the lens that open and close to determine the lens aperture.

diffuser Material such as fabric or paper that is placed over the light source to soften the light. **dpi (dots per inch)** A measure of printing resolution.

dynamic range The difference between the lightest and darkest values in an scene as measured by f-stops. A camera that can hold detail in both highlight and shadow areas over a broad range of f-stops is said to have a high dynamic range.

exposure The amount of light reaching the image sensor. At a given ISO, exposure is the result of the intensity of light multiplied by the length of time the light strikes the sensor.

exposure meter A general term referring to the built-in light meter that measures the light reflected from the subject back to the camera. EOS cameras use reflective meters. The exposure is shown in the viewfinder and on the LCD panel as a scale, with a tick mark under the scale that indicates ideal exposure, overexposure, and underexposure.

extender An attachment that fits between the camera body and the lens to increase the focal length of the lens.

extension tube A hollow ring attached between the camera lens mount and the lens, that increases distance between the optical center of the lens and the sensor, and decreases minimum focusing distance.

fast A term that refers to film, ISO settings, and photographic paper that have high sensitivity to light. This also refers to lenses that offer a wide aperture, such as f/2.8 or f/1.4, and to a short shutter speed.

filter A piece of glass or plastic that is usually attached to the front of the lens to alter the color, intensity, or quality of the light. Filters are also used to alter the rendition of tones, reduce haze and glare, and create special effects such as soft focus and star effects.

flare Unwanted light reflecting and scattering inside the lens, causing a loss of contrast and sharpness, and/or artifacts in the image.

flat A term that describes a scene, light, photograph, or negative that displays little difference between dark and light tones. This is the opposite of contrasty.

f-number A number representing the maximum light-gathering ability of a lens, or the aperture setting at which a photo is taken. It is calculated by dividing the focal length of the lens by its diameter. Wide apertures are designated with small numbers, such as f/2.8. Narrow apertures are designated with large numbers, such as f/22. See also *aperture*.

fps (frames per second) In still shooting, fps refers to the number of frames either in One-shot or Continuous shooting modes. In video film recording, the digital standard is 30 fps.

Glossary

focal length The distance from the optical center of the lens to the focal plane when the lens is focused on infinity. The longer the focal length is, the greater the magnification.

focal point The point in an image where rays of light intersect after reflecting from a single point on a subject.

focus The point at which light rays from the lens converge to form a sharp image. This is also the sharpest point in an image achieved by adjusting the distance between the lens and image.

frame A term used to indicate a single exposure or image. This also refers to the edges around the image.

f-stop See f-number and aperture.

ghosting A type of flare that causes a clearly defined reflection to appear in the image symmetrically opposite to the light source, creating a ghost-like appearance. Ghosting is caused when the sun or a strong light source is included in the scene, and a complex series of reflections occur among the lens surfaces.

gigabyte The usual measure of the capacity of digital mass storage devices; a gigabyte is slightly more than 1 billion bytes.

grain See noise.

gray-balanced The property of a color model or color profile where equal values of red, green, and blue correspond to a neutral gray value.

gray card A card that reflects a known percentage of the light that falls on it. Typical gray cards reflect 18 percent of the light. Gray cards are standard for taking accurate exposure-meter readings and for providing a consistent target for color balancing during the color-correction process using an image-editing program.

grayscale A scale that shows the progression from black to white using tones of gray. This also refers to rendering a digital image in black, white, and tones of gray. It is also known as monochrome.

highlight A term describing a light or bright area in a scene, or the lightest area in a scene.

histogram A graph that shows the distribution of tones or colors in an image.

hue The color of a pixel defined by the measure of degrees on the color wheel, starting at 0 for red, depending on the color system and controls.

HDV and AVCHD High Definition Video and Advanced Video Codec High Definition refer to video compression and decompression standards.

infinity The farthest position on the distance scale of a lens (approximately 50 feet and beyond).

ISO (International Organization for Standardization) A rating that describes the sensitivity to light of film or an image sensor. ISO in digital cameras refers to the amplification of the signal at the photosites. This is also commonly referred

to as film speed. ISO is expressed in numbers such as ISO 100. The ISO rating doubles as the sensitivity to light doubles. For example, ISO 200 is twice as sensitive to light as ISO 100.

JPEG (Joint Photographic Experts Group) A lossy file format that compresses data by discarding information from the original file to create small image file sizes.

Kelvin A scale for measuring temperature based around absolute zero. The scale is used in photography to quantify the color temperature of light.

LCD (liquid crystal display) The image screen on digital cameras that displays menus and images during playback and Live View shooting.

LCD panel A panel located on the top of the 7D camera; the LCD panel displays exposure information and changes made to exposure, white balance, drive mode, and other camera functions.

lightness A measure of the amount of light reflected or emitted. See also *brightness* and *luminance*.

linear A relationship where doubling the intensity of light produces double the response, as in digital images. The human eye does not respond to light in a linear fashion. See also *nonlinear*.

lossless A term that refers to file compression that discards no image data. TIFF is a lossless file format. **lossy** A term that refers to compression algorithms that discard image data, often in the process of compressing image data to a smaller size. The higher the compression rate, the more data that is discarded and the lower the image quality. JPEG is a lossy file format.

luminance The light reflected or produced by an area of the subject in a specific direction and measurable by a reflected light meter. See also *brightness*.

megabyte Slightly more than 1 million bytes.

megapixel One million pixels. This is used as a measure of the capacity of a digital image sensor.

memory card In digital photography, removable media that stores digital images, such as the CompactFlash media used to store 7D images.

metadata Data about data, or more specifically, information about a file. This information, which is embedded in image files by the camera, includes aperture, shutter speed, ISO, focal length, date of capture, and other technical information. Photographers can add additional metadata in image-editing programs, including name, address, copyright, and so on.

middle gray A shade of gray that has 18 percent reflectance.

midtone An area of medium brightness; a medium-gray tone in a photographic print. A midtone is neither a dark shadow nor a bright highlight.

neutral density filter A filter attached to the lens or light source to reduce the required exposure.

noise Extraneous visible artifacts that degrade digital image quality. In digital images, noise appears as multicolored flecks and as grain that is similar to grain seen in film. Both types of noise are most visible in high-speed digital images captured at high ISO settings.

nonlinear A relationship where a change in stimulus does not always produce a corresponding change in response. For example, if the light in a room is doubled, the room is not perceived as being twice as bright. See also *linear*.

normal lens or zoom setting A lens or zoom setting whose focal length is approximately the same as the diagonal measurement of the film or image sensor used. In full-frame 35mm format, a 50 to 60mm lens is considered to be a normal lens. On the 7D, normal is about 28mm. A normal lens more closely represents the perspective of normal human vision.

open up To switch to a lower f-stop, which increases the size of the diaphragm opening.

overexposure Giving an image sensor more light than is required to make an acceptable exposure. The resulting picture is too light.

panning A technique of moving the camera horizontally to follow a moving subject, which keeps the subject sharp but blurs and/or streaks background details.

photosite The place on the image sensor that captures and stores the brightness value for one pixel in the image.

pincushion distortion A lens aberration causing straight lines to bow inward toward the center of the image.

pixel The smallest unit of information in a digital image. Pixels contain tone and color that can be modified. The human eye merges very small pixels so that they appear as continuous tones.

plane of critical focus The most sharply focused part of a scene. This is also referred to as the point or plane of sharpest focus.

polarizing filter A filter that reduces glare from reflective surfaces such as glass or water at certain angles.

ppi (pixels per inch) The number of pixels per linear inch on a monitor or image file that are used to describe overall display quality or resolution. See also *resolution*.

RAW A proprietary image file in which the image has little or no in-camera processing. Because image data has not been processed, you can change key camera settings, including brightness and white balance, in a conversion program (such as Canon DPP or Adobe Camera Raw) after the picture is taken.

reflective light meter A device — usually a built-in camera meter — that measures light emitted by a photographic subject back to the camera.

reflector A surface used to redirect light into shadow areas of a scene or subject.

resolution The number of pixels in a linear inch. Resolution is the amount of data used to represent detail in a digital image. Also, the resolution of a lens that indicates the capacity of reproduction. Lens resolution is expressed as a numerical value such as 50 or 100 lines, which indicates the number of lines per millimeter of the smallest black-and-white line pattern that can be clearly recorded.

RGB (Red, Green, Blue) A color model based on additive primary colors of red, green, and blue. This model is used to represent colors based on how much of red, green, and blue is required to produce a given color.

saturation As it pertains to color, a strong, pure hue undiluted by the presence of white, black, or other colors. The higher the color purity is, the more vibrant the color.

sharp The point in an image at which fine detail is clear and well defined.

shutter A mechanism that regulates the amount of time during which light is let into the camera to make an exposure. Shutter time or shutter speed is expressed in seconds and fractions of seconds, such as 1/30 second.

slave A flash unit that is synchronized to and controlled by another flash unit.

slow A reference to film, digital camera settings, and photographic paper that have low sensitivity to light, requiring relatively more light to achieve accurate exposure. This also refers to lenses that have a relatively wide aperture, such as f/3.5 or f/5.6, and to a long shutter speed.

speed The relative sensitivity to light of photographic materials such as film, digital camera sensors, and photographic paper. This also refers to the ISO setting, and the ability of a lens to let in more light by opening to a wider aperture. See also *fast*.

spot meter A device that measures reflected light or brightness from a small portion of a subject.

sRGB A color space that approximates the gamut of colors of the most common computer displays. sRGB encompasses approximately 35 percent of the visible colors specified by the CIE.

stop See aperture.

stop down To switch to a higher f-stop, thereby reducing the size of the diaphragm opening.

telephoto A lens or zoom setting with a focal length longer than 50 to 60mm in full-frame 35mm format.

TIFF (Tagged Image File Format) A universal file format that most operating systems and image-editing applications can read. Commonly used for images, TIFF supports 16.8 million colors and offers lossless compression to preserve all the original file information.

tonal range The range from the lightest to the darkest tones in an image.

TTL (Through the Lens) A system that reads the light passing through a lens that strikes an image sensor.

tungsten lighting Common household lighting that uses tungsten filaments. Without filtering or adjusting to the correct white balance settings, pictures taken under tungsten light display a yellow-orange colorcast. **underexposure** The effect of exposing an image sensor to less light than is required to make an accurate exposure. The resulting picture is too dark.

viewfinder A viewing system that allows the photographer to see all or part of the scene that will be included in the final picture.

vignetting Darkening of edges on an image that can be caused by lens distortion, using a filter, or using the wrong lens hood. This is also used creatively in image editing to draw the viewer's eye toward the center of the image.

white balance The relative intensity of red, green, and blue in a light source. On a digital camera, white balance compensates for light that is different from day-light to create correct color balance.

wide angle A lens with a focal length shorter than 50 to 60mm in full-frame 35mm format.

NUMBERS

7D camera back of, 8-12 bottom of, 13-14 camera front, 3-4 custom functions menu, 22 lens controls, 14-16 mode dial, 5 movie shooting menu, 19 My Menu, 22 playback menus, 20 setup menu, 20-21 shooting menus, 18-19 side of, 12-13 top of, 5-8 using with studio lighting systems, 182 viewfinder display, 16-17 14-bit files, use of, 95 720 standard, using with video, 160 1080 standard, using with video, 160 9999 image, recording, 31

A

access lamp, location and function of, 9, 11 action images enhancing color, 213 exposure approaches, 212–213, 215–217 shooting, 55, 57 shooting modes, 217 shooting techniques, 212–213, 215–217 shutter speeds, 213 action photography gear camera cover, 210 cameras, 209 CF cards, 210

charged batteries, 210 laptop computer, 210 monopod or tripod, 210 portable storage device, 210 telephoto zoom lenses, 209-210 weatherproof sleeves, 210 wide-angle lenses, 209 action shooting setup Al Servo AF mode, 211 automatic AF-point selection, 211 Custom Functions, 212 Evaluative metering mode, 212 high-speed Continuous drive mode, 211 Picture Style, 212 RAW + JPEG image guality, 210 Tv shooting mode, 210-211 Add aspect ratio information, 138-139 Add image verification data, 138 Adobe RGB color space, 94, 96 AE Lock (Auto Exposure Lock), 78-79, 232 AE Lock/FE Lock/Index/Reduce button, 11 AEB (Auto Exposure Bracketing). See also exposures using, 81-83 shifting, 231 AF (autofocus) area, choosing, 86-88, 90-91 AF Microadjustment, 129-130 AF mode command, options, 19 AF Mode/Drive Mode button, 6, 8 AF point displaying, 38, 131 registering, 137 selecting, 2, 90-91 selection pattern, 131 AF-assist beam firing, 132 AF-Drive button, making changes for, 2

AF-On/AF Start button, 9, 12 AF-point disp (display) command, options, 20 AF-point orientation, setting, 86 AF-Point Selection/Magnify button, 9, 11 Al Focus AF mode, choosing, 85 Al Servo AF mode, choosing, 85 Al Servo functions, 127-129 aperture, changing for built-in flash, 172 aperture-priority AE (Av) shooting mode using, 58-60 using with built-in flash, 171 aspect ratio information, adding, 138-139 Audio/Video OUT/Digital terminal, 13 Auto Exposure (AE) Lock, using, 78-79, 232 Auto Exposure Bracketing (AEB), 81-83 shifting, 231 Auto Lighting Optimizer option, 37, 61, 75-76 Auto power off command options, 20, 38 auto reset file numbering, 33-34 Auto Rotate command options, 20, 38 autofocus improving accuracy of, 89 improving performance of, 89 speed, 89 autofocus (AF) area, choosing, 86-88, 90-91 Autofocus mode. See also focus choosing, 84-86 using with Live View, 152-153 Autofocus/Drive custom functions, 121-122, 127-128 automatic shooting modes. See also shooting modes Creative Auto, 63-65 Full Auto, 63 Av shooting mode using, 58-60 using with built-in flash, 171 AWB option, using, 235

B

battery compartment cover, location of, 14 Battery info. command, options, 21 battery pack, location of, 14 battery power, checking, 37 Beep command, options, 18, 36 Bluetooth-enabled GPS, adding, 181 Blur or sharpen background control, 64 bounce flash, using, 183 bracketing, 81–83. *See also* exposures Bracketing auto cancel, 123–124 bracketing range, setting for high-dynamic range, 229 Bracketing sequence, 124 Brightness histogram, using, 72-73 built-in flash. See also flash sync speed; wireless flashes advantage of, 179 exposure settings, 171 gauging power of, 172 guide number, 172 ISO sensitivity settings, 172 popping up, 5 range, 172 Red-eve reduction, 173 shooting with, 171-172 using, 173 using in lower light scenes, 179 using with Live View shooting, 150 Bulb exposures, making, 62. See also exposures

C

C modes, registering for outdoor shooting, 224-226 C1-C3 shooting modes accessing, 5 registering, 140-142 using, 62 CA (Creative Auto) shooting mode, 63-65 calibration, compensating for, 234 camera controls main dial, 2 multi-controller, 2 **Quick Control dial**, 2 Set button, 3 camera menus custom functions, 22 Movie Shooting, 19 My Menu, 22 Plavback 1-2, 19 Set-up 1-3, 20-21 Shooting 1-4, 18-19 camera settings, changing, 56 Camera user setting command, options, 21 Camera User Settings, 5 clearing, 142 registering, 140-142 cameras (EOS 7D) back of, 8-12 bottom of, 13-14 camera front, 3-4 custom functions menu, 22 lens controls, 14-16 mode dial, 5 movie shooting menu, 19 My Menu, 22 playback menus, 20 setup menu, 20-21

cameras (EOS 7D) (continued) shooting menus, 18-19 side of, 12-13 top of, 5-8 using with studio lighting systems, 182 viewfinder display, 16-17 Canon 580EX II Speedlite, using, 183 Canon EF lenses, angle of view, 187 Canon lenses. See also lenses 27D series, 204 EF 24-70mm f/2.8L USM, 186 EF 28-135mm, 186 EF 70-200mm f/2.8L IS USM, 15, 186 EF 100mm f/2.8 Macro USM, 196 EF 180mm f/3.5L Macro USM, 196 card slot cover, location of, 14 catchlights, adding to eyes, 183-184 C.Fn groupings Autofocus/Drive, 121-122 Exposure, 120, 122-125 Image, 121 Operation/Others, 122 C-Fn options, 22 Clear all camera settings command, options, 21 Clear all Custom Func. command, options, 22 close-up lenses, using, 204 cloudy light, getting best color in, 248 color correcting, 106 enhancing in actions and events, 213 color checker, using, 262 color spaces Adobe RGB, 94 choosing, 94-95, 97 comparing, 95-96 options, 19, 37, 94 sRGB, 94 color temperature, setting, 103-104 composition, importance of, 238 continuous file numbering, 32-33 copyright information, adding, 39-40 Copyright information command, options, 21 Creative Auto (CA) shooting mode, 63-65 Creative Auto screen, displaying, 112 Custom Controls, 134-138 custom function groupings Autofocus/Drive, 121-122 Exposure, 120, 122-125 Image, 121 Operation/Others, 122 Custom Functions, setting, 139-140 Custom WB command, options, 18 customization, categories, 119

D

Date/Time command, options, 21 DC coupler cord hole, 3 deleting images, 45-46 depth of field controlling, 58-60 maximizing, 239 previewing, 60 Depth of Field preview button, 4 Dial direction during Tv/Av, 138 dials, main and Quick Control, 2 digital noise controlling, 67 high ISO, 126 long-exposure, 125-126 diopic adjustment knob, location and function of, 6-7 Display all AF points, 131 distance scale, 15 distance scale and infinity compensation mark, 16 DPP (Digital Photo Professional), converting RAW images with, 258-260 dragging the shutter technique, using, 214 Drive mode making changes for, 2 selecting, 91-92 dual-function buttons, making changes for, 2 Dust Delete Data command, options, 19

E

EF 70-200mm f/2.8L IS USM lens, 15 EF lenses, using extension tubes with, 204 EF-S lens mount, design of, 187-188 EOS 7D camera back of, 8-12 bottom of, 13-14 camera front, 3-4 custom functions menu, 22 lens controls, 14-16 mode dial, 5 movie shooting menu, 19 Mv Menu, 22 playback menus, 20 setup menu, 20-21 shooting menus, 18-19 side of, 12-13 top of, 5-8 using with studio lighting systems, 182 viewfinder display, 16-17 EOS Utility, transferring images with, 34 Erase button, location and function of, 9-10 Erase images command, options, 20

erasing images, 45-46 E-TTL II technology, use with flash units, 170 EV (Exposure Value), explained, 61 event photography gear camera cover, 210 cameras, 209 CF cards, 210 charged batteries, 210 laptop computer, 210 monopod or tripod, 210 portable storage device, 210 telephoto zoom lenses, 209-210 weatherproof sleeves, 210 wide-angle lenses, 209 event shooting setup Al Servo AF mode, 211 automatic AF-point selection, 211 Custom Functions, 212 Evaluative metering mode, 212 high-speed Continuous drive mode, 211 Picture Style, 212 RAW + JPEG image quality, 210 Tv shooting mode, 210-211 events enhancing color, 213 exposure approaches, 212-213, 215-217 shooting techniques, 212-213, 215-217 Expo. comp/AEB command, options, 18 exposure adjustment Auto Exposure Lock (AE Lock), 78-79 Auto Lighting Optimizer, 75-76 Highlight Tone Priority, 76-77 Safety Shift, 77 exposure bracketing, combining with White Balance Bracketing, 105 **Exposure** Compensation negative, 231 using, 79-81 using in nonaverage scenes, 234 Exposure custom functions, 120 exposure settings, using with built-in flash, 171 Exposure simulation command, 19, 37 Exposure Value (EV), explained, 61 exposures. See also AEB (Auto Exposure Bracketing); bracketing; Bulb exposures; ISO sensitivity settings; metering modes advanced approach, 232-233 basic technique, 229-232 calculating, 49 considerations, 48-49 equivalent, 49-50 evaluating, 71-75 JPEG versus RAW, 74

modifying, 231 of nonaverage scenes, 234–236 philosophy, 48 setting for outdoor shooting, 227–228 using recommendations for, 61 EX-series Speedlites, using, 179 extenders, using with lenses, 203, 221 Extension System terminal, location of, 14 extension tubes, using, 204 External media backup command, options, 20 External microphone IN terminal, 13

F

Faithful Picture style described, 107 example of, 111 FE (Flash Exposure) Lock, setting, 175-176 File numbering options, 20 auto reset, 33-34 continuous, 32-33 manual reset, 35 files, transmitting, 181 Filter effect, applying, 108 filter mounting thread, 15 filters neutral density, 222 polarizers, 222 using in landscape photography, 222 using in nature photography, 222 warm-up, 222 Firmware Ver. (version) command, options, 21 flash advantage of, 179 exposure settings, 171 gauging power of, 172 guide number, 172 ISO sensitivity settings, 172 popping up, 5 range, 172 Red-eve reduction, 173 shooting with, 171-172 using, 173 using in lower light scenes, 179 using with Live View shooting, 150 flash autofocus assist beam, using, 178-179 Flash button, 5 Flash Control menu options, 18, 176-178 Flash Exposure Compensation, 173-175 Flash Exposure (FE) Lock, setting, 175-176 Flash Firing control disabling, 178 explained, 177 using, 64

Canon EOS 7D Digital Field Guide

flash sync speed importance of, 171 using, 57 Flash sync. speed in Av mode, 125 flash techniques adding catchlights to eves, 183-184 bounce flash, 183 flash technology, 170 flash units controlling, 179 hot shoe for, 7 voltage advisory, 183 focal plane mark, location and function of, 6-7 focal-length multiplier 1.6x. 192 function of, 187-188 focus, checking, 41. See also Autofocus mode Focus display in AI SERVO/MF, 132 Focus Mode switch, 16 focusing distance range selection switch, 15 focusing ring, 15-16 folders creating and selecting, 31-32 erasing images in, 46 Format command, options, 20 format option, 39 frame, enlarging in Live View, 2 frame rate, considering for video, 161 frames, shooting at negative exposure, 231 Full Auto shooting mode, 63 Full Auto versus P shooting modes, 54

G

gray card, using, 233, 261–262 Grid display option, 19, 37

H

HD (High-Definition) options, choosing, 161 HD TV, viewing images on, 43 HDMI mini OUT terminal, 13 High ISO speed noise reduction, 126 high-dynamic range (HDR) scenes, 229–230 Highlight alert command, options, 20 highlight alert option, 38 Highlight Tone Priority, using, 76–77, 126–127 highlights, modifying, 231 histograms Brightness, 72–73 displaying, 41, 74–75 options, 20, 38 RGB, 73–75 hot shoe, location and function of, 6–7 hyperfocal distance focusing, setting, 239

I

IFCL (Intelligent Focus Color Luminosity) metering system, benefit of, 68 image brightness, adjusting, 64 Image custom functions, 121 image format, setting, 29 Image jump options, 20, 42 image guality, setting, 29 image stabilization, explained, 205 image stabilized (IS) lenses, using, 197-199 Image stabilizer mode switch, 16 image verification data, adding, 138 images displaying as index, 42 displaving on TV, 43 erasing, 45-46 moving through, 42 navigating on card, 41 plaving back, 41-42 protecting, 44-45 searching for, 42 selecting and downloading, 34 transferring to computer, 34 index, displaying images as, 42 INFO button, location and function of, 9-10, 21, 39 interlaced designation, using with video, 160 IS (image stabilized) lenses, using, 197-199 ISO expansion, 123 ISO sensitivity settings, 65-68, 172. See also exposures ISO speed setting increments, 123 ISO/Flash Exposure Compensation button, 6, 8

J

JPEG capture versus RAW, 26, 28–30, 74, 255–256 JPEG format enhancing color in, 235 image quality, 29 maximum burst rate, 29 size in megapixels, 29 using, 24–25 JPEG shooting, correcting vignetting for, 202

K

K White Balance setting, using, 103

L

landscape images, shooting, 237-238 landscape photography gear filters, 223 lens sleeves, 223 macro lenses, 223 telephoto lenses, 221 weatherproof camera, 223 wide-angle lenses, 221 landscape photography, maximizing depth of field in, 239 Landscape Picture style, described, 107 Language command, options, 21 LCD brightness command, options, 21, 39 LCD Panel Illumination button, 6-8 lens controls lens mounting index, 14 MF (Manual Focusing), 14 Lens drive when AF impossible, 129 lens extenders, using, 203, 221 lens mounts differences in, 187-188 function of, 3 lens peripheral correction, setting, 201-202 Lens Release button, 4 lens system, building, 186-187, 195 lens terminology AF Stop, 206 Diffractive optics, 206 EF lens mount, 204 Floating System, 206 Focus preset, 206 full-time manual focusing, 206 image stabilization, 205 inner and rear focusing, 206 L-series, 205 macro, 206 USM (ultrasonic motor), 204-205 lenses. See also Canon lenses 70-200mm f/2.8L IS USM, 199 angle of view, 191 calibrating for focus accuracy, 199-201 close-up, 204 EF 24-70mm f/2.8L USM, 195 EF 70-200mm f/2.8L IS USM, 15, 195 focal-length multiplier, 187-188 image stabilized, 197-199 macro, 196-197 making microadjustments, 200-201 normal, 195 prime, 190-191 telephoto, 193-194 tilt-and-shift, 197

TS-E, 197 types of, 188-189 using extension tubes with, 204 wide-angle, 189, 191-193 zoom, 189-190 light, metering, 69 light falloff, occurrence of, 201 Live View enlarging frame in, 2 shooting in, 152-153 tips, 151-152 using autofocus with, 152-153 Live View focus (Face Detection) Live Mode, 148 Live mode, 148 Manual focus, 148 Quick mode, 148 Live View shooting command, 19 exposure simulation, 149 metering, 149 saving settings for, 141 setting up for, 150-151 side effects, 146-147 silent shooting modes, 149 using flash, 150 using for studio work, 154 Live View Shooting/Movie Shooting Switch/Start/ Stop button, 9, 12 Long-exposure noise reduction, 125-126 lowlight scenes, shooting, 236 L-series lenses, described, 205

М

M (Manual) shooting mode using, 60-61 using with built-in flash, 171 macro images, capturing, 237 macro lenses function of, 206 usina, 196-197 magnification increasing with extension tubes, 204 maximum, 41-42 magnified image, moving around, 42 magnified view, moving through images in, 2 Main dial explained, 2 location and function of, 6-7 Manual (M) shooting mode using, 60-61 using with built-in flash, 171 Manual Focusing (MF), switching to, 14

Canon EOS 7D Digital Field Guide

Manual reset option, using, 35 manual shooting mode, 51 Menu button, location and function of, 9-10 menu items, confirming changes made to, 3 menu options, selecting, 36-39 menu settings, saving, 140-141 menu sub-options, selecting, 36-39 menus custom functions, 22 Movie Shooting, 19 My Menu, 22 Playback 1-2, 19 Set-up 1-3, 20-21 Shooting 1-4, 18-19 metered exposure, modifying, 79-81 metering modes. See also exposures center-weighted average, 70-71 evaluative, 68-70 partial, 69-70 spot. 70-71 using AE Lock in, 79 Metering Mode/White Balance button, 6, 8 Metering timer command, options, 19 MF (Manual Focusing), switching to, 14 mirror, function of, 3 Mirror lockup, 133-134 Mode dial shooting modes, 51 turning, 5 Monochrome Picture style described, 107-108 example of, 111 motion, adding sense of, 214-215. See also action images Movie mode settings, saving, 141 Movie recording size command, options, 19 movies. See also video playing back, 167-168 recording, 165-167 setting up for recording, 164-165 multi-controller, location and function of, 2, 11 Multi-function button, location and function of, 6-7 My Menu adding items to, 142-143 customizing, 142 options, 22

Ν

nature images, shooting, 237–238 nature photography gear filters, 223 lens sleeves, 223

macro lenses, 223 telephoto lenses, 221 weatherproof camera, 223 wide-angle lenses, 221 negative exposure, shooting frames at, 231 neutral density filters, using, 222 Neutral Picture style described, 107 example of, 111 using, 112 night scenes, shooting, 236 noise reduction controlling, 67 high ISO, 126 long-exposure, 125-126 normal lenses, using, 195 NTSC TV system, explained, 43, 162 numbering options for files auto reset, 33-34 continuous, 32-33 manual reset, 35

0

One-shot AF mode, choosing, 84 One-touch RAW+JPEG command, options, 19 Operation/Others custom functions, 122, 134-139 Orientation linked AF point, 132-133 outdoor light, using, 247-248 outdoor shooting AF mode and AF-point selection, 225 approaches to exposure, 227-228 Av shooting mode, 224-225 basic exposure technique, 229-232 Custom Functions, 226 drive modes, 226 Evaluative mode, 226 HDR (high-dynamic range) scenes, 229 Picture Styles, 226 registering C modes, 224-226 shooting modes, 227 Spot Metering mode, 226

Ρ

P B shooting mode, using with built-in flash, 171 P mode advantage of, 52 versus Full Auto shooting modes, 54 using, 52–53 PAL color encoding system, explained, 43, 162 panning technique, using, 214–215 PC terminal, function of, 12

people photography gear backup EOS camera body, 243 brushes, 244 CF cards, 244 combs, 244 cosmetic blotters, 244 EX-series flashes, 244 EX-series light stands, 244 EX-series softboxes 244 EX-series umbrellas, 244 monopod, 244 reflectors, 243-244 spare batteries, 244 telephoto lenses, 243 tripod, 244 two 7Ds, 243 wide-angle lenses, 243 peripheral illumin. Correct. command, options, 18.36 Peripheral Illumination Correction, turning on, 202 photographic gray card, using, 233 Picture Style button, location and function of, 9-10 Picture Style command, options, 19 Picture Style Editor, using, 114-118 **Picture Styles** choosing, 109-113 Color Tone option, 110 Contrast option, 109-110 customizing, 109-113 explained, 107 installing, 117-118 modifying, 112-113 registering, 113-114 Saturation option, 110 saving custom, 117 settina, 94 Sharpness option, 109 Playback button, location and function of, 9-10 playback display, changing, 41 polarizer filters, using, 222 Portrait Picture style, described, 107 portrait shooting setup Av shooting mode, 244 Custom Functions, 246 Evaluative metering mode, 246 low-speed Continuous drive mode, 246 one-shot AF mode, 245 Picture Style, 246 Spot AF with manual selection, 245 portraits controlling depth of field, 250 exposure approaches, 250-251 guidelines, 253

with one-light setup, 252 outdoor, 247–248 studio, 251–252 window light, 249 power switch, location and function of, 6–7 preview image, magnifying, 41 prime lenses features of, 190–191 versus zoom lenses, 190 Print order command, options, 20 Program AE (P) shooting mode, 52–54 progressive scan designation, using with video, 160 Protect images command, options, 20

Q

Quality command options, 18 using with RAW and JPEG, 29 Quick Control button, 9–10 Quick Control dial, location and function of, 2, 9–10 Quick Control (Lock) switch, location and function of, 9–10 Quick Control screen, activating, 2, 56

R

RAW and JPEG, shooting, 28-30 RAW capture versus JPEG, 255-256 output of, 257 RAW capture option drawbacks, 28 using, 25-28 RAW conversion program, using, 258-260 **RAW** files converting, 26 getting accurate color with, 100 image quality, 29 versus JPEG format, 26 maximum burst rate, 29 size in megapixels, 29 **RAW** images capturing first f-stop of image data, 257 exposure of, 256-257 shooting, 100 shooting for high-dynamic range, 229 underexposure, 257 RAW process, 96 RAW versus JPEG, 26, 28-30, 74, 255-256 RAW+JPEG button, using, 9, 30 Recording func.+media select command, options, 20 Red-eye On/Off command, options, 18

Canon EOS 7D Digital Field Guide

Red-eye reduction, turning on, 173 Red-eye Reduction/Self-timer lamp, 3 reflectors, using to shoot portraits, 243–244 Release shutter without card command, options, 18, 36 remote control sensor, function of, 3 Remote Control terminal function of, 12 location of, 13 review time command, options, 18, 36 RGB histogram, using, 73–75 Rotate command, options, 20

S

Safety Shift, enabling, 77, 124 SD (Standard recording) options, choosing, 161 Select AF area selection mode, 130 Select folder command, options, 20 semi-automatic shooting mode, 51 Sensor cleaning command, options, 21 Setting (SET) button, function of, 11 settings, changing, 56 setup options, Shooting 1 menu, 36 sharpness, adjusting, 7 shooting modes. See also automatic shooting modes aperture-priority AE (Av), 58-60 bulb, 51 Bulb exposure, 62 C1-C3, 62 manual, 51 Manual (M), 60-61 P versus Full Auto, 54 Program AE (P), 52-54 selecting, 5 semi-automatic, 51 shiftable, 52 shutter-priority AE (Tv) mode, 54-58 shooting settings, saving, 140 Shutter button, location and function of, 6-7 shutter speeds in 1/3-stop increments, 56 for action shooting, 213 changing increments, 56 controlling with Av mode, 59 increasing, 66 selecting, 54 setting for motion, 216 showing fractions of, 55 tips, 57 shutter-priority AE (Tv) mode, 54-58 Silent shooting command, options, 19 Slide show command, options, 20

smart buffering, 92 Sound recording command, options, 19 Speedlites Canon 580EX II. 183 setting as slave units, 181 setting for action and events, 216 usina, 176, 182 using modifiers with, 182 using wirelessly, 179 sports, shooting, 55 Spot AF, enabling, 86-88 sRGB color space, 96 stabilization, importance to lenses, 198, 205 studio portraits, making, 251-252 submenus, opening, 3 sun, shooting into, 236

Т

telephoto lenses, using, 193-194 temperature, determining with white balance, 97, 99 terminals Audio/Video OUT/Digital, 13 Extension System, 14 External microphone IN, 13 HDMI mini OUT, 13 PC, 12 Remote Control, 12 tethered shooting, 154-157 tilt-and-shift lenses, using, 197 Toning effect, applying, 108 tripod socket, location of, 14 TS-E lenses, using, 197 TV, displaying images on, 43 Tv (TimeValue) shooting mode using, 54-55, 57 using with built-in flash, 171

U

USM (ultrasonic motor), function of, 204-205

۷

VF display illumination, 131 VF (Viewfinder) grid display command, options, 21 VF grid display option, 39 video. *See also* movies on 7D, 161–163 audio considerations, 162 battery life, 162 camera settings, 162 capacities and cards, 163 exposures, 162 focusing, 163

frame grabs, 163 frame rate, 161 playing back, 167–168 standards, 160–161 still-image shots during recording, 163 Video system command, options, 21 viewfinder display, 16–17 Viewfinder eyepiece and eyecup, 12 vignetting correcting, 202 defined, 201

W

warm-up filters, using, 222 WB SHIFT/BKT command, options, 19 wedding photography, dragging shutter in, 214 WFT Settings command, options, 20 WFT-ES Wireless File Transmitter, adding, 181 white balance changing presets, 99 Custom option, 99–102 function of, 97 setting, 98–99 White Balance Auto bracketing, setting, 104–106 White Balance command, options, 18 White Balance Correction, using, 106 White balance setting, 2, 94, 155 wide-angle lenses features of, 189 using, 191–193 window light, metering, 249 wireless connection, shooting with, 154–157 wireless flashes, setting up, 181–183. *See also* built-in flash

Ζ

zoom lenses features of, 189–190 versus prime lenses, 190 zoom ring, turning, 15

Guides to

Colorful, portable Digital Field Guides are packed with essential tips and techniques about your camera equipment. They go where you go; more than books-they're gear. Each \$19.99.

978-0-470-39236-2

Also available

Canon EOS Rebel XSi/450D Digital Field Guide • 978-0-470-38087-1 Nikon D40/D40x Digital Field Guide • 978-0-470-17148-6 Sony Alpha DSLR A300/A350 Digital Field Guide • 978-0-470-38627-9 Nikon D90 Digital Field Guide • 978-0-470-44992-9 Nikon D300 Digital Field Guide • 978-0-470-26092-0 Canon 50D Digital Field Guide • 978-0-470-45559-3

Available wherever books are sold.

Wiley and the Wiley logo are registered trademarks of John Wiley & Sons, Inc. and/or its affiliates. All other trademarks are the property of their respective owners